Gallery
Technical
Bulletin

Volume 24, 2003

National Gallery Company
London

Distributed by
Yale University Press

This volume of the *Technical Bulletin* is published with the generous support of the **Samuel H. Kress Foundation** and the **American Friends of the National Gallery, London, Inc.**

Series editor **Ashok Roy**

First published in Great Britain in 2003 by
National Gallery Company Limited
St Vincent House, 30 Orange Street
London WC2H 7HH

www.nationalgallery.co.uk

British Library Cataloguing in Publication Data
A catalogue record for this journal is available from the British Library

ISBN 1 85709 997 4
ISSN 0140 7430
525043

Publisher **Kate Bell**
Project manager **Jan Green**
Editor **Diana Davies**
Designer **Tim Harvey**
Picture research **Xenia Corcoran and Kim Klehmet**
Production **Jane Hyne and Penny Le Tissier**

Printed in Italy by Conti Tipocolor

FRONT COVER
Georges Seurat, *Bathers at Asnières* (NG 3908), detail of PLATE 4, page 7

TITLE PAGE
Giulio Romano, *The Birth of Jupiter* (NG 624), detail of PLATE 1, page 38

Contents

Seurat's Painting Practice:
Theory, Development and Technology

JO KIRBY, KATE STONOR, ASHOK ROY, AVIVA BURNSTOCK, RACHEL GROUT AND RAYMOND WHITE

SEURAT IS EXTREMELY WELL REPRESENTED in London. Holdings of his work in the National Gallery and the Courtauld Institute allow the development of his career to be studied here as nowhere else. Furthermore, the majority of Seurat's works in the two collections – all the large paintings and a considerable number of oil sketches – have recently been examined and analysed. The National Gallery's *Bathers at Asnières* (NG 3908) and the related small oil sketches in the collection were examined by a variety of analytical techniques for the exhibition *Seurat and The Bathers*, held at the Gallery in 1997, but only a limited amount of technical information was included in the catalogue.[1] Following a technical study of Seurat's paintings in the Courtauld Institute collection carried out

between 2000 and 2001,[2] it was decided to combine and publish here the results acquired by the two institutions as together they provide an unusually full survey of the painter's development in the course of his short career. In spite of the very large art-historical literature devoted to the painter, there is surprisingly little on his methods and materials, apart from the 1989 study of *A Sunday on La Grande Jatte*, published by the Art Institute of Chicago,[3] and the brief account of the *Bathers* in the 1997 exhibition catalogue. This is unexpected in view of Seurat's well-documented interest in colour theory: it is inconceivable that this would not have influenced, for example, his choice of pigments. The materials available to him were in turn dictated by the state of development of the paint industry, the

PLATE 1 Georges Seurat, *Man painting a Boat*, 1883. Panel, 15.9 × 25 cm.
Reproduced by kind permission of the Courtauld Institute Gallery, Somerset House, London.

TABLE 1 Paintings examined in the survey, their supports and grounds

	Dimensions (h × w)	Support; canvas weave and thread count	Sizing	Priming
FINISHED PAINTINGS				
Bathers at Asnières, 1883–4, reworked 1886–7 (NG 3908)	201 × 300 cm (single piece of canvas)	Linen, plain weave (coarse)	Probably sized	Commercially applied greyish-white ground (lead white with some carbon black)
Le Bec du Hoc, Grandcamp, 1885, reworked 1888, Tate Modern, on loan to the National Gallery (L 728)	65 × 81 cm (size No. 25, *figure*)	Linen, plain weave; 33 × 34 per sq. cm	Probably sized	Commercially applied white ground (single layer?)
The Bridge at Courbevoie, 1886–7, Courtauld Collection (P.1948.SC.394)	46.3 × 55.1 cm (size No. 10, *figure*)	Linen, plain weave; 28 × 24 per sq. cm	No	None
Young Woman powdering Herself, 1889–90, Courtauld Collection (P.1932.SC.396)	95.5 × 79.5 cm (originally size No. 30, *figure*; stretcher altered)	Linen, plain weave; 22 × 20 per sq. cm	Animal glue size	Double priming: lower ground: commercial application, greyish (lead white, chalk, some carbon black in heat-bodied linseed oil) upper ground: artist's application (lead white and chalk in heat-bodied linseed oil)
The Channel of Gravelines, Grand Fort-Philippe, 1890 (NG 6554)	65 × 81 cm (size No. 25, *figure*)	Linen?, plain weave (fine)	No size layer apparent but absorbent oil-bound first priming layer	Double priming (artist's application): lower ground: chalk in oil upper ground (two applications): lead white in oil
STUDIES				
Fisherman in a Moored Boat, c.1882, Private Collection on extended loan to the Courtauld Gallery (LP.1997.XX.16)	15.8 × 25.1 cm	Hardwood (mahogany?)	–	None
A Boat near a Riverbank, Asnières, c.1883, Courtauld Collection (P.2000.XX.2)	15.4 × 24.8 cm	Hardwood (mahogany?)	Possibly sized	None
Man in a Boat, c.1883, Private Collection on extended loan to the Courtauld Gallery (LP.1997.XX.2)	25 × 16.1 cm	Hardwood (mahogany?)	–	Single layer, white pigment in oil (lead white?)
Man painting a Boat, 1883, Courtauld Collection (P.1948.SC.393)	15.9 × 25 cm	Hardwood (mahogany?)	–	Single layer, white pigment in oil (lead white + some silica)
Horses in the Water: Study for 'Bathers at Asnières', 1883–4, Private Collection on extended loan to the Courtauld Gallery (LP.1997.XX.17)	c.15.8 × 24.7 cm	Hardwood (mahogany?)	–	None
A River Bank (The Seine at Asnières), c.1883 (NG 6559)	15.8 × 24.7 cm	Hardwood	–	None
The Rainbow: Study for 'Bathers at Asnières', 1883–4 (NG 6555)	15.5 × 24.5 cm	Hardwood	–	None
Study for 'Bathers at Asnières', 1883–4 (NG 6561)	16 × 25 cm	Hardwood	–	None
The Angler, c.1884, Private Collection on extended loan to the Courtauld Gallery (LP.1997.XX.15)	24.9 × 15.9 cm	Hardwood (mahogany?)	–	None
Study for 'La Grande Jatte', c.1884–5 (NG 6556)	15.2 × 24.8 cm	Hardwood	–	None
Study for 'La Grande Jatte', c.1884–5 (NG 6560)	16 × 25 cm	Hardwood	–	None
The Morning Walk, 1885 (NG 6557)	24.9 × 15.7 cm	Hardwood	–	None
The Seine seen from La Grande Jatte, 1888 (NG 6558)	15.7 × 25.7 cm	Hardwood	–	Thin lead white priming
Study for 'Le Chahut', c.1889, Courtauld Collection (P.1948.SC.395)	c.22 × c.15.8 cm	Mahogany? (cut down from larger piece)	–	Single layer, white pigment in oil
At Gravelines, 1890, Courtauld Collection (P.1948.SC.397)	c.15.9 × c.25.2 cm	Hardwood (mahogany?)	–	Single layer, white pigment in oil (lead white + some silica)

PLATE 2 Georges Seurat, *Study for 'Bathers at Asnières'* (NG 6561), 1883–4. Panel, 15.2 × 25 cm.

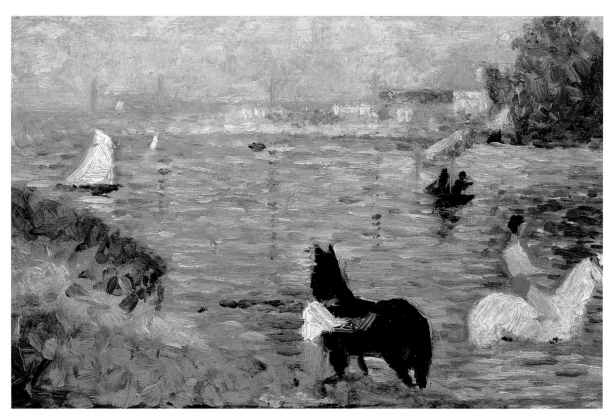

PLATE 3 Georges Seurat, *Horses in the Water: Study for 'Bathers at Asnières'*, 1883–4. Panel, 15.2 × 24.8 cm.
Private collection on extended loan to the Courtauld Institute Gallery, Somerset House, London.

PLATE 4 Georges Seurat, *Bathers at Asnières* (NG 3908), 1883–4, reworked 1886–7. Canvas, 201 × 300 cm.

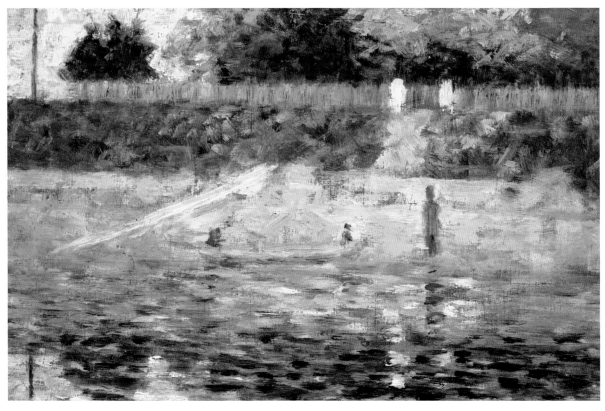

PLATE 5 Georges Seurat, *A Boat near a Riverbank, Asnières, c.*1883. Panel, 15 × 24 cm.
Reproduced by kind permission of the Courtauld Institute Gallery, Somerset House, London.

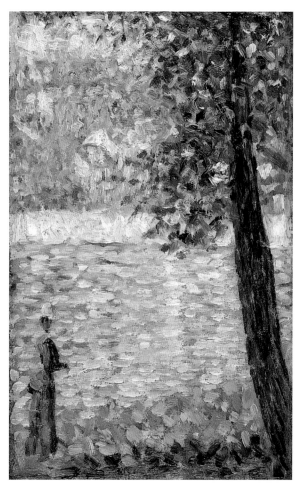

PLATE 6 Georges Seurat, *The Morning Walk* (NG 6557), 1885. Panel, 24.9 × 15.7 cm.

those used in the more finished pictures, where the choice of, for example, one particular green pigment might be significant for the very precise optical effects Seurat sought. It is important to realise that nothing in Seurat's art seems to have been unconsidered – even the most cursory drawing or painted sketch appears to have had a very precise function in the production of the finished work. This may be one of the reasons why Seurat's work is so recognisable, because he consistently chose a particular range of materials for each purpose. In effect, by always using a fixed set of materials – for example the habitual use of charcoal and conté crayon in the drawings – an element of unpredictability, a variable in scientific terms, was removed: the artist could concentrate on what he was aiming to express rather than on the means of expression.

Georges Seurat was born in Paris in 1859 into a wealthy middle-class family who supported him during his formal artistic training and, after his military service (1879–80), during his independent studies.[5] This freed him from any need to sell his work or seek commissions. From 1876 to 1878, he took drawing lessons at the Ecole Municipale de Sculpture et de Dessin in Paris, run by the sculptor Justin Lequien *fils*, where students were encouraged to simplify forms and to avoid unnecessary detail. Most of those attending the school were destined to work in the applied and industrial arts; for them such a drawing education was eminently suitable. It seems also to have had a lasting influence on Seurat's painting style, as well as on his characteristic tonal drawings in soft materials such as charcoal, pastel and conté.

In 1878 he was admitted to the Ecole des Beaux-Arts and entered the studio of Henri Lehmann, a former pupil of Ingres. Here he followed a conventional academic programme, including drawing from plaster casts of antique sculptures and from life; he also made drawings from the works of old masters such as Raphael, Holbein and Poussin. It is easy to imagine that Seurat would have been attracted to the work of Ingres and it is clear that he did respond to the working methods of this archetypal academic painter, distilled through the teaching of Lehmann. However, it seems that even at this early stage of his career he was also interested in the work of other very different painters. It is reported, for example, that he visited the fourth Impressionist exhibition in 1879, where he would have seen works by Caillebotte, Degas, Monet and Pissarro, among others, and that of the American painter Mary Cassatt, who exhibited two paintings

manufacture of artists' materials and the extent to which these were manipulated by suppliers and *marchands du couleurs*.

The paintings examined comprise fifteen oil sketches (see Table 1; PLATES 1–3, 5, 6, 21), including several for the *Bathers* and for the *Grande Jatte*, and four finished, fully realised paintings dating from between 1883 and 1890. These are: *Bathers at Asnières* (NG 3908; PLATE 4), *The Bridge at Courbevoie* (Courtauld Institute Gallery; PLATE 8), *Young Woman powdering Herself* (Courtauld Institute Gallery; PLATE 9), and *The Channel of Gravelines, Grand Fort-Philippe* (NG 6554; PLATE 11). *Le Bec du Hoc, Grandcamp* (London, Tate Modern, on loan to the National Gallery; PLATE 7), was also examined visually for this survey, but no samples were taken.[4]

As well as showing changes that took place in the artist's choice of materials as his style and technique developed in the ten or so years of his career, this survey enables a comparison to be made between those materials used for the sketches and

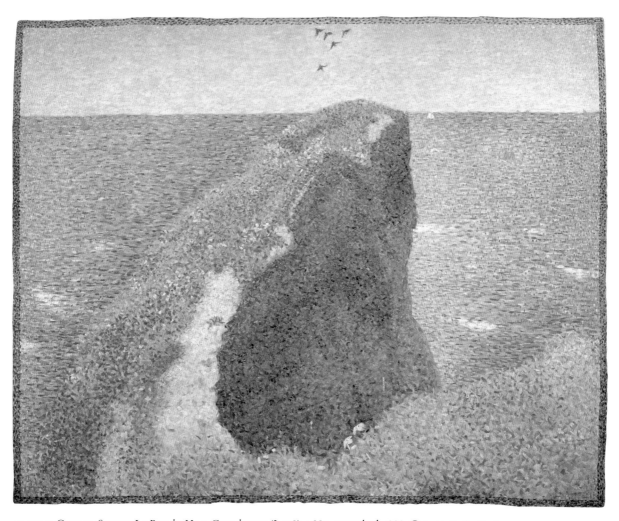

PLATE 7 Georges Seurat, *Le Bec du Hoc, Grandcamp* (L728), 1885, reworked 1888. Canvas, 64.8 × 81.6 cm. On loan from Tate Modern, London.

in coloured frames.[6] Renoir, whose work Seurat admired particularly, had work accepted at the Salon that year and so did not participate in this Impressionist exhibition. On completing his military service, Seurat did not return to the Ecole des Beaux-Arts but concentrated on developing a theoretical foundation for his art by reading, and pursued his own independent researches in the Louvre and in the Salon exhibitions. He is known, for example, to have made a free copy of *The Poor Fisherman* (Paris, Musée d'Orsay) by Pierre Puvis de Chavannes,[7] shown in the Salon exhibition of 1881, and he looked seriously at the works of Eugène Delacroix, including the wall paintings in the church of St-Sulpice. Delacroix's paintings influenced Seurat deeply, much as they had the Impressionists some twenty years before. During 1881 he made notes on Delacroix's palettes and on his use of red and green in conjunction, and on where he allowed tones of blue and orange, yellow and violet to play against one another.[8] In view of his later discussions

with the mathematician and aesthetician Charles Henry, it is interesting that even at this stage in his career Seurat seems to have been more impressed by the harmonies arising from such pairs of complementary colours rather than the contrasts.

Although a drawing of his – a portrait of his close friend Aman-Jean (Amand-Edmond Jean) – was accepted for the Salon exhibition of 1883, Seurat did not otherwise have much success with this official venue: *Bathers at Asnières*, for example, was rejected the following year.[9] The Salon was no longer under State control by this time, however, and its annual exhibitions gradually declined in importance. The political climate was also different from that of the early 1870s when the Impressionists had so signally failed to achieve official recognition. Dealer exhibitions became more influential and smaller groups, often founded by artists, came into being. The *Bathers* was shown in the summer of 1884 at the first exhibition of one such group, the Groupe des Artistes Indépendants, of which Seurat

9

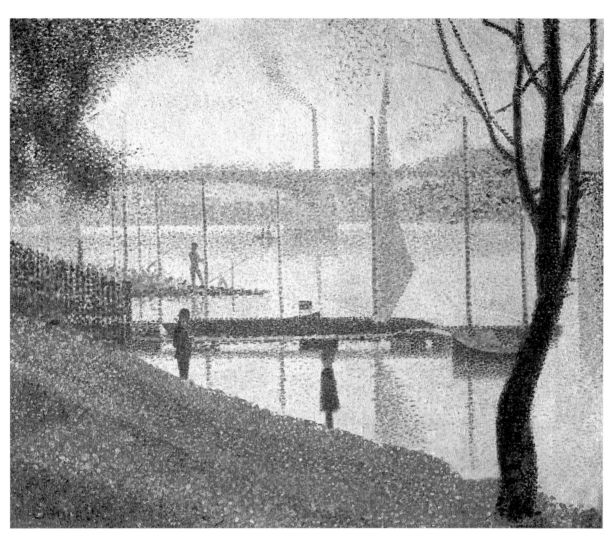

PLATE 8 Georges Seurat, *The Bridge at Courbevoie*, 1886–7. Canvas, 45.4 × 55.3.
Reproduced by kind permission of the Courtauld Institute Gallery, Somerset House, London.

was a founder member, and which, like the first Impressionist exhibition in 1874, contained works by artists who had been rejected by the Salon jury. It was at this time that he met Paul Signac. As a result of this exhibition the Société des Artistes Indépendants was established and Seurat contributed regularly to their exhibitions until his death. In fact, most of Seurat's finished paintings were exhibited to the public at independent exhibitions of this type during his lifetime. *A Sunday on La Grande Jatte* and *Le Bec du Hoc, Grandcamp* were shown at the last Impressionist exhibition in 1886, at the exhibition of 'Les Vingt' in Brussels in 1887 (both by invitation), and at the second exhibition of the Société des Artistes Indépendants,[10] also in 1886, while *The Channel of Gravelines, Grand Fort-Philippe* was on display at the Society's seventh exhibition at the time of Seurat's death in March 1891.[11]

The results of Seurat's constant researches into optical and aesthetic theory, with the attendant

modifications to his handling of paint and developments like the use of coloured borders and frames, were frequently the subject of criticism and analysis by artists and critics alike, but Seurat himself said little about the theory of his painting techniques – he left such explanations to others such as Felix Fénéon. A letter written to Maurice Beaubourg in August 1890 gives a brief statement summarising his views on the harmonious use of tone, colour and line.[12] It is clear that Seurat relied very much on the written word in developing his ideas, to an unusually large extent compared with other painters at that time. From the beginning of his career he sought an 'optical formula' for the proper construction of his paintings and he turned for assistance to the theories of scientists, partly as interpreted by other authors. He read Charles Blanc's article on Delacroix in the *Gazette des Beaux-Arts* (1864) during his student days and, more significantly, his *Grammaire des arts du dessin* (1867).[13] Through this

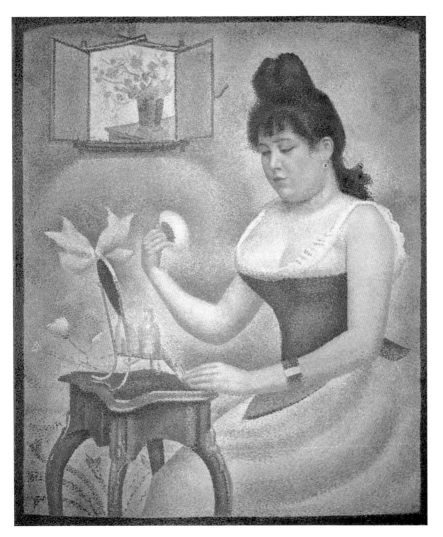

PLATE 9 Georges Seurat, *Young Woman powdering Herself*, 1889–90. Canvas, 95.5 × 79.5 cm. Reproduced by kind permission of the Courtauld Institute Gallery, Somerset House, London.

book he was first introduced to the essential elements of Michel-Eugène Chevreul's work, along with the conventionally accepted notion of primary colours and colour mixing, with complementary colours illustrated in a star-shaped diagram (PLATE 10).

Chevreul became Director of Dyeing at the Gobelins tapestry workshops in 1824. One of his tasks was to investigate the apparent dullness of certain textile dyestuffs. This had been assumed to be a technical problem relating to the dyestuffs, but Chevreul found that the lack of brightness was a phenomenon arising from the optical mixture of the hues of adjacent threads. It is worth noting that the primary colours as generally understood by most painters during the nineteenth century were red, yellow and blue; the complementary secondary colours produced by mixing pairs of these primaries are thus green (blue + yellow), violet (red + blue) and orange (red + yellow). Chevreul found that where neighbouring threads were of complementary

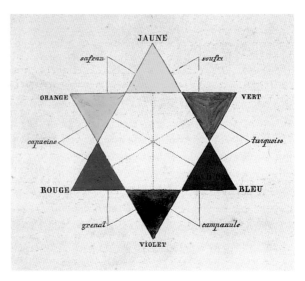

PLATE 10 Diagram of complementary colours from Charles Blanc, *Grammaire des arts du dessin* (2nd edn Paris 1870).

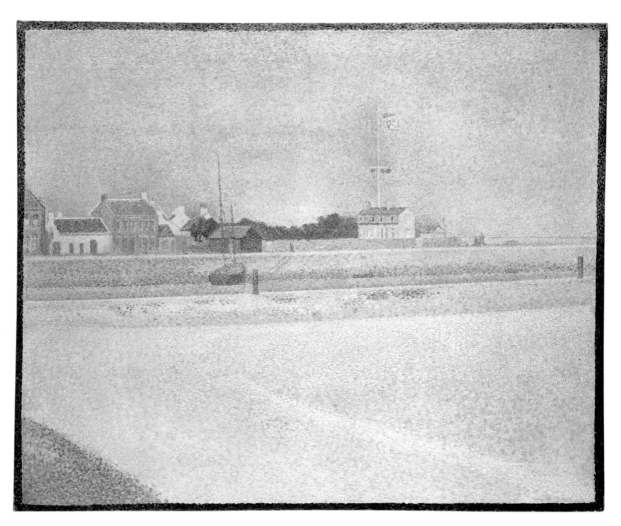

PLATE 11 Georges Seurat, *The Channel of Gravelines, Grand Fort-Philippe* (NG 6554), 1890. Canvas, 65 × 81 cm.

colours – blue and orange, for example – the resulting appearance to the eye was greyish. Chevreul formulated his observations as the law of simultaneous contrast of colours, which stated that when the eye saw two contiguous colours at the same time, they would appear as dissimilar as possible, both in hue and in tone. In the case of two different colours, the hue of each is modified by the effect of the complementary colour of the other, for example, if red is placed next to blue, its colour will appear a more orange-red than it would if used alone or placed next to yellow. The blue, meanwhile, appears more green than if used alone. Another optical effect Chevreul described was 'the phenomena of the duration of a light impression on the retina', as Seurat summarised it in the letter to Beaubourg – in other words, successive contrast. If the eye looks at a coloured area, say red, intensively for a while, and then looks away, for a moment the 'fatigued' eye perceives a green after-image, that is, the complementary colour. If the eye then looks at another colour, say yellow, the colour actually registered will

PLATE 12 Detail of shadow on the riverbank in *Bathers at Asnières* (PLATE 4) showing the use of simultaneous contrast of colour.

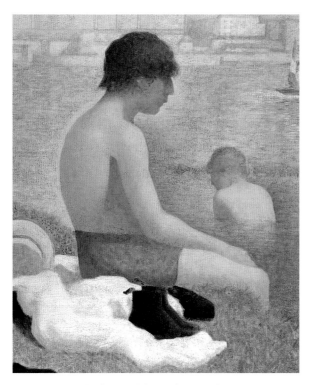

PLATE 13 Detail of central figure from *Bathers at Asnières* (PLATE 4) showing the thick, smooth brushwork of the flesh paint, the dark blue band of water outlining the front of the figure and light-coloured paint outlining his back. Note the paler colour contrasts of pink and pale mauve with cream and pale yellow, and the late application of orange and blue dots in the shadow of the lower back.

be a lime or apple green – the combination of the yellow and the induced green. Chevreul first reported these and related findings in a lecture in 1829, but the work was only published ten years later in the much reprinted *De la loi du contraste simultané des couleurs, et de l'assortiment des objets colorés* (1839).[14] A large part of the book was concerned with examples of colour contrast in different contexts, including the framing of pictures, effects which Seurat came to exploit in the coloured borders and frames in some of his later works.

Whether or not Seurat read Chevreul's book in its entirety, he did note down several paragraphs from the section on painting, including those on the raising and lowering of tones of different colours by their juxtaposition to achieve harmony, and the attainment of chiaroscuro by the juxtaposition of different tones of the same colour, an effect Seurat came to exploit with great subtlety.[15] The simultaneous contrast between areas of two complementary colours (PLATE 12) is particularly marked along the boundary between them, a feature that may be observed on many of his paintings, for example in the National Gallery *Bathers*, where the pale, heavily reinforced outline of the shoulder and upper arm of the boy seated on the bank stands out against the strong blue of the water (PLATE 13). A similar technique is used in the Courtauld Institute Gallery's *Young Woman powdering Herself* where the blue colour of the background has been intensified to bring out the palest tones of the sitter's arms and the white lace of her shoulder straps (PLATE 14).

Seurat regularly used simultaneous contrast to emphasise chiaroscuro, the sculptural quality of an object, and to isolate the subject from its background; clearly this effect was an important device in the tonal construction of his compositions and also, it should be said, in his drawings. In this his reading of Blanc and Chevreul was perhaps reinforced by a short paragraph on 'irradiation' in one of a series of articles by the Swiss aesthetician David Sutter, which appeared in the journal *L'Art* in 1880.[16] Sutter's 'irradiation' could be described as

PLATE 14 Detail from *Young Woman powdering Herself* (PLATE 9), showing intensification of the colour of the background adjoining the flesh paint and bodice.

PLATE 15 Detail from *Le Bec du Hoc, Grandcamp* (PLATE 7), showing the band of lighter paint of the sea outlining the promontory to the right, and darker paint at the left, exploiting the 'irradiation' effect.

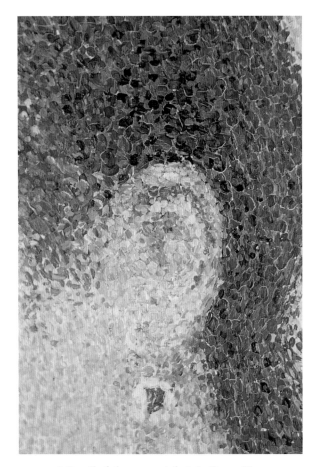

PLATE 16 Detail of the woman's hair in *Young Woman powdering Herself* (PLATE 9).

an effect seen at the boundary between a very light object against a darker background (or vice versa), giving the object high relief as well as separating it from the background.[17] This increase in the definition of the form certainly describes very well the characteristic 'detached' appearance of the bathing figures in the *Bathers,* and of the figures in the small version of *Les Poseuses* (*c.*1888; Private Collection), and in several of the sketches and drawings for this composition, for example *Seated Model in Profile* (1887; Paris, Musée d'Orsay). However, the effect is also employed in his landscapes, notably to outline the spectacular rocky promontory in *Le Bec du Hoc, Grandcamp* (PLATE 15). In the later *Young Woman powdering Herself* the technique is used in a very much more subtle and indeed more decorative way. The woman's dark hair is constructed in dots largely of red, blue and green which in some places give an overall blackish appearance (PLATE 16). This is surrounded by a halo of light-coloured paint made up of touches of pale blue, light creamy yellow and white, while the areas inside her right elbow and above her left forearm, both very pale flesh tones, are painted in a moderately dark blue-

green colour, giving a marked light and dark contrast. In addition, however, the areas of light and dark greenish-blue paint of the background wall-covering create a pattern of decorative swirls, as well as depicting the irradiation effect around the figure. The effects of simultaneous contrast have here been exploited – on the scale of individual dots of paint, and on the larger scale of broader areas of colour – to provide tonal contrast and even to create a lively pattern within the painting.

The way colour was actually perceived by the eye was, by Seurat's time, quite well understood. Research done by Thomas Young at the beginning of the nineteenth century and developed by Hermann von Helmholtz had revealed that white light consisted of three primary colours: an orange-red, green and a blue-violet (the colours to which the cones in the retina of the human eye respond).[18] If light of these colours is mixed in the correct proportions, white light is obtained; yellow light results from mixing red light and green light. This is additive mixing. When pigments and dyestuffs are combined, however, the mixing is subtractive: a yellow pigment, for example, appears yellow because it absorbs light from the blue and violet regions of the spectrum, reflecting the remainder; and a mixture of red, yellow and blue, the three subtractive primaries, should yield black, or a greyish colour; mixing a primary (red) with its complementary secondary colour (green) will also give grey or, ideally, black. (This was the problematic effect that Chevreul in fact observed in the dyed textiles.)

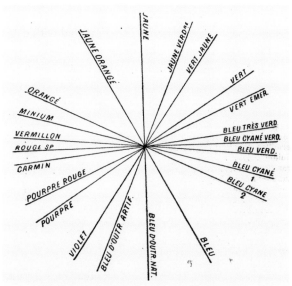

Fig. 120. — Diagramme des contrastes d'après O. Rood.

FIG. 1 Diagram of colour contrasts from Ogden Rood, *Théorie scientifique des couleurs* (Paris 1881).
© By Permission of The British Library, London

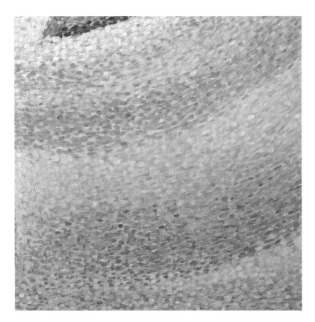

PLATE 17 Detail of the brushwork and colour of the skirt in *Young Woman powdering Herself* (PLATE 9).

How the principles of additive mixing might be represented on the canvas had also been the subject of study. The clearest and most relevant explanations of the theory and its practical applications were given in Ogden Rood's *Modern Chromatics, with Applications to Art and Industry* (New York 1879) which Seurat read in its first French translation in 1881.[19] Rood carried out colour matching experiments, many based on spinning discs of papers painted in different colours, others using coloured glass filters, under different lighting conditions. The spinning disc experiments were based on earlier work of the 1850s by the Scottish physicist James Clerk Maxwell, who experimented with discs of red, green and blue paper in which the sizes of sectors of each colour illuminated could be varied. Using algebraic colour matching equations, the precise quantity of the illumination of each of the three colours needed to match any spectral colour could then be specified. Rood used red, green and blue papers (painted using vermilion, emerald green and artificial ultramarine), together with smaller black and white papers to make a neutral grey, but he also allowed for the fact that the three colours were not equal in luminosity. He was able to construct an accurate diagram of contrasting colours (FIG. 1), from which it can be seen that, for example, vermilion is complementary to a greenish blue and emerald green is complementary to purplish red.[20]

The same diagram could be used to produce harmonious effects based on the angle between one colour and another on the colour wheel. Angles of

less than 80° or 90° between colours gave rise to effects of contrast that were unsatisfactory or even discordant. Sets of three colours, separated by angles of about 120°, were often particularly appealing in Rood's opinion; the examples he gave of the use of such 'triads' of colour by artists suggested that two of the three should be 'warm' colours, such as red and yellow, which took precedence over ideals of contrast. The association of colours separated only by a small interval (red and orange-red) was very effective when, for example, it was necessary to represent small gradations in colour.[21] This effect bears some relation to Chevreul's simultaneous contrast of tones; it can be seen in Seurat's work in the flesh painting and skirt of *the Young Woman powdering Herself* (PLATE 17). The placing of small dots of colour side by side so that, when viewed from certain distances, 'the blending is more or less accomplished by the eye of the beholder', was a method of achieving such gradation and the tints observed were, according to Rood, identical to those obtained by the method of spinning discs of coloured paper, rather than by mixing pigments on the palette. Rood described this method as giving 'true mixtures of coloured light', the nearest the artist could get to the additive mixture of colour explained by Helmholtz.[22]

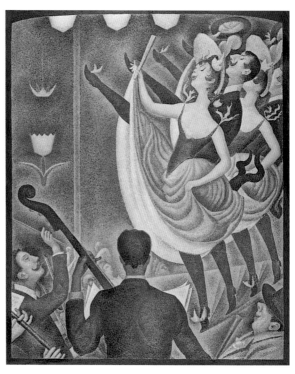

PLATE 18 Georges Seurat, *Le Chahut*, 1889–90. Canvas, 171.5 × 140.5 cm. Collection Kröller-Müller Museum, Otterlo, The Netherlands. Photo: Indien van Toepassing, Amsterdam.

PLATE 19 Detail of purple shadow on grass from *Bathers at Asnières* (PLATE 4), showing contrast between viridian green and mixed purple paint.

It is clear that Seurat wished to explore harmony of colour over and above effects of simple contrast. As well as the information he gained from Rood's book, his meeting and subsequent friendship with the mathematician Charles Henry encouraged him in this. Henry developed theories concerned with the symbolic values and associations of colours. Warm colours were more or less pleasant, whereas cold colours such as green, violet and blue were somewhat sad or inhibiting. He too constructed a chromatic circle where colours were associated with a particular emotional direction; thus pleasant (dynamogenous, that is, physiologically stimulating) colours correspond to agreeable directions: upwards and left to right. In his desire for a logical and scientific basis for the construction of his paintings, Seurat was particularly indebted to Henry's theories on the combination, direction and relationships of the linear elements of his compositions to control harmony and mood. Seurat's preoccupation with colour harmony can be seen in his earliest works and after 1886, when he first met Henry,[23] he also began to incorporate Henry's ideas on the perceptual effects of geometry and spatial arrangement on his compositions. Seurat's development in this regard can be seen clearly from a comparison of the *Bathers* and the rather later landscapes, for example *The Bridge at Courbevoie*, where so many vertical features are stressed, and the *Channel of Gravelines, Grand Fort-Philippe*, in which the idea is more subtly demonstrated by the slight upward rise in the line of the horizon from left to right, emphasised by painted borders. The symbolic use of line and also colour were perhaps explored to a greater extent in the interior scenes, all painted after 1886, such as *Le Chahut* (PLATE 18) and the *Young Woman powdering Herself*.

At some time Seurat copied out Rood's colour wheel and made notes on one of the experimental sections of the book. He may well have used the colour wheel to construct some of the contrasts and harmonies visible in the *Bathers*, as it was exhibited in 1884 – there are, for example, many based on cold viridian green and purple (PLATE 19), which are complementary colours according to Rood's system – but at this stage he had yet to investigate the effects of 'optical mixture' opened up for him by Rood and Henry and to develop the dotted brushwork so characteristic of his later paintings. In fact, his interest in and exploitation of contemporary colour theories are clearly evident in his earlier works, where the brushwork, although broadly directional, was more conventional. For Seurat, the purpose of this type of brushwork was both to optimise the optical mixture by juxtaposing the desired complementary colours in adjacent dots of paint, and also, on a larger scale, to construct areas of tonal contrast. It is, however, important to emphasise that Seurat's colour harmonies and contrasts whether constructed on the basis of Chevreul's work, or on Delacroix's, Blanc's, Rood's or Henry's, are in no way naturalistic. His earliest outdoor sketches, and indeed his studies of a model posed in the studio, may have been painted from what he observed; but the colour in the later studies and in the final painting has been ordered and contrived as part of the intellectual process of the construction of the picture.

Seurat's working practice

The five fully realised exhibition pictures examined here cover the whole development of Seurat's style, from the earlier controlled and directional brushwork seen in the *Bathers* in its first phase, and when first exhibited, to his adoption first of divisionist brushwork (that is, individual small touches of paint) and, slightly later, of subtly constructed harmonies and contrasts of colour in the *Channel of Gravelines* and the *Young Woman powdering Herself*. This apparently straightforward description of Seurat's development is complicated by the fact that he reworked many of his earlier pictures, including the *Bathers* and the *Grande Jatte,* in his

PLATE 20 Detail from *Horses in the Water* (PLATE 3) showing the colour of the support (panel) showing through the paint.

harmonies and contrasts generated in the scene in front of him. Because Seurat reworked so many of his pictures, the use of materials typical of his later divisionist technique is evident even on the earlier compositions in the reworked areas.

Examination of the sketches for these and other compositions has revealed a great deal about the painting materials Seurat used throughout his life. On the whole these are consistent with those found in the finished pictures. The small sketches were primarily compositional works, in which considerations of colour theory were of subsidiary importance, which is why perhaps their palettes were relatively restricted in comparison with the large-scale works based on them and do not change very much over time – apart from Seurat's abandonment of earth pigments some time after he painted the *Bathers*. Another consistent feature of Seurat's small compositional studies is his use of thin wood panels as supports, while his finished paintings are all on canvas with light-coloured or white grounds.

later, divisionist style, in some cases adding a toning painted border.[24] Seurat's most elaborate use of his own theories can be seen in his indoor compositions such as the *Young Woman powdering Herself* and *Les Poseuses*, in which he was free to define imaginary colour combinations and contrasts. These seem to have been painted under artificial light, unlike the outdoor scenes, such as *The Bridge at Courbevoie* and *Gravelines*, where the parameters of shifting natural light imposed constraints on his invention by the sheer number of possible

Supports and grounds

There were a number of possible supports that could be used for small preparatory sketches. Contemporary artists' suppliers list papers, mill-

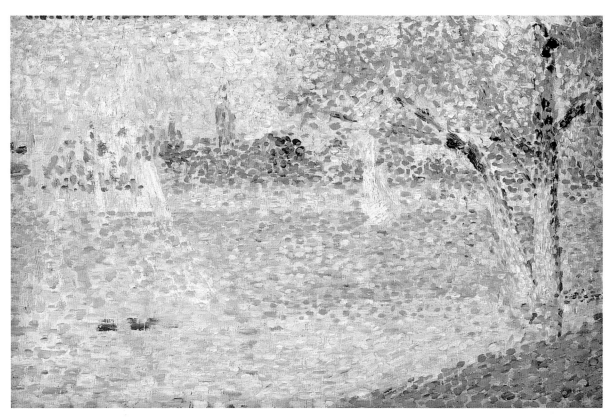

PLATE 21 Georges Seurat, *The Seine seen from La Grande Jatte* (NG 6558), 1888. Panel, 15.7 × 25 cm.

board, wood panels and canvases in a range of formats and sizes. The Impressionists preferred to employ canvas for all their works, but the Barbizon painters, such as Camille Corot, Théodore Rousseau and Charles-François Daubigny, used all types of support both for landscapes and for other subjects, and even for the most informal of their works.[25] Where works by these painters have been examined, the support usually carries some kind of ground. Seurat, on the other hand, habitually worked on small unprimed (PLATE 20) or simply filled wood panels.[26] In catalogues such as those produced by Lefranc & Cie smaller sizes of panel similar to those used by Seurat were advertised as *panneaux d'étude*. These, like other panels, were available with or without a priming or *rebouchés* (with the grain simply filled) and could be bought in sizes that would fit into a paint box, convenient to use out of doors. One standard size, listed as a No.2 landscape format by major Parisian suppliers such as Lefranc or Bourgeois *aîné*, was nominally 24–5 cm by 16 cm, and most of Seurat's small panels fall within this size range (PLATE 21). Panels were available as *mince* (thin) or *fort* (strong, or thicker); the actual thicknesses were not stated. Seurat's panels, which are about 0.4 cm thick, must be the 'thin' variety.[27] The painting boxes are listed in catalogues under names such as *boîtes de poche*, *boîtes au pouce*, *boîtes d'étude*, *boîtes paysage* and *boîtes d'étude à coulisses* (sliding), *rallongées* (extended leaf) and *crémaillères* (racked). Some painting boxes could hold several tiny *panneaux d'étude* suitable for outdoor work.[28] If Seurat used such a box to transport his studies for the *Bathers*, for example, this may explain the flattening of the impasto seen in some of the sketches: many of his panels display marks or grooves at the edges from being held in place within the lid of the box.

The *panneaux d'étude* were available in *bois blanc* (softwood, probably pine) and the more expensive *acajou* (mahogany): these are typical of

the selection sold by most colourmen. Seurat's panels in the Courtauld Institute and the National Gallery have mostly been identified tentatively as mahogany. The support for the *Study for Le Chahut* appears rather different in format and has been cut down from a larger piece of wood.[29] Walnut panels were also available, and also, at the very end of the nineteenth century, more expensive woods such as tulip wood. In a few of the National Gallery sketches, the grain of the panel suggests the use of walnut rather than mahogany.

Ready-stretched canvases were widely available in a similarly standardised but more extensive range of sizes and with a considerable choice, in both colour and thickness, of primings.[30] Examination of *The Bridge at Courbevoie* failed to reveal a priming on the canvas, although this is very unusual. The canvas is close in size to a so-called No.10 portrait canvas measuring 55 by 46 cm. *Le Bec du Hoc, Grandcamp* and the *Channel of Gravelines, Grand Fort-Philippe* were both painted on No.25 portrait-format canvases (81 cm by 65 cm). In these cases, the canvases have been turned on their sides and used in landscape format. *Couple walking: Study for the 'Grande Jatte'* (c.1884–5; Cambridge, Fitzwilliam Museum) is also painted on a No.25 canvas, in this case in the upright 'portrait' orientation.[31] Evidently, Seurat's preference was for the squarer 'portrait' shape, rather than the slightly narrower 'landscape' or 'marine' formats also available in standard sizes. *Young Woman powdering Herself* appears also to have been painted on a standard size portrait-format canvas, but later alterations to the stretcher mean that its present dimensions (about 94 cm by 78 cm) no longer correspond with any standard size.

The monumental scale of the finished paintings of *Bathers at Asnières* and *A Sunday on La Grande Jatte* suggests that the canvases must have been stretched to order. This would explain the coarseness of the linen used. Both works were painted on a single piece of canvas, and it is likely that they were of identical size before the *Grande Jatte* was enlarged by Seurat, who re-covered the tacking margin to accommodate a painted border.[32]

A plain-weave canvas was used for *The Bridge at Courbevoie* and *Young Woman powdering Herself*. Both canvases are of a tightly woven, fine weave and similar canvases were used for *Le Bec du Hoc* and *Gravelines*. Canvases of this type were favoured in academic circles for finished works and exhibition pictures and it is probable that Seurat's particular preoccupations with brushwork and optical effects

PLATE 22 Detail from *The Channel of Gravelines* (PLATE 11) showing the exposed white priming on the canvas.

were better achieved on a relatively smooth surface. A considerable variety of weaves was available for ready-stretched canvases, from a simple plain, relatively coarse weave for *pochades et études* through *toile demi-fine* to *toile très-fine* and *extra fine* in, for example, the Bourgeois catalogue of 1888. The *Study for 'A Sunday on La Grande Jatte'* (1884–5; New York, Metropolitan Museum of Art)[33] has a thread count of 30 by 29 threads per centimetre and *Le Bec du Hoc* 33 by 34 threads per centimetre, both extremely fine canvases which would probably come under one of these last categories.

Apart from the few occasions where Seurat appears to have used unprimed canvas (in this survey, *The Bridge at Courbevoie* and also the *Study for 'A Sunday on La Grande Jatte'*), his canvas paintings have light-coloured or white grounds. Most were commercially primed: the ground can be seen covering the tacking edges, as in, for example, the lower pale grey ground layer of the *Young Woman powdering Herself*. This is similar in colour to the ground on the large canvas of the *Bathers* which consists largely of lead white in oil lightly tinted with carbon black. In some paintings another ground layer has been applied over the commercial ground, as in the *Young Woman powdering Herself* where a very thin lead white ground has been applied on top of the commercial one. The canvas for the *Channel of Gravelines* also has a double-layered white ground, but in this case it appears to have been primed by the artist since neither layer extends onto the tacking edges. The lower layer consists of calcium carbonate, while the upper layer is lead white, both bound in oil. It is conceivable that, later in his career, Seurat desired a pure white ground for its optical effect, particularly as it was allowed to show in some areas of the composition

PLATE 23 Macro detail from *Study for Le Chahut* (London, Courtauld Institute Gallery) showing preliminary outline in blue paint of foreground figure. Photographed at 2×.

(PLATE 22). This could have represented a wish for a smoother surface texture, except that the artist's rather textured application was less smooth than that produced by the blades, similar to large palette knives, used by commercial canvas primers. The commercial *lisse* priming (generally at least two layers) was in fact very smooth. All the grounds examined analytically proved to be bound in oil. Canvases with absorbent grounds of calcium carbonate in aqueous (glue) media were available and Seurat experimented with such a *toile à plâtre* for *Les Poseuses* in 1887, but was displeased with the results. Paul Signac, who tried a similar ground, commented in a letter to Lucien Pissarro that the medium-rich paint stained the ground and sank on drying.[34]

Painting structure and development

Examination by infrared reflectography of the *Study for 'A Sunday on La Grande Jatte'* in the Metropolitan Museum of Art has shown that two overlapping drawn grids divided the canvas first into regular quarters and then into square sixths. A similar, although not identical, grid related to a drawing of the subject and visible with the naked eye, has also been found on the Fitzwilliam Museum canvas study, *The Couple walking, Sketch for the 'Grande Jatte'* (Cambridge, Fitzwilliam Museum). The grid appears to have been done in black conté crayon. On the other hand, examination of the *Bathers* failed to reveal any squaring up, although, in cross-sections, some evidence was found for preliminary drawing in charcoal or conté over the light-coloured ground. Certain of the later sketches, for example *Study for 'Le Chahut'* and *Gravelines*, show long continuous strokes of cobalt blue outlining the design (PLATE 23). This is also clearly visible in the *Study for 'Le Cirque'* (Paris, Musée du Louvre), in *Poseuse debout* (1887; Paris, Musée d'Orsay) and in the preparatory sketch (Houston, Museum of Fine Arts) for the *Young Woman powdering Herself*. While these features can be seen in the studies, it is not possible to say whether he used a similar method for the completed paintings.

The majority of Seurat's works have preparatory drawings and painted studies, indicating the meticulous academic planning that went into his finished paintings. The *plein air croquetons* show the sense of immediacy and spontaneity commonly associated with certain types of Impressionist sketch, but their function was entirely subsidiary to the overall concept of the finished work. *Horses in the Water:*

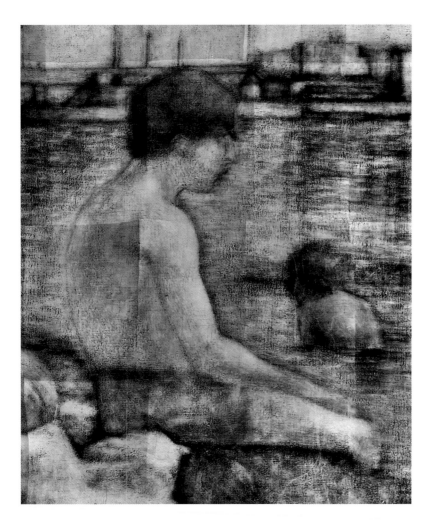

FIG. 2 X-ray detail of boy seated on the bank from *Bathers at Asnières* (PLATE 4). The thinner paint outlining the reserve left for the figure registers as a dark band in the X-ray image, and is particularly evident below the boy's thigh.

Study for 'Bathers at Asnières' (1883–4; London, Courtauld Institute; PLATE 3), for example, is a very freely painted sketch of the banks of the Seine, closely similar to the view depicted in the *Bathers*, but it includes two horses and figures which do not appear in the finished, large painting.

It is known from X-ray study of the *Bathers* that Seurat left reserves for the principal elements of his

PLATE 24 Macro detail from *The Bridge at Courbevoie* (PLATE 8) showing yellow-green lay-in of the riverbank over white paint of the water. Photographed at 1.5×.

large composition, particularly the figures (FIG. 2),[35] and it seems likely that he followed much the same method in the execution of the *Grande Jatte*, which is even more complex in design. The principle of leaving reserves for the main elements of the composition seems to have been followed throughout his career in his finished paintings and in a few of the studies. Simple blocking-in of areas of the composition, leaving reserves revealing the ground or support, is apparent in *The Angler* (London, Courtauld Institute of Art), a study for the *Grande Jatte*; the orange-coloured support is visible around the figure to the right. Reserves have been observed in *The Bridge at Courbevoie* (visible in the X-radiograph), *Le Bec du Hoc* at the top of the rocky outcrop, where the ground is exposed, and in the *Young Woman powdering Herself* (also detectable in the X-radiograph). In the *Channel of Gravelines*, the paint is so densely applied that it is impossible to judge whether or not reserves were left for any parts of the composition, and the X-ray image, for the same reason, is not revealing in this respect.

In both the *Bathers* and the *Grande Jatte*, the broad features of the landscape – the riverbank, the

PLATE 25 Cross-section of paint from shadow behind seated figure in *Bathers at Asnières*, showing the multi-layered structure; at least three of the layers contain viridian (transparent chromium oxide). Photographed at 450×; actual magnification 360×.

PLATE 27 Detail from the painted border of *The Channel of Gravelines* (PLATE 11) containing cobalt violet and cadmium orange.

PLATE 26 Cross-section of deep blue-green surface paint over bright orange from the foreground riverbank in *Bathers at Asnières*. The underlayers contain chrome yellow and viridian, representing perhaps a commercially mixed paint. Photographed at 320×; actual magnification 250×.

PLATE 28A (LEFT); PLATE 28B (RIGHT) Unmounted fragment of paint from the trousers of the reclining man, foreground left, from *Bathers at Asnières*, containing a mixture of French ultramarine with madder and cochineal lakes. A. photographed in reflected light at 250×. B. photographed by ultraviolet illumination showing fluorescence of the lakes; 200×.

water, the sky and so on – were brushed in with a thin layer of appropriately coloured lean paint. Thin dry paint was similarly used to lay in the compositions of *The Bridge at Courbevoie* and *Le Bec du Hoc*. The initial blocking-in in *The Bridge at Courbevoie* is much simpler than the same stage in the *Bathers* (PLATE 24). It is a smaller and less elaborate composition and Seurat's preoccupations with colour, and particularly brushwork, were rather more developed by this time; also, the very large scale of the *Bathers* dictates a broader and less time-consuming application of paint in the initial stages.

Seurat's selection of pigments, as identified from the analysis of paint samples, for the pictures covered by this survey are recorded in Table 3. It is clear that from an early stage in his career Seurat fixed on a core palette, composed largely of strong, spectrally pure colours:[36] cobalt blue and French

(synthetic) ultramarine; red lake and vermilion; chrome and cadmium yellows; viridian (PLATE 25) and emerald green, and lead white. Mixtures of these pigments are also found to give other reds, oranges, greens, purples and occasionally browns and blacks. Certain of these combinations may have been supplied ready mixed by the colourman, for example the green based on viridian with a little chrome yellow and lead white (PLATE 26). The Table shows the more restricted use, in addition, of other pigments such as red and yellow ochres, cadmium orange, manganese violet and the occasional use of carbon and bone black. It is the earlier pictures that show the widest range of palette, whereas the manganese violet and cadmium orange occur only in the late *Channel of Gravelines*, in the painted border (PLATE 27). Depending on the subject, a similar restriction in the range of pigments can be seen

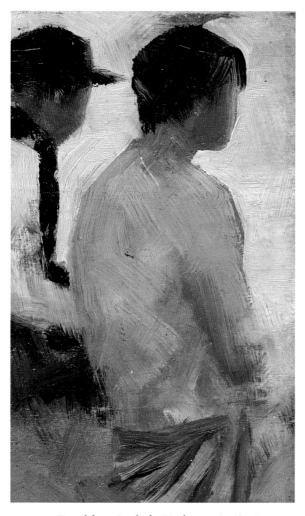

PLATE 29 Detail from *Study for 'Bathers at Asnières'* (PLATE 2) showing Seurat's use of earth pigments.

in the works of the Impressionists from the mid-1870s into the 1880s.[37] The motivation was perhaps the same: to obtain the most effective and vibrant colour contrasts, and, initially at least, it seems likely that Seurat was influenced by the Impressionists in this respect as much as by anything he may have read.

It is significant, perhaps, that neither chrome green (a pigment manufactured by the co-precipitation of Prussian blue with chrome yellow, and often described as *vert anglais*) nor Prussian blue itself feature in any of Seurat's pictures studied; both were widely available, inexpensive, useful colours and commonly employed in later nineteenth-century painting. These two colours, although of very strong intensity, lack the spectral purity of the core colours chosen by Seurat. Prussian blue tends to be rather green in tone and therefore less useful for the construction of essentially simple colour contrasts of the type that he, and the Impressionists, sought. Chrome green, which is already a mixture of

pigments, lacks the force of the pure pigment greens, viridian and emerald green, and is less effective in forming successful colour contrasts. The greenish cast of cerulean blue, another colour widely available, seems also not to have appealed to painters concerned with the application of simultaneous contrast and similar optical effects in their pictures, including Seurat.

It can be seen from the Table that Seurat's purples and violets were most frequently mixed from red lakes and French ultramarine, occasionally with the use of a red earth pigment rather than red lake, and sometimes with cobalt blue replacing, or in addition to, the ultramarine. In one case only in this survey, the *Channel of Gravelines*, an actual mauve pigment – manganese violet – was detected. At first sight it might appear surprising that the artist chose not to use a pure unmixed colour (cobalt violet was also available after 1859) as he did for the greens; however, the pigments in his mixed purple paints, that is, red lake and French ultramarine, have particularly high tinting strengths, and this quality, unusually, is retained in their mixture (PLATE 28). The mixture is also relatively transparent and can be used to create the saturated dark tones frequently found in areas of shadow in Seurat's work, as well as to create the lighter, more opaque mauves by the addition of lead white. Cobalt and manganese violets are less versatile.

Red and yellow earth pigments, whether these were natural earths or Mars (synthetic) colours, occur in his works until about 1884. In this survey these include both small studies on panel (PLATE 29) and *Bathers at Asnières*. Earths are also reported to be present in the first (1884–5) stage of the *Grande Jatte*.[38] All, of course, are essentially landscape compositions for which earth pigments are actually very useful and convenient. The use of these relatively muted pigments is more marked in the small sketches, where the artist was recording a particular scene or motif, but not exploring colour effects in detail. In the *Bathers*, the earth pigments tend to have been used in the lower layers, when the first stage of the design was being developed. At the surface, their colours are produced by mixtures of the more optically pure pigments noted above. In the later works, some time after Paul Signac's injunction to Seurat in 1884 to abandon earth pigments in favour of the 'prismatic colours' favoured by the Impressionists, Seurat does indeed seem to have relinquished them, with the possible exception of yellow ochre.[39]

It is not unusual to find a relatively large number

of yellow pigments present in an otherwise rather limited palette. This is because the colour of a yellow pigment is difficult to modify by mixing other than by the addition of white to lighten it. It is possible, with care, to obtain a warmer shade by the addition of a little red, but mixture with other pigments will change the yellow colour to a green or a brown. The yellow pigments identified here in Seurat's work cover the whole range from pale primrose, through the lemon of strontium yellow, to more golden hues of cadmium and chrome yellows.

It may also be significant that although fairly few pigments are used, Seurat consistently worked with two blues (cobalt blue and French ultramarine), two greens (viridian and emerald green) and at least two reds (vermilion and red lake). In practical terms this generally proves necessary not only for reasons of intrinsic hue – that is, in the case of the blue pigments, the quality of the blue, whether it is purplish or greenish – but also for the way in which the pigments behave when mixed to give another colour (purple, for example) or when required for areas of the deepest shadow. The ultramarine is used in areas of shadow and often mixed with red lake to form deep, translucent purples, whereas cobalt blue is seldom used for mixed purples, but occurs regularly in sky paint. These considerations also apply to the greens: viridian is used to represent deep shadows, for which emerald green, with its rather unnatural grass green colour, would be entirely ineffective. In the case of the reds, vermilion is a markedly more opaque pigment than are red lakes and, in conventional painting, a rather dominant colour. The difference in transparency, which

was widely exploited in earlier centuries for the painting of draperies, seems not to have been relevant to Seurat's technique. It is notable, however, that vermilion is frequently combined with some red lake in such a way that its tendency to dominate in a composition is mitigated (PLATE 30), and thus it contributes towards the more integrated surface that Seurat aimed to achieve with his broken brushwork.

Developments in paint technology

By Seurat's time, the pigments heralded as new in the early decades of the nineteenth century had established themselves as standard materials on the palette, particularly cobalt blue, a range of chrome yellows, emerald green, French ultramarine and viridian.[40] The cadmium yellows and cobalt and manganese violets became more widely used a little later, certainly by the 1880s. A surprisingly large number of traditional artists' pigments continued to be available throughout the nineteenth century, although in some cases their method of manufacture had been improved by innovations in chemical technology; these included Naples yellow (lead antimonate yellows), madder lakes, Prussian blue, vermilion and lead white. In addition, a range of synthetic dyestuffs that could be used as the basis of pigments were introduced during the latter part of the century. Some, such as alizarin, had a naturally occurring equivalent in the madder plant, others, such as mauveine and the coal-tar dyes, eosin colours and related products, had no counterpart in nature.[41] There is no evidence so far to suggest that any of these purely synthetic dyestuff-based colours feature in Seurat's palette, either as pigments in their own right or as additives or as adulterants to other pigments.[42]

The table of pigment occurrences (Table 3) indicates Seurat's consistent and widespread use of chrome yellow, which was available in several varieties. The 1888 Bourgeois aîné catalogue of artists' materials, for example, listed at least four shades of chrome yellow, presumably all lead chromates produced under differing conditions of precipitation, particularly temperature, alkalinity and dilution.[43] Other chromate yellows containing barium, zinc and strontium gave rather different more transparent lemon shades, listed under names such as jaune citron in suppliers' catalogues. In addition to these chromes, Seurat used yellow ochre, cadmium yellow and a pigment which may have consisted of a yellow organic dyestuff on a lead white substrate.[44] Although yellow ochre is found in

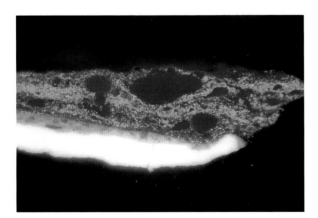

PLATE 30 Cross-section of bright red paint composed of a mixture of red lake with vermilion from the border of *The Channel of Gravelines*. The combination of pigments may be a colour-maker's mixture. Cobalt blue and the white ground lie beneath. Photographed at 280×; actual magnification 225×.

PLATE 31 Detail of yellow flowers near the signature, lower left, in *Bathers at Asnières* (PLATE 4), painted in cadmium yellow.

PLATE 32 Detail of the application of dots of paint around the straw hat on the riverbank in *Bathers at Asnières* (PLATE 4), probably applied by Seurat in 1887. The olive green is a discoloured mixture of emerald green (copper acetoarsenite) and zinc yellow (zinc potassium chromate), while the brownish-orange colour is based on zinc yellow. These paints contain starch as an extender or modifier of paint working properties.

Seurat's paintings throughout his career, he tended to use it less frequently after about 1884. Cadmium yellow and the organic yellow pigment both appear in the *Bathers* (PLATE 31), apparently for the first time, and are used sporadically thereafter for the particular quality of yellow they provided. Cadmium yellows were made in almost as wide a range of hues as the chromes: the Bourgeois catalogue of 1888 lists four (*citron, clair, moyen* and *foncé*).[45] It would therefore have been possible for Seurat to obtain the range of yellow he needed largely from stable cadmium pigments, as indeed Monet had chosen to do after experiencing some problems with the chromes he had been using.[46] The fact that the cadmium yellows were four times the price of the chromes must have discouraged their wider use. Similarly, stable mid-priced yellows composed of lead and antimony (true Naples yellow) had enjoyed a revival in the second half of the nineteenth century, probably as a result of dissatisfaction with certain chrome yellows. Renoir, for example, used Naples yellow in the 1880s, rather than chrome;[47] Seurat, however, seems not to have used this pigment, perhaps because its particular, slightly pinkish tone was not useful to him.

Analysis of all these chromate yellows frequently reveals the presence of barium sulphate, lead sulphate, calcium sulphate and zinc oxide, which modify the colour, transparency and handling properties.[48] These are examples of extenders, although it is difficult to be sure whether they were co-precipitated with the yellow chromate, deliberately ground

PLATE 33 Macro detail from *The Bridge at Courbevoie* (PLATE 8), bottom right corner of the riverbank, revealing undiscoloured yellow paint in a flake loss. Photographed at 3.5×.

together with it by the manufacturer, or both.

In spite of the reputation that chrome yellow and its congeners had for instability to light – a tendency noted by Mérimée as early as 1830 [49] – this seems not to have been a problem in Seurat's pictures. All the areas of chrome yellow paint appear to have remained in good condition, apart from those areas in which a particular zinc-yellow-containing paint was used. Zinc yellow (zinc potassium chromate) is known to be one of the less light-stable forms of yellow chromate pigments, turning from a bright lemon yellow to grey-green due to the formation of green chromic oxide.[50] Seurat had purchased this pigment from the Maison Edouard for the reworking of the *Grande Jatte* on

the recommendation of Camille Pissarro in October 1885:[51] no zinc yellow has been found on the preparatory studies. The same unstable material was identified in discoloured greenish-brown spots applied by Seurat in 1887 in his reworking of the *Bathers* (PLATE 32). This was described by Signac, who also noted the darkening and the fact that the pigment had been bought from Edouard.[52] This is about the same time that Seurat painted *The Bridge at Courbevoie* (that is, the winter of 1886/7) where the pure yellows have taken on a distinctly ochreous tone and caused darkening of the pigment mixtures in the light greens and oranges (PLATE 33). It is perhaps significant that, in each of these pictures, the zinc yellow paint has been shown to contain a starch-based extender (FIG. 3) which may play a part in the mechanism of discoloration, but this is difficult to elucidate because of the complexity of the inorganic phases present. It is also worth pointing out that the manufacture of all chromate yellow pigments required a careful post-treatment following the precipitation reaction giving the pigment. If this was not sufficiently thorough, an unstable product was the result.[53]

Red lakes were an important part of the palette for their intensity of hue and colour saturation. The most common sources of red dyestuff throughout most of the nineteenth century were the madder root and the cochineal insect, and lakes prepared from both of these sources have been identified in the works of many nineteenth-century painters. Towards the end of the century, after the elucidation of the structure of the alizarin molecule and its subsequent synthesis in 1868 by Graebe and Liebermann, the manufacture of synthetic 'madder' lakes became feasible.[54] In addition, other synthetic coal-tar dyestuffs, including reds, such as eosin, were made into lakes, although not necessarily for use as *couleurs fines*. It is known that an eosin-based lake was listed under names such as 'Geranium red', but there is no evidence from this survey that Seurat used this particular fugitive pigment.

During the nineteenth century considerable progress was made in the understanding of the colouring principles present in the madder root. Alizarin was extracted and identified by Robiquet and Colin in 1826; similarly purpurin,[55] although this is not itself present in the root in large quantity – the compound found in the root is pseudopurpurin, a purpurin carboxylic acid derivative. On the basis of this research considerable improvements were made in the preparation of madder lakes, resulting in a large variety of shades available to the

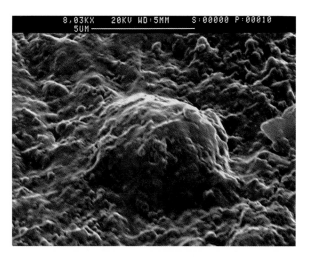

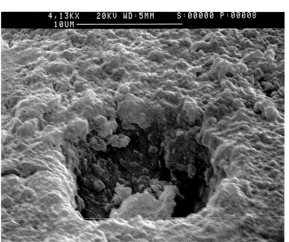

FIGS 3A and B SEM micrographs of discoloured yellow paint containing zinc yellow from *Bathers at Asnières*. A. Starch grain (extender or paint property modifying agent) protruding from surface; magnification 8,030×. B. Pit in paint surface caused by loss of starch grain. These pits fill with dirt and varnish, leading to increased discoloration of the paint layer; magnification 4,130×.

painter as recorded in the colourmen's catalogues. A process first devised by Robiquet and Colin in 1828 was the treatment of the madder root with aqueous sulphuric acid to give a brown material known as 'garancine'. Alizarin and the other anthraquinones are present in the fresh root largely in the form of glucosides (with sugar moiety attached); as a result of this acid hydrolysis treatment, the free anthraquinones are liberated. In addition, the pseudopurpurin is largely converted to purpurin. The end result is a product that is very much richer in dyestuff than the original root, rendering lake making and dyeing considerably more efficient and economical.

Slightly later in the century, other methods of processing the fresh root were devised. Kopp's

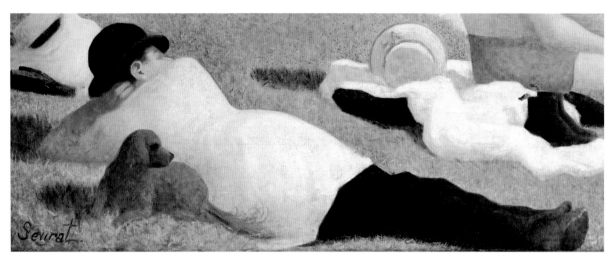

PLATE 34 Detail of reclining figure, left, on the riverbank in *Bathers at Asnières* (PLATE 4) in which the trousers are painted in a mixture of French ultramarine and red lake pigments based on madder and cochineal.

purpurin (1861), for example, was prepared from ground madder root soaked in water, saturated in sulphurous acid (H_2SO_3). After further treatment the resulting product contained pseudo-purpurin, purpurin, and other anthraquinones. Garancine, Kopp's purpurin and the other similar derivatives available at the time could then be used for lake making in a conventional way by precipitating the dyestuff on to a substrate of hydrated alumina, or other materials.[56]

Analysis has shown that some late nineteenth-century madder lakes are rich in sulphur; one explanation for this could be the use of a madder derivative of this kind as the source of the dyestuff, although the presence of a sulphur-rich substrate is perhaps more likely.[57] This has been shown to be so for a number of lakes found in Seurat's paintings, for example *Young Woman powdering Herself* and the *Channel of Gravelines*. Under the microscope, the lakes are generally an orange-red, with a marked pale orange fluorescence under ultraviolet illumination (see PLATE 28). Chromatographic examination of the dyestuff (HPLC) has revealed the presence of a madder dyestuff with a very high content of pseudopurpurin and some purpurin, but very little alizarin; this is a common pattern for late nineteenth-century madder lakes, however, and not all show such a marked fluorescence or sulphur content. They can usually be described as being of the *laque de garance rose* type.[58] Seurat also used a lake containing cochineal dyestuff, for example in the brownish-purple trousers of the figure in the foreground of the *Bathers* (PLATE 34), where it is mixed with a madder lake and French ultramarine. It is not possible to say, however, whether Seurat mixed the two lakes himself, or if the mixture was

sold as a tube colour (it was available under the name *carmin de garance*).

Developments in the technology of pigments in the nineteenth century were paralleled to some extent by improvements to paint binding media, especially following Chevreul's research into the drying behaviour of the oils used, the effects of different methods of processing and the addition of metal salts as siccatives.[59] This paved the way for a greater understanding of the factors involved in the drying of oil paint and thus for efficient manufacture of the oils themselves. It also coincided with the development of collapsible metal tubes, generally of tin, which were a considerable improvement over the earlier storage method of bladders. Bladders, once punctured to release the contents, could only be imperfectly resealed with a tack; inevitably the paint tended to dry. This would have been particularly true of lead white and other fast-drying pigments. The screw cap of the metal tubes permitted effective sealing; furthermore, because the tube could be rolled up as the contents were used, the air was efficiently excluded. The shelf life of tube colours was also much greater. When the manufacturer could not rely on the container preventing premature drying, indeed setting, of the paint, it was not feasible to modify the siccative properties and consistency of the oil medium to any great extent other than, perhaps, to use the better drying linseed oil for poorly drying pigments such as lakes, ultramarine and blacks. These properties could be adjusted by the artist by the addition of oils, proprietary media, siccatives and so on. The use of metal tubes allowed the manufacturer to use modified oil media to improve drying where required, or to modify handling properties. This is

demonstrated by the finding of heat-bodied (that is, heat-thickened) oils in some of Seurat's paints, whether they were bound in linseed or poppyseed oils (Table 2).

Examination of the binding medium in a number of samples from Seurat's paintings reveals certain trends, but no very consistent pattern, other than the fact that the lead white paint he bought usually seems to have been prepared with poppyseed oil. It also appears probable that he used more than one supplier for his tubes of paint: for example, the constitution of the paints used for the retouchings on the *Bathers*, bought from the Maison Edouard, show some similarities with those examined from *The Bridge at Courbevoie* and it is possible these came from the same supplier.[60] The results suggest a greater use of paint containing heat-bodied oil, mainly linseed oil, in the later paintings, and this type of paint may have been chosen because Seurat found that its handling properties suited his pointillist technique. Linseed oil appears to be the predominant binder for the poorly drying red lakes and for vermilion, while the blues were sometimes bound in the less yellowing poppyseed oil. In this the manufacturer of the finished paints was following what had become established practice by this date. The greens and yellows were usually bound in linseed oil.

It is known that a variety of materials were added both to the pigment, before mixture with any medium, and to the tube paint itself for a number of reasons, including the prevention of settling out in the tube of heavy pigments such as vermilion and to alter the consistency or flow properties of the paint. Certain pigments, for example Prussian blue, benefited from the incorporation of colourless extenders, which both lightened an otherwise extremely dark colour and improved working properties. Pigments with a high tinting strength could be extended in this way without any loss of colour saturation, and the product would be cheaper, but not necessarily of poor quality. Materials used as extenders might include barium sulphate, chalk, silica, calcium sulphate, and starch in one form or another. At a later stage in the preparation of the paint, before it was put into tubes, materials might be added to modify its handling properties or to extend its shelf life. The addition of wax might be made primarily to prevent separation of pigment and medium, although it would also alter the consistency of the paint, increasing its paste-like quality; water might be added for the same reason. During examination of French paintings dating from the late nineteenth century in the National Gallery collection, however, wax, apparently used for such a purpose, has been found on only two occasions, in both cases in vermilion paint.[61]

Other ingredients might be added to the paint for rather different reasons. These include the addition of driers and the incorporation of substances (including water) to improve the 'wetting' of the pigment by the oil binder. This was particularly necessary for hydrophilic pigments such as French ultramarine; the surfactants used by the paint manufacturers for this purpose included soaps such as aluminium stearate.[62] There is some analytical evidence to indicate that this practice was followed for certain of the tube paints Seurat used.

The analysis of Seurat's paints in this survey indicates that on the whole the pigments were of high quality; there is little evidence for the presence of excessive amounts of extender and none for the use of pigments which had been adulterated or modified during manufacture by the addition of cheaper materials or brightly coloured but fugitive synthetic dyestuffs.

The pictures

'If you consider a few square inches of uniform tone in Monsieur Seurat's *Grande Jatte*, you will find on each inch of this surface, in a whirling host of tiny spots, all the elements which make up the tone.'[63] This was Fénéon's response to *A Sunday on La Grande Jatte* in his review of the eighth Impressionist exhibition of 1886, written for the new journal *Vogue* – the brushwork by this stage in Seurat's career embodies the logical outcome of the practical application of his researches into optical theory. This evolution can be summarised by comparing the surface paint of the foreground in the *Bathers* with the brushwork in the *Young Woman powdering Herself*, which changes from curving, criss-cross strokes of vibrating colour to small discrete dots and strokes of paint in which form is defined not only by the colour of the dots but also by their density (PLATES 35 and 36). In terms of the brushwork, pictures such as the *Grande Jatte* and *The Bridge at Courbevoie* could be described as transitional in their different ways.

The influence of Delacroix and certain Impressionist works can be seen in the brushwork of Seurat's earliest works and also in the small studies. However, although directional strokes are very obvious in studies such as *A Boat near a Riverbank, Asnières* (1883; Courtauld Institute Gallery; PLATES

5 and 37), it should be remembered that the function of these small paintings was more to experiment with the motif than with the brushwork and the handling of the paint. It is self-evident that horizontal features are conveniently represented by horizontal strokes of the brush, particularly for speed and economy of effort. Seurat's sketches are notably successful in their simplicity, conveying the essential features of a scene or motif efficiently and with concentrated focus – he may paint figures in just two or three strokes, but all that he requires for the further development of his projected composition is there.

The *Bathers* is a monumental composition in both conception and scale. No one form of brush-

PLATE 35 Detail of the brushwork in *Bathers at Asnières* (PLATE 4).

PLATE 36 Detail of the brushwork in *Young Woman powdering Herself* (PLATE 9).

work is used consistently throughout. The foreground has been constructed with an interlaced network of coloured *balayé* (sweeping) brushwork over a more solid underpaint, to create the flickering effect of the play of light over grass. It is a method Seurat often used to render similar features such as cornfields and broad masses of foliage. Elsewhere, smooth horizontal brushstrokes have been used for the water and an even smoother effect has been sought in the painting of the flesh of the bathers themselves. Here, and in the water, the paint has been heavily worked as it was built up in many layers, resulting in a somewhat dry and pasty texture. Soft, irregular blotches of paint were used for the dog, the figures' clothing and hair, the sky and other features, producing a mottled, indefinite effect. A curious detail is the febrile network of light blue brushwork around the dog's hindquarters and tail, which is very reminiscent of Seurat's drawing style at this time. Around 1886 or 1887, over two years after the painting was completed and first exhibited, Seurat revisited his composition and applied small dots of colour, principally to the bathers and their immediate surroundings, based on the type of brushstroke he used in his final reworking of the *Grande Jatte*, in which it first appears. The 'orderly, elongated, parallel dashes' as defined by Henri Dorra and John Rewald, used to construct the forms of the tree trunks, clothing, parasols, and other features in the *Grande Jatte*, are absent from the *Bathers*, although they do occur in a few others of his works of about this date.[64]

The composition of *The Bridge at Courbevoie* has been laid in using directional and criss-cross brushstrokes, worked wet-in-wet over a preliminary underpainting. It was then finished with a series of superimposed dots, applied with a small brush (PLATE 38). *Le Bec du Hoc* was begun, and also worked up, with a similar technique of horizontal and *balayé* strokes; the dots were not applied until some time later, when the painting was being lent for exhibition: the pale-coloured criss-cross strokes are still visible in the sky under the dotted application. In this painting, the dots are far from circular. Short horizontal lines and tiny vertical strokes in the water suggest its shimmer (PLATE 39); dots around the periphery of the composition follow the direction of those in the adjacent painted border. The painting of the promontory itself is rather reminiscent of the manner of painting of the foreground in the *Bathers*, although the scale of the brushstrokes is smaller and diminishes in general size and spacing towards the point of the cliff, suggesting recession.

PLATE 37 Detail showing the brushwork in *A Boat near a Riverbank, Asnières* (PLATE 5).

PLATE 39 Detail from *Le Bec du Hoc* (PLATE 7) showing the variety of brushwork.

PLATE 38 Detail from *The Bridge at Courbevoie* (PLATE 8) showing the variety of brushwork.

PLATE 40 Detail of the brushwork in *Young Woman powdering Herself* (PLATE 9).

Even in Seurat's later works, such as *Young Woman powdering Herself* and the *Channel of Gravelines*, the dots cannot be described as a single type of brushstroke and were certainly not applied in a mechanical and unthinking manner. Seurat used his brushes to form strokes of many different sizes and shapes, oriented in varied directions to delineate form and create movement. In both these paintings, and particularly in *Young Woman powdering Herself*, Seurat seems to change his brushstrokes according to the amount of detail desired, or the prominence of the motif (PLATE 40). The brushwork in the skirt of the young woman is much broader and more directional than the tiny dots used to build up the features of her face. Similarly, the dashes used to paint the beach in the foreground of *Gravelines* are fatter and freer than those used in the

middle ground and distance, creating the effect of aerial perspective (PLATE 41).

In the large earlier version of *Les Poseuses* (1886–8; Merion, Barnes Foundation), the background is depicted using dots of a very small scale, which Paul Signac considered too small to be effective. He described the resulting overall tonality as grey, whereas 'other parts, which are treated more broadly, are of a much more beautiful colour'.[65] A second smaller version of the composition, Private Collection, formerly in the Berggruen Collection, was painted in 1888, in a looser, broader style of brushwork; although less readable at close range, this version appears much fresher in colour and a livelier work from a natural viewing distance. In spite of Ogden Rood's theoretical assertion that paint of complementary colours applied in adjacent

PLATE 41 Detail from *The Channel of Gravelines* (PLATE 11), centre of beach, showing the brushwork of the foreground.

small dots produced the most vibrant effects and the most realistic representation of the effects of light, in practice small brushstrokes, however highly coloured, tend to produce a greyed overall appearance when viewed from a distance so that the constructed forms emerge from the maze of brushwork, and the strokes themselves appear to blend into one another. On the other hand, in their works of the 1870s, painters such as Renoir and Monet achieved a far more striking and effective use of complementary colour in the depiction of everyday landscape scenes by using similarly vivid pigments, but using larger strokes and blocks of colour.

The five finished paintings examined during this survey provide examples of the complete range of Seurat's oeuvre, from the point of view of subject matter: landscapes, compositions involving groups of figures and portraits. The only category that seems to have been of little interest to him was still life. Each of these types of painting imposes its own technical discipline on the painter: thus painting a landscape necessarily dictates a particular range of colours and choice of palette, and the painter will have to take into account changing patterns of light and weather. Painting an indoor scene allows painters to control and determine light and shade, to place the subject, and even to devise a totally imaginary setting, entirely to their own requirements. For Seurat, the particular appeal of indoor scenes was that his interests in the expression of mood and optical effects could be integrated and were under his full imaginative and practical control. At the same time, he maintained his interest in the effects of changing natural light on landscape and water, painting many views at Gravelines and elsewhere on the coast. Even in his later landscapes, however, Seurat creates a level of artificiality, a static quality, which is a product of the divisionist technique. It is noticeable that in none of the paintings examined here – *Bathers*, *Bridge at Courbevoie*, *Le Bec du Hoc*, *Young Woman powdering Herself* and the *Channel of Gravelines* – is there much sense of depth or recession, and this is also largely the result of the particular manner in which Seurat applied the divisionist technique. When the eye can resolve individual dots and brushstrokes, these are inevitably perceived to lie in the same plane, but it seems likely that this phenomenon was of subsidiary importance to Seurat.

Throughout his career, Seurat constructed his compositions around the principles of simultaneous and complementary contrast of colour, although not entirely in the ways suggested by the theories of Chevreul and Rood. For example, incidences of a simple red–green textbook combination are very infrequent and similarly the stark use of yellow against purple is also rarely seen, whereas the orange–blue juxtaposition was a favourite of Seurat's (PLATE 42). The other consistently used combinations involve an orange-red with blue, and various greens, including a light yellow-green, with purple.

Many of these ideas of colour, brushwork and composition had already reached fruition in the *Bathers*, the earliest of the group of works examined. This can be seen in the use of broken and directional brushstrokes discussed above, but also in the complex layering and juxtaposition of colour both in terms of contrast and in terms of lightness and darkness of tone. Contrasts are set up between

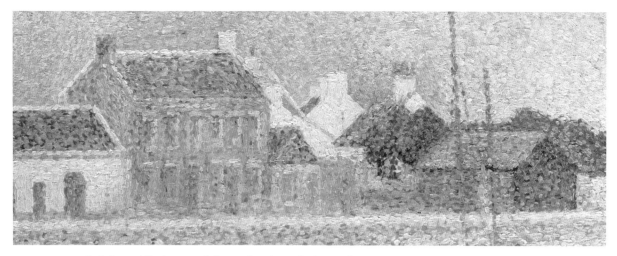

PLATE 42 Detail of the middle distance, left, in *The Channel of Gravelines* (PLATE 11) showing Seurat's use of complementary contrast of orange and blue.

individual brushstrokes, working up to broader areas of neighbouring colour in the painting. The complexity of execution is at its greatest in the colour and structure of the sunlight grass in the foreground compared with those areas of the bank cast in shadow. A similar, more subtle, effect can be seen in the pale blues, oranges, yellows and greens of the water. It is generally the case that when Seurat mixed a desired colour the number of pigments used was as few as possible to retain the purity of tone. In the *Bathers*, for example, cobalt blue, which is found in both sky and water, was used in pure form or mixed only with white, while greyer blue tints, containing French ultramarine, were applied as separate brushstrokes. The most intense green colours of the bank are composed of viridian or simple mixtures of the pigment with white or cadmium or chrome yellow. Cobalt blue combined with viridian provided a dark green. Almost all the applications of paint incorporate a proportion of lead white, giving the painting a light and opaque appearance. This is a general feature of Seurat's works and it is notable that he did not incorporate proprietary resin-containing painting media into any of his paints to increase their gloss or transparency. Within the overall green colour of the grass are touches of intense blue (cobalt blue), a greyer blue (French ultramarine with white), mauves and purples (cobalt blue, French ultramarine and red lake), yellow (cadmium and chrome yellows), pink and red (vermilion, red lake and white), and orange (vermilion and chrome yellow).[66]

In the later *Channel of Gravelines* simultaneous contrast of colour has to some extent become subordinate to simultaneous contrast of tone, that is, the contrast between light and dark shades of the same colour. The painting is constructed largely in shades of yellow in the foreground and gradations of blue and lilac in the sky. At the same time there is the overall complementary contrast of colour between the sky and the beach; the effect achieved is quite subtle because of the blonde colour. In this painting the consistent use of a divisionist technique throughout the whole composition unifies the surface and creates a calm effect.

Conclusion

In assessing Seurat's career it is clear that the guiding principles underlying his paintings were theory and technique and the connection between the two. This resulted in an unusual clarity of purpose in the planning and execution of his paintings, so much so that he seems never to have had any doubts about what he was trying to achieve (FIG. 4). This certainty in turn impressed others so that he attracted a number of followers, among them Paul Signac, and a considerable degree of public interest in his work. The paintings surveyed here reveal unambiguous trends in his technical development as far as the expression of theoretical concepts and the handling of paint are concerned. The *Bathers*, however, does not quite fit comfortably into this pattern of development and appears to be a point at which Seurat changed direction. The *Bathers* was intended as an Academic piece on a monumental scale constructed on the basis of many studies. Unlike their surroundings, the unclothed figures, particularly that of the central bather, are conventionally and smoothly painted. One may speculate that the rejection of this painting by the Salon may have been a factor in Seurat's reconsideration of the direction his painting

FIG. 4 Georges Seurat, *The Artist in his Studio*, c.1884. Conté crayon on paper, 31.5 × 22.5 cm. © Philadelphia Museum of Art (A.E. Gallatin Collection).

should follow. *A Sunday on La Grande Jatte* has a similar subject, and is also a large-scale work based on many studies, but the use of more formulaic systems of brushwork throughout the whole painting suppresses the importance of the figures in such a way that they become part of a patterned surface. Having decided that the real subject of his art was the exploration of optical and aesthetic theories of colour and design, Seurat carried his researches through to their logical conclusion. The 'painterly' quality of painting – the individualistic touches of impasto, the idiosyncratic use of line, wash and handling of paint – was eliminated by the use of standardised brushwork: colour, light and shade became the means of expression. At the same time forms became even more simplified and here we may see the influence of his earliest drawing lesson at the Ecole Municipale de Sculpture et de Dessin. The fact that Seurat was able to crystallise the principles behind his art in the letter to Maurice Beaubourg in 1890 suggests that he felt he had achieved his aims. 'Art is harmony. Harmony is the analogy of contrary and of similar elements of tone, of colour and of line considered according to their dominants and under the influence of light, in gay, calm or sad combinations.'[67]

Acknowledgements

This article was compiled and written by Jo Kirby and Ashok Roy and is based on technical research carried out at the National Gallery and at the Courtauld Institute. *Bathers at Asnières* (NG 3908) was examined and analysed by Ashok Roy, Jo Kirby and Raymond White in 1996 in preparation for the exhibition *Seurat and The Bathers* (National Gallery, London, 2 July–28 September 1997); a number of the sketches were also analysed at this time. Work on the Courtauld Gallery paintings and sketches was undertaken by Kate Stonor for her final-year dissertation (2001) in the Department of Conservation and Technology at the Courtauld Institute under the supervision of Aviva Burnstock, who was also responsible for the analytical studies of paint samples. Additional analysis of the National Gallery paintings has since been carried out by Rachel Grout, Research Fellow in the Scientific Department at the National Gallery, who, with Kate Stonor, compiled the tables of results included in the article. Catherine Higgitt has provided additional medium and other organic analyses, supplementing those obtained originally by Raymond White. The authors would like to thank Christopher Riopelle, curator of nineteenth-century painting at the National Gallery, for reading and commenting on the script.

Aviva Burnstock is Senior Lecturer in the Department of Conservation and Technology, Courtauld Institute. Kate Stonor is presently Intern in Paintings Conservation at the Hamilton Kerr Institute, University of Cambridge.

Notes and references

1 J. Leighton and R. Thomson, with D. Bomford, J. Kirby and A. Roy, *Seurat and The Bathers*, London 1997, esp. pp. 51–83.

2 K. Stonor, 'Seurat and the Evolution of Impressionism: An Examination of The Artist's Materials and Techniques in the Works of the Courtauld Collection', unpublished diploma dissertation, Department of Conservation and Technology, Courtauld Institute of Art, London 2001.

3 I. Fiedler, 'A Technical Evaluation of the *Grande Jatte*', *The Art Institute of Chicago Museum Studies*, 14, 2, 1989, pp. 173–9.

4 Paint samples were examined and analysed by standard methods: microscopy of dispersed samples and cross-sections; EDX analysis; XRD powder diffraction; HPLC; GC–MS; FTIR and staining tests.

5 R.L. Herbert, *Georges Seurat 1859–1891*, exh. cat., Paris, Grand Palais/New York, Metropolitan Museum of Art, 1991, pp. 11–13. For drawings made at this time and during his military service see pp. 14–30.

6 J. Rewald, *A History of Impressionism*, 4th edn, London 1973, pp. 419–24; H. Dorra and J. Rewald, *Seurat: l'oeuvre peint. Biographie et catalogue critique*, Paris 1959, p. xxxv; L. Rosenthal, 'Ernest Laurent', *Art et Décoration*, 3, 1911, pp. 6–76, esp. p. 65.

7 Leighton et al. 1997 (cited in note 1), p. 93; Herbert 1991 (cited in note 5), pp. 109, 111.

8 Herbert 1991 (cited in note 5), pp. 394–6; M.L. Zimmermann, *Seurat and the Art Theory of his Time*, Antwerp 1991, pp. 45–7.

9 Herbert 1991 (cited in note 5), p. 147; J. Rewald, *Post-Impressionism: From van Gogh to Gauguin*, 2nd edn, New York 1962, p. 80.

10 Herbert 1991 (cited in note 5), p. 411.

11 Rewald 1962 (cited in note 9), pp. 100–2.

12 There were four versions of this letter: see Herbert 1991 (cited in note 5), pp. 372–3, 381–3; see also Dorra and Rewald 1959 (cited in note 6), pp. lxxii, xcix (fig. 37). For a general summary of the scientific and psychological theories underlying Seurat's work see W.I. Homer, *Seurat and the Science of Painting*, Cambridge, Mass. 1964 (1978 reprint), pp. 20–48; 112–79. For further discussion of how far Seurat's approach was, in fact, scientific see also J. Gage, 'The Technique of Seurat: A Reappraisal', *Art Bulletin*, LXIX, 1987, pp. 448–54; A. Lee, 'Seurat and Science', *Art History*, 10, 1987, pp. 203–26; P. Smith, 'Seurat: The Natural Scientist?', *Apollo*, CXXXII, no. 346, 1990, pp. 381–5.

13 C. Blanc, 'Eugène Delacroix', *Gazette des Beaux-Arts*, 16, 1864, pp. 5–27, 97–129; C. Blanc, *Grammaire des arts du dessin*, Paris 1867. For the importance of Blanc to the theoretical basis of Seurat's work see P. Smith, *Seurat and the Avant-Garde*, New Haven and London 1997, pp. 23–48; see also Herbert 1991 (cited in note 5), pp. 384–6. Seurat's wish for an 'optical formula' is mentioned in a letter to Félix Fénéon, dated 20 June 1890: see Herbert 1991, pp. 383–4. Two other versions of this letter were found in Seurat's studio at his death.

14 M.-E. Chevreul, *De la loi du contraste simultané des couleurs, et de l'assortiment des objets colorés*, Paris 1839, pp. 1–16, 49–67. See also Herbert 1991 (cited in note 5), pp. 388–90; Zimmermann 1991 (cited in note 8), pp. 42–4; Homer 1964 (cited in note 12), pp. 20–9, 82–4.

15 Chevreul 1839 (cited in note 14), paragraphs 335–40, pp. 197–201. See also Herbert 1991 (cited in note 5), pp. 388–91.

16 D. Sutter, 'Les phénomènes de la vision', *L'Art*, VI, I, 1880, pp. 74–6, 124–5, 147–9, 195–7, 216–20, 268–9; for irradiation and chiaroscuro see paragraphs xlv–xlvii, p. 216. See also Herbert 1991 (cited in note 5), pp. 387–8; Zimmermann 1991 (cited in note 8), pp. 52–3.

17 The optical effect to which the name of irradiation is usually given is defined as the apparent enlargement of the edges of a strongly illuminated object when seen against a dark background. It was so described by Hermann von Helmholtz in an article entitled 'L'optique et la peinture', published in Ernst von Brücke's *Principes scientifiques des beaux-arts*, Paris 1878: see esp. pp. 207–9 (Brücke's own work on colour physiology, published in Leipzig in 1866, became available in French translation in 1881). Helmholtz thought the explanation lay in the fact that the cornea and lens of the eye are a little cloudy, thus causing some refraction, and therefore scattering, of a proportion of the light received. The effect has its maximum intensity near the object, diminishing strongly at a greater distance, giving the appearance of a halo and it can still be seen if the object – Helmholtz used a lighted match as an example – is blocked out by holding a finger between it and the eye of the observer. This effect is quite close to that seen in some of Seurat's drawings.

18 H. von Helmholtz, *Physiological Optics*, English trans. of 3rd German edn (Hamburg 1911, 1st edn 1866), New York 1924; the French translation, *Optique physiologique*, was published in 1867. For nineteenth-century colour theory in general see P.D. Sherman, *Colour Vision in the Nineteenth Century: The Young-Helmholtz-Maxwell Theory*, Bristol 1981; the theories are summarised in C.A. Padgham and J.E. Saunders, *The Perception of Light and Colour*, London 1975, pp. 67–74, and K. McLaren, *The Colour Science of Dyes and Pigments*, Bristol 1983, pp. 63–73. For the importance and applications of colour theory to painting see J. Gage, *Colour and Culture: Practice and Meaning from Antiquity to Abstraction*, London 1993, esp. pp. 171–6; M. Kemp, *The Science of Art: Optical Themes in Western Art from Brunelleschi to Seurat*, New Haven and London 1990, pp. 306–22.

19 O.N. Rood, *Théorie scientifique des couleurs et leurs applications à l'art et à l'industrie*, Paris 1881: French edn of *Modern Chromatics, with Applications to Art and Industry*, New York and London 1879. See also Herbert 1991 (cited in note 5), pp. 390–1; Zimmermann 1991 (cited in note 8), pp. 54–5.

20 For the diagram in the context of colour contrast see Rood 1881 (cited in note 19), p. 213; it is repeated in the section on combination of colours, p. 252. In the English edn, Rood 1879 (cited in note 19), see pp. 250, 293. For Seurat's copy see Homer 1964 (cited in note 12), pp. 40–1; the diagram, which is in the Signac archives, was first published by J. Rewald, 'Seurat – The Meaning of the Dots', *Art News*, 48, April 1949, pp. 24–7, 61–3, reprinted in J. Rewald, *Studies in Post-Impressionism*, New York 1986, pp. 157–67. It is important to note that 'emerald green' (copper acetoarsenite, *vert Véronèse* in French) in the English edition has been translated by *vert émeraude*, the common name for viridian (hydrated chromium oxide), which is a bluer green. This may have been the source of some slight misinterpretation by Seurat (depending on

how much use he made of the circle in practice) and others.

21 For 'triads' of colours see Rood 1881, pp. 246–62, esp. pp. 257–60; Rood 1879, pp. 286–304, esp. pp. 299–301 (both cited in note 19); for small intervals and gradations of colour see Rood 1881, pp. 235–45, Rood 1879, pp. 273–85.

22 Rood 1881, pp. 117–19, 241–2; Rood 1879, pp. 139–41, 279–80 (both cited in note 19).

23 For Rood's discussion of warm or pleasant colours see Rood 1881, pp. 254–7; Rood 1879, pp. 295–9. Emerald green (*vert émeraude* in the French edition) and violet gave particularly hard, cold combinations: p. 249 (1881 edn), p. 289 (1879 edn). For Charles Henry see Herbert 1991 (cited in note 5), pp. 391–3; Zimmermann 1991 (cited in note 8), pp. 227–46, 249–75, 279–300, esp. pp. 295–300. The notion that the direction of the slope of lines within a picture could influence its mood had already been proposed by David Humbert de Superville in the 1830s and was recapitulated by Charles Blanc, where Seurat could first have come across the idea: see Herbert 1991, p. 386.

24 The borders were applied from 1888 onwards: see Herbert 1991 (cited in note 5), pp. 376–7. For the *Bathers* see Leighton et al. 1997 (cited in note 1), pp. 81–2; for the *Grande Jatte* see Fiedler 1989 (cited in note 3), pp. 172, 178–9.

25 A. Roy, 'Barbizon Painters: Tradition and Innovation in Artists' Materials', in A. Burmester, C. Heilmann and M.F. Zimmermann (eds), *Barbizon: Malerei der Natur – Natur der Malerei*, Munich 1999, pp. 330–42.

26 In the present study of the small oil sketches on panel, no evidence was found for Seurat's use of cigar-box lids as supports.

27 Bourgeois *aîné*, *Catalogue générale illustré. Fabrique de couleurs fines et materiel pour l'aquarelle, la gouache, le dessin, le modelage, la peinture à huile et la peinture sur porcelaine*, Paris (January) 1888, p. 88.

28 Bourgeois *aîné* 1888 (cited in note 27), p. 89.

29 Stonor 2001 (cited in note 2), pp. 14–15.

30 Lefranc et Cie, *Fabrique de couleurs et vernis, toiles à peindre* [catalogue], Paris 1883, p. 27; Bourgeois *aîné* 1888 (cited in note 27), p. 87.

31 The Fitzwilliam Museum painting was examined by K. Stonor in a subsequent study.

32 Fiedler 1989 (cited in note 3), pp. 175, 178–9. Prepared canvases of all grades could be supplied in lengths of 10m at a width of 2m; the *demi-fine* and *fine forte* grades were also available in widths of 2m 35cm, 2m 75cm and 3m: Bourgeois *aîné* 1888 (cited in note 27), p. 88.

33 Private communication to K. Stonor from Charlotte Hale, Department of Paintings Conservation, Metropolitan Museum of Art, New York.

34 Signac to Lucien Pissarro, Collioure, 29 August 1887: Rewald 1962 (cited in note 9), p. 105, quoting an unpublished letter then in the collection of the late Mrs Ester Pissarro, London.

35 The radiograph is printed in Leighton et al. 1997 (cited in note 1), p. 68.

36 D. Bomford, J. Kirby, J. Leighton and A. Roy, *Art in the Making: Impressionism*, London 1990, pp. 51–72: 'Impressionism and the Modern Palette'. A palette belonging to Seurat, presumably dating from 1891, was found in his studio at his death and is now in the Musée d'Orsay, Paris. The pigments on it have not been examined, although their arrangement has been discussed at length. For a colour illustration see Smith 1997 (cited in note 13), p. 32; see also W.I. Homer, 'Notes on Seurat's Palette', *The Burlington Magazine*, CI, May 1959, pp. 192–3; Stonor 2001 (cited in note 2), pp. 21–3 and notes 119–23.

37 Bomford et al. 1990 (cited in note 36), pp. 200–1, 'The Artists' Palettes'.

38 Fiedler 1989 (cited in note 3), p. 176.

39 Rewald 1962 (cited in note 9), p. 82; see also P. Signac, *D'Eugène Delacroix au Néoimpressionnisme*, 4th edn, Paris 1939 (first published 1899), pp. 83–5. In so-called version B of the letter Seurat wrote to Félix Fénéon in June 1890, found in his studio at his death so presumably never sent, Seurat claimed to have given up earth colours in 1882–4 and, on Pissarro's advice, viridian in 1885: 'Sur le conseil de Pissarro je lâche le vert émeraude 1885' (Herbert 1991 (cited in note 5), pp. 383–4; *vert émeraude* is mistranslated as emerald green). Both these statements are demonstrably untrue.

40 Examination of samples of viridian in Seurat's paints indicated that at least two forms of the pigment, differing very slightly in their infrared spectra, were present. When samples were examined by wavelength dispersive X-ray analysis traces of boron were identified in some, indicating that the method of manufacture was probably that devised by Guignet in 1859, which involved calcining a mixture of boric acid and potassium bichromate. Depending on the method of manufacture, the composition of the pigment is likely to have varied slightly, which probably explains the differences observed in the infrared spectra. See R. Newman, 'Chromium oxide greens: Chromium Oxide and Hydrated

Chromium Oxide', in *Artists' Pigments: A Handbook of their History and Characteristics*, Vol. 3, ed. E. West FitzHugh, Washington DC and Oxford 1997, pp. 273–93, esp. pp. 279–81.

41 S. Garfield, *Mauve: How One Man Invented a Colour that Changed the World*, London 2000. For pigments prepared from synthetic dyes see, for example, G.H. Hurst, *Painters' Colours, Oils and Varnishes: A Practical Manual*, 2nd edn, London 1896, pp. 272–91; G. Halphen, *Couleurs et vernis*, Paris 1895, pp. 18–29. The Lefranc et Cie catalogue for 1890 (see note 30) lists four *laques d'aniline* among the *couleurs extra-fines en tubes*, including a *laque géranium*. These were among the more expensive paints, although cheaper than the madder lakes or carmine.

42 An eosin-containing colour has been identified in works by Vincent van Gogh: see J.H. Hofenk de Graaff, M.F.S. Karreman, M. de Keijzer and W.G.T. Roelofs, 'Scientific Investigation', in C. Peres, M. Hoyle and L. van Tilborgh (eds), *A Closer Look: Technical and Art-Historical Studies on Works by Van Gogh and Gauguin*, (Cahiers Vincent no. 3), Zwolle 1991, pp. 75–85, esp. pp. 76–8; J.-P. Rioux, 'Caratérisation de pigments décolorés dans les tableaux de Van Gogh peints à Auvers-sur-Oise', in J. Bridgland (ed.), *ICOM Committee for Conservation, 12th Triennial Meeting, Lyon, 29 August–3 September 1999: Preprints*, London 1999, Vol. I, pp. 402–8.

43 J.-F.-D. Riffault Deshêtres, A.-D. Vergnaud and C.-J. Toussaint, *Nouveau manuel complet du fabricant de couleurs et de vernis*, new edn revised by F. Malepeyre and E. Winckler, 2 vols (Encyclopédie Roret – Manuels Roret), Paris 1884, Vol. 2, pp. 16–44.

44 The pigment is an intense bright yellow, with no tendency towards green or orange. Examination of a sample of the pigment by EDX and FTIR has indicated the presence of lead white only, suggesting that it may consist of an organic dyestuff with a lead white substrate or extender. If this is so, it is likely to be synthetic as no flavonoid dyes could be detected by HPLC and the presenc of a carotenoid dye is unlikely. An unknown synthetic yellow dyestuff was present in one of Van Gogh's paints: see Hofenk de Graaff et al. 1991 (cited in note 42).

45 Bourgeois aîné 1888 (cited in note 27), p. 82.

46 I. Fiedler and M.A. Bayard, 'Cadmium Yellows, Oranges, and Reds', in *Artists' Pigments: A Handbook of their History and Characteristics*, Vol. 1, ed. R.L. Feller, Cambridge 1985, pp. 65–108, esp. pp. 102–4.

47 Bomford et al. 1990 (cited in note 36), pp. 188–95.

48 Hurst 1896 (cited in note 41), pp. 123–41 (chrome yellows), 57–94 (extenders); Halphen 1895 (cited in note 41), pp. 15–17.

49 J.-F.-L. Mérimée, *De la peinture à l'huile*, Paris 1830, p. 106.

50 Leighton et al. 1997 (cited in note 1), pp. 82–3; H. Kühn and M. Curran, 'Zinc Yellow', in Feller 1985 (cited in note 46), pp. 201–4, esp. p. 202.

51 Fiedler 1989 (cited in note 3), p. 178.

52 J. Rewald (ed.), 'Extraits du journal inédit de Paul Signac, I, 1894–1895', *Gazette des Beaux-Arts*, 6th period, XXXVI, 1949, pp. 97–128 (English trans., pp. 166–74): entry for 29 December 1894, pp. 114, 170–1.

53 J.S. Remington, and W. Francis, *Pigments: Their Manufacture, Properties and Use*, London 1954, pp. 102–14; the modern zinc-containing chrome yellow is described as more permanent than the lead chromes, pp. 111–14.

54 C. Graebe and C. Liebermann, 'Über künstliches Alizarin', *Dingler's Polytechnisches Journal*, 193, 1869, pp. 321–3.

55 'Sur un nouveau principe immédiat des végétaux (l'alizarin) obtenu de la garance. Note extraite d'un travail de MM. Colin et Robiquet' (article initialled A.B.), *Journal de Pharmacie et de Chemie*, 12, 1826, pp. 407–12.

56 H. Schweppe, *Handbuch der Naturfarbstoffe: Vorkommen; Verwendung; Nachweis*, Landsberg/Lech 1993, pp. 242–3; H. Schweppe and J. Winter, 'Madder and Alizarin', in FitzHugh 1997 (cited in note 40), pp. 109–42, esp. pp. 119–23. On garancine see 'Mémoire de MM. Robiquet et Colin sur la question, "Séparer la matière colorante de garance, et déterminer la quantité qu'un poids donné de garance peut en contenir"', *Bulletin de la Société industrielle de Mulhouse*, 1828, pp. 126–45. For Kopp's purpurin see E. Kopp, 'Recherches sur la garance d'Alsace, *Répertoire de Chimie appliquée*, III, 1861, pp. 85–95.

57 An unexpectedly large amount of sulphur was detected in samples by EDX analysis, together with aluminium from the substrate. It is possible that the substrate contains basic aluminium sulphate, mentioned in nineteenth-century French paint technology literature; see, for example, Halphen 1895 (cited in note 41), pp. 178–9. Its advantage over a substrate containing hydrated alumina alone was that it formed a non-gelatinous precipitate that was easier to filter and wash. The sulphur

cannot be ascribed to, for example, the presence of a barium sulphate extender. Sulphur was present in a sample of Kopp's purpurin prepared in the laboratory, but not much.

58 A sulphur-rich madder lake with a similarly strong fluorescence was identified in Monet's *Irises* (1914–17; NG 6383). As with the Seurat lakes, the principal constituent was pseudopurpurin, 1,2,4-trihydroxyanthraquinone-3-carboxylic acid (seen, after derivatisation, in its methylated form), purpurin and a little alizarin. On the other hand, a madder lake containing a similar pattern of dyestuffs, but showing only a faint fluorescence and no sulphur, was identified in Monet's *The Water-Lily Pond* (1899; NG 4240). In all cases the substrate was otherwise essentially aluminium-containing only. It is possible that slightly different forms of madder root, or root derivative, were used as the starting material; the method of preparation may also have varied. A wide range of madder lakes were available which may well have included the *laques Robert* and *laques de Smyrne*: see Bourgeois aîné 1888 (cited in note 27), p. 83.

59 R. White, J. Pilc and J. Kirby, 'Analyses of Paint Media', *National Gallery Technical Bulletin*, 19, 1998, pp. 74–95, esp. pp. 79–83, 90–4.

60 Maison Edouard's paints were hand ground and had a good reputation. At this time the establishment was run by the brothers Mulard, with the workshop at the rue Clauzel and the retail shop in rue Pigalle: see A. Callen, *The Art of Impressionism: Painting Technique and the Making of Modernity*, New Haven and London 2000, pp. 103–5, esp. p. 104; Bomford et al. 1990 (cited in note 36), pp. 41–2. The ingredients would have been bought from specialist manufacturers, however, and it is not possible to say with certainty if, for example, barium-containing or starch extenders were added to the pigment by the manufacturer, before the colourman bought it, or by the colourman at the grinding stage. Other shops sold Edouard's colours so Seurat need not necessarily have bought them in the rue Pigalle. For the range available from Lechertier, Barbe & Co. in 1885 see J. Bouvier, *A Handbook for Oil Painting*, London 1885, p. 56. Stamps on the back of the *Young Woman powdering Herself* (1889–90) and *Le Bec du Hoc, Grandcamp* (1885, reworked in 1888) give the name of the supplier as Chabod, who seems also to have supplied colours: see Stonor 2001 (cited in note 2), p. 12. His address was listed as 20 rue Jacob, near the Ecole des Beaux-Arts, but not near any of Seurat's known addresses (all in the general area of the place Pigalle). This part of Paris, Montmartre, was the home of many artists and, unsurprisingly, colour merchants, so there was no obvious need for Seurat to travel to the rue Jacob, unless, having used Chabod in his student days, he preferred to remain with a supplier whose products he trusted.

61 In Van Gogh's *A Cornfield with Cypresses* (NG 3861): see J. Leighton, A. Reeve, A. Roy and R. White, 'Vincent Van Gogh's "A Cornfield with Cypresses"', *National Gallery Technical Bulletin*, 11, 1987, pp. 42–59, esp. p. 59; and in Pissarro's 'The Côte de Boeufs at L'Hermitage' (NG 4197): see Bomford et al. 1990 (cited in note 36), pp. 74–5.

62 A description of the addition of soaps and other materials to improve dispersion of certain pigments, including ultramarine, in the oil medium is given in N. Heaton, *Outlines of Paint Technology*, 3rd edn, London 1948, pp. 382–3. The possible additives are perhaps rather more numerous than anything mentioned in late nineteenth-century literature, although unfortunately this particular topic is not one that is much discussed.

63 F. Fénéon, *Les impressionnistes en 1886*, Paris 1886, reprinted in F. Fénéon, *Oeuvres*, Paris 1948, pp. 79–80. The translation quoted is taken from Rewald 1962 (cited in note 9), p. 98; a slightly different version appears in Herbert 1991 (cited in note 5), p. 173. See also J.U. Halperin, *Félix Fénéon: Aesthete and Anarchist in Fin-de-Siècle Paris*, New Haven and London 1988, pp. 77–85, esp. p. 81.

64 Dorra and Rewald 1959 (cited in note 6), p. lxxxv.

65 J. Rewald (ed.), 'Extraits du journal inédit de Paul Signac, II, 1897–1898', *Gazette des Beaux-Arts*, 6th period, XXXIX, 1952, pp. 265–84 (English trans., pp. 298–304): entry for 28 December 1897, pp. 270–1, 300.

66 Leighton et al. 1997 (cited in note 1), pp. 76–81.

67 Herbert 1991 (cited in note 5), pp. 372–3, 381–3.

TABLE 2 Seurat's tube paints and their binding media

Date	Painting(s)	Pigment or mixture	Medium[1]	Other ingredients
1883–4	Studies for the *Bathers at Asnières: A River Bank (The Seine at Asnières)*, NG 6559; *The Rainbow: Study for 'Bathers at Asnières'*, NG 6555; *Study for 'Bathers at Asnières'*, 1883–4, NG 6561	red lake	probably linseed oil	
		viridian	probably poppy oil	
		viridian + traces of lead white, chrome yellow (probably colourman's or manufacturer's mixture)	heat-bodied linseed oil (possibly + some poppy?)	extender including barium sulphate or lithopone
		French ultramarine	probably poppy oil	
		cobalt blue: i) *A River Bank*	linseed oil	
		ii) *The Rainbow*	poppy oil	
		lead white	poppy oil	
1884	*Bathers at Asnières*, NG 3908, first campaign	madder, cochineal lakes	linseed oil	
		vermilion, often + red lake	linseed oil	
		cadmium yellow	linseed oil, possibly heat-bodied	
		viridian	probably linseed oil	
		viridian + traces of lead white, chrome yellow	linseed oil	
		French ultramarine	poppy oil, probably heat-bodied	
		cobalt blue	probably linseed oil, possibly heat-bodied	
		lead white (paint)	poppy oil	
		lead white (ground)	linseed oil	
1884–5	Studies (*Study for 'La Grande Jatte'*, NG 6556; *Study for 'La Grande Jatte'*, NG 6560; *The Morning Walk*, NG 6557)	chrome yellow	linseed oil	
		viridian	linseed oil, heat-bodied in one case	
		viridian + traces of lead white, chrome yellow	linseed oil	extender including barium sulphate or lithopone; some soap formation or a soap added, possibly a palmitate[2]
		French ultramarine	linseed oil, possibly heat-bodied	
		lead white	poppy oil	
		lead white (in cream-coloured reeds, NG 6556)	linseed oil	
1886–7	*Bathers at Asnières*, NG 3908, reworking; *The Bridge at Courbevoie*, Courtauld Collection, P.1948.SC.394	zinc yellow + other chromate yellows	linseed oil	extender including barium sulphate, starch; some soap formation or a soap added, possibly a palmitate
		emerald green	poppy oil, heat-bodied	extender, possibly barium sulphate
		emerald green + lead white + traces of zinc yellow, cadmium yellow, possibly chrome yellow?	linseed oil, heat-bodied	extender including barium sulphate or lithopone, starch
		French ultramarine	linseed oil, heat-bodied	some soap formation or a soap added, possibly a palmitate
		cobalt blue	linseed oil, heat-bodied	some soap formation or a soap added, possibly a palmitate, in the *Bridge at Courbevoie* sample
		lead white	i) heat-bodied linseed oil, ii) linseed + poppy oils, heat-bodied	
1888	*The Seine seen from La Grande Jatte*, NG 6558	emerald green	probably linseed oil	
		lead white (paint)	poppy oil, heat-bodied	
		lead white (ground)	linseed + poppy oils, partially heat-bodied	extender of siliceous material
1889–90	*Young Woman powdering Herself*, Courtauld Collection, P.1932.SC.396; *The Channel of Gravelines, Grand Fort-Philippe*, NG 6554; all samples from borders unless otherwise stated	madder lake + vermilion (either artist's or colourman's mixture)	linseed oil, heat-bodied	
		cadmium orange	linseed oil, heat-bodied	
		French ultramarine	linseed oil, heat-bodied	
		cobalt blue	linseed oil, heat-bodied	
		manganese violet	linseed oil, heat-bodied	
		lead white (border, *Young Woman*)	linseed oil, heat-bodied	
		lead white (white on beach, perhaps intensified during painting of border, *Gravelines*)	linseed oil, heat-bodied	
		lead white (ground, *Young Woman*)	linseed oil, heat-bodied	
	The Channel of Gravelines, main body of painting[3]	'red'	poppy oil, perhaps + some linseed, lightly heat-bodied	
		'blue'	poppy oil	

Notes

1 Many of the samples examined contained mixtures of pigments. In some cases the palmitate/stearate ratios obtained were intermediate between those expected for linseed oil and those for poppy oil, so within the region for walnut oil. It would therefore be possible to interpret these results as suggesting the presence of walnut oil in the paint. However, examination of the pigment content suggested that these were better interpreted as mixtures of linseed and poppy: most contained lead white which was usually bound in poppy oil, while the other pigments, where a pure sample could be examined, usually contained linseed oil. It should also be remembered that Seurat could have added a little extra oil to his paint to adjust its working properties, which was not necessarily the same as that in the tube.

2 An indicator for the presence of soaps, probably of lead, in several samples,

most notably from *The Bridge at Courbevoie*, is an apparent increase in the proportion of palmitate in the paint. Soap formation might be expected over time and might be encouraged by the presence of certain pigments or additives, or even water, but it seems unlikely that this would affect the oil fatty acid proportions so unevenly. The effect observed may be due to the deliberate addition of a palmitate soap at some stage during the manufacture or packing of the paint, possibly to improve wetting of the pigment by the oil medium. French ultramarine, for example, is a hydrophilic pigment and, without some effort or the assistance of a wetting agent, is poorly wetted by the oil. In one or two cases the raised palmitate content meant that the analytical results could not be interpreted.

3 Unfortunately the pigment content of these samples was not examined.

TABLE 3 Pigment occurrences in Seurat's works examined

	Red	Orange	Yellow	Green
FINISHED PAINTINGS				
Bathers at Asnières, 1883–4 (NG 3908)	red lake; (pink) red lake, tr. French ultramarine + lead white; (red-brown) earth pigments + vermilion; vermilion, red lake + little lead white	(bright orange) vermilion + chrome yellow (also + lead white and/or red lake); (discoloured addition, 1886 modification) zinc yellow, tr. vermilion + barium sulphate[2]	cadmium yellow + a little lead white; organic yellow (not characterised)[5]	range of mixed greens based on viridian,[6] cobalt blue, chrome yellow, lead white and French ultramarine; (lime green) viridian, cadmium yellow + (possibly) chrome yellow; (discoloured addition, 1886 modification) emerald green and lead white + tr. cadmium yellow + zinc yellow + barium sulphate (starch)[3]
The Bridge at Courbevoie, 1886–7, Courtauld Collection	red lake; vermilion	vermilion + zinc yellow (starch)[3]	zinc yellow (+ starch)[3] + chrome yellow; barium chromate + tr. yellow earth; calcium chromate + yellow dyestuff	viridian + emerald green; emerald green + zinc yellow
Young Woman powdering Herself, 1889–90, Courtauld Collection	red lake; vermilion; vermilion + red lake[1]	vermilion + chrome yellow	chrome yellow; cadmium yellow	viridian; emerald green; emerald green + chrome yellow
The Channel of Gravelines, Grand Fort-Philippe, 1890 (NG 6554)	vermilion + madder lake	cadmium orange	organic yellow (not characterised);[5] strontium chromate + chrome yellow	(bright, cool green) emerald green + a little cobalt blue + lead white; (yellow-green) emerald green + strontium yellow + chrome yellow
STUDIES				
Fisherman in a Moored Boat, c.1882, Courtauld Gallery	red lake, vermilion; semi-transparent red earth	red earth + yellow ochre + chrome yellow	chrome yellow; yellow ochre; chrome yellow + yellow ochre	viridian; emerald green; viridian + emerald green + chrome yellow
A Boat near a Riverbank, Asnières, c.1883, Courtauld Gallery	red lake; vermilion; red lake + vermilion	red earth; yellow ochre + chrome yellow	chrome yellow; yellow ochre; chrome yellow + yellow ochre	viridian; emerald green; viridian + emerald green + cobalt blue
Man in a Boat, c.1883, Courtauld Gallery	red lake; vermilion; red earth	red + yellow ochre	chrome yellow; yellow ochre	viridian; French ultramarine + chrome yellow + yellow ochre
Man painting a Boat, 1883, Courtauld Collection	red lake; vermilion; red earth; red lake + vermilion	vermilion + chrome yellow	chrome yellow; zinc yellow; yellow ochre	viridian + chrome yellow; emerald green + chrome yellow; French ultramarine + chrome yellow
Horses in the Water: Study for 'Bathers at Asnières', 1883–4, Courtauld Gallery	red lake; vermilion; red earth; red lake + vermilion	red + yellow ochre	chrome yellow; yellow ochre	viridian + emerald green; viridian + emerald green + chrome yellow
A River Bank (The Seine at Asnières), c.1883 (NG 6559)	not examined	not examined	chrome yellow	viridian
The Rainbow: Study for 'Bathers at Asnières', 1883–4 (NG 6555)	not examined	not examined	not examined	viridian
Study for 'Bathers at Asnières', 1883–4 (NG 6561)	not examined	red lake + unidentified yellow	not examined	(yellow-green) viridian + chrome yellow + French ultramarine
The Angler, c.1884, Courtauld Gallery	red lake; vermilion; vermilion + red lake	vermilion + chrome yellow	chrome yellow; yellow ochre	viridian; emerald green; viridian or emerald green + chrome yellow
Study for 'La Grande Jatte', c.1884–5 (NG 6556)	pinkish-red lake + white	not examined	(yellow-brown) chrome yellow + vermilion + tr. cadmium pigment	viridian + chrome yellow in varying proportions
Study for 'La Grande Jatte', c.1884–5 (NG 6560)	red lake	not examined	organic yellow (not characterised) + tr. viridian + tr. vermilion	viridian; unidentified, intense yellow pigment + viridian
The Morning Walk, 1885 (NG 6557)	not examined	(orange-brown) chrome yellow + tr. emerald green[4] and tr. vermilion	organic yellow (not characterised) + some emerald green	emerald green; (lime green) emerald green + chrome yellow
The Seine seen from La Grande Jatte, 1888 (NG 6558)	red lake	(orange-brown) chrome yellow + vermilion	not examined	(lime green) chrome yellow + tr. emerald green; (green-blue): emerald green + white + a little cobalt blue
Study for 'Le Chahut', c.1889, Courtauld Collection	red lake; vermilion; vermilion + red lake	vermilion + chrome yellow	chrome yellow; yellow ochre	viridian; emerald green; emerald green + chrome yellow
At Gravelines, 1890, Courtauld Collection	red lake; vermilion; vermilion + red lake	vermilion + chrome yellow	chrome yellow	viridian + emerald green; emerald green and chrome yellow

Notes:

tr. = trace

1 Mixtures of vermilion and red lake are common in the works examined. It is not certain whether these represent colourmen's mixtures or are a part of Seurat's practice.

2 Lithopone could be present in these samples.

3 Starch, probably added by the manufacturer as an extender or to modify paint handling properties, was detected microscopically, by SEM and FTIR. It is found particularly in zinc yellow containing paint, which has discoloured in a number of cases.

4 Emerald green is copper acetoarsenite; *vert Véronèse* in the contemporary French colour lists (see note 6 below).

Blue	Purple	White	Black	Brown/Earths
cobalt blue; French ultramarine; cobalt blue and/or French ultramarine + small additions of red lake + viridian; cobalt blue, viridian + lead white	(reddish-mauve) pinkish-red lake, French ultramarine, cobalt blue + lead white; (glaze) French ultramarine + red lake	lead white	not examined	(orange-brown) lead white + natural red-brown earths; (mid-brown) yellow-brown earth + red lake
French ultramarine; cobalt blue; French ultramarine + cobalt blue	red lake or vermilion + French ultramarine or cobalt blue	lead white	red lake + French ultramarine	not examined
French ultramarine; cobalt blue	red lake + French ultramarine	lead white (chalk extender)	French ultramarine + viridian	not examined
French ultramarine, cobalt blue	(deep purple) manganese violet[7] + some madder lake + a little lead white	lead white	not examined	not examined
French ultramarine; cobalt blue	red earth + French ultramarine	lead white[8]	carbon black; red earth or red lake, emerald green or viridian + French ultramarine	sienna type earth
French ultramarine; cobalt blue	red lake, French ultramarine + lead white	lead white[8]	not examined	tr. sienna type earth
French ultramarine; cobalt blue	not examined	lead white[8]	carbon black	dark ochre/sienna type earth
French ultramarine	not examined	lead white	bone black	sienna type earth
French ultramarine	possibly cobalt violet	lead white[8]	carbon black (tr.); vermilion, French ultramarine + red lake or red earth	dark ochre/sienna type earth
cobalt blue; cobalt blue + a little French ultramarine	(pinkish-mauve) white, red lake + French ultramarine	lead white[9]	not examined	not examined
French ultramarine; cobalt blue, French ultramarine, white + viridian	(dark purple-brown) French ultramarine + brownish-red lake	lead white	not examined	not examined
French ultramarine	(dark purple) French ultramarine + red lake	not examined	not examined	not examined
French ultramarine; cobalt blue	red lake + French ultramarine	lead white[8]	carbon black (trace); red lake + French ultramarine	not examined
French ultramarine + cobalt blue	not examined	not examined	not examined	red lake, yellow ochre + French ultramarine; (orange-brown) orange-brown earth + viridian
French ultramarine	not examined	lead white	not examined	not examined
French ultramarine (possibly with a little cobalt blue)	(mauve) French ultramarine, red lake + white	lead white	not examined	not examined
cobalt blue	not examined	lead white	not examined	not examined
cobalt blue; cobalt blue, viridian + emerald green	not examined	lead white (chalk extender)	carbon black;[10] cobalt blue + viridian	not examined
cobalt blue + a little French ultramarine	not examined	lead white	not examined	not examined

5 The organic yellow is associated with lead white as a substrate or extender.
6 Viridian is transparent (hydrated) chromium (III) oxide; *vert émeraude* in the contemporary French colour lists.
7 Manganese violet is one or other form of manganese phosphate pigment.
8 Lead white presumed to be the white pigment used; not analysed.
9 Sample contains some silica.

10 Black pigment is present in the surface design.

Giulio Romano and *The Birth of Jupiter*: Studio Practice and Reputation

LARRY KEITH

GIULIO ROMANO's *Birth of Jupiter* (PLATE 1) was probably created in the late 1530s as part of a comprehensive redecoration of part of the Palazzo Ducale in Mantua, and eventually entered the National Gallery collection in 1859.[1] Once held in high esteem, the painting suffered a decline in reputation, and it has not been displayed on the main-floor galleries for many decades. However, the recent decision to restore the picture (it had not been treated for well over a century) has stimulated research into its technique, and into the circumstances surrounding its manufacture. In addition, independent research undertaken by Guido Rebechini at the same time as the restoration has shed new light on the commission, offering a speculative reconstruction of the room for which the panel was painted.[2] The painting provides insights into some of the practical workings of Giulio's studio – its materials, methods, and organisation – while its subsequent history is no less interesting as an example of the shifting taste and attitudes regarding its creator.

Giulio's reputation was established during his apprenticeship in the studio of Raphael, where, according to Vasari, he was responsible for parts of the fresco decoration of the Vatican Stanze, including most famously reliefs painted in imitation of bronze in the dado below the *Fire in the Borgo* in the Stanza dell'Incendio. After Raphael's death in 1520, Giulio was also responsible for much of the decoration of the Sala di Costantino. By 1524 his importance was such that Federico Gonzaga – with the apparent intercession of Baldassare Castiglione – was able to bring him to his court in Mantua, where he received some of the most extensive and important patronage in sixteenth-century Italy, and where he remained until his death in 1546.[3]

PLATE 1 Giulio Romano, *The Birth of Jupiter* (NG 624), mid-1530s. Panel, 106.4 × 175.5 cm.

PLATE 2 Giulio Romano, *The Nurture of Jupiter*, mid-1530s. Panel, 110.8 × 141.4 cm. Hampton Court, The Royal Collection. © 2003 Her Majesty Queen Elizabeth II.

The most important product of this famous relationship was undoubtedly the Palazzo del Te, constructed between 1525 and 1536. Giulio was not only responsible for the design and construction of the building and grounds, but also for the decoration, which included a comprehensive scheme of fresco, stucco, panel paintings, and other furnishings.[4] Given the extent of the enterprise, Giulio must have been particularly adept at delegating tasks to teams of artists and workers, a skill no doubt derived from his artistic formation in the very large workshop of Raphael.

As the work on the Palazzo del Te was drawing to a close, another major project was initiated that was to occupy Giulio's studio throughout the mid-1530s: the creation of a series of new state apartments within the structure of the existing Palazzo Ducale. One of these new rooms was the Sala di Giove, the setting for the National Gallery panel. The *Birth of Jupiter* describes an episode in which the Corybantes – the Cretan guardian divinities of the infant Jupiter – are shown making music in order to drown the child's cries and help conceal him from his father, Saturn, who wished to devour him. It was one of a series of mythological panels dedicated to the rule of Jupiter and his power, with obvious allusions to Giulio's patron, Federico Gonzaga; the focus on youthful scenes from the life of the god is probably intended to refer to the succession of Federico's son Francesco, who would have been about five years old at the start of the project. Elaborate stucco decoration on the same theme still survives within the room, while a plausi-

ble reconstruction of the original disposition of the panel paintings has recently been advanced.[5] Several other surviving panels from the series are now in the Royal Collection, which generously lent what must have been the adjoining scene, *The Nurture of Jupiter* (PLATE 2), for purposes of technical study and comparison during the restoration of the National Gallery panel; the Royal Collection panel retains its discoloured nineteenth-century varnish layers.[6]

It is important to remember that the execution of these paintings, as a relatively minor component of a large decorative scheme, would have been assigned in large part to members of the workshop, working from designs by Giulio. Modern concepts of authorship have tended to place more emphasis on the distribution of labour than would have been the case in the sixteenth century, although few educated contemporary viewers would have mistaken any of the Jupiter panels for works from Giulio's hand. Critical interest in such paintings would instead have concentrated on the areas for which he was wholly responsible – the sophistication of the invention and the effectiveness of the design – and would have been less concerned with the finer distinctions of paint handling. Closer study of the technique of the *Birth of Jupiter* gives a better idea of how the painting's execution was delegated, thus allowing a fuller understanding of Giulio's role in the process.

The *Birth of Jupiter* was painted on a pine panel consisting of three vertical planks; unfortunately, this support was drastically thinned and cradled in

FIG. 1 *The Nurture of Jupiter*, back of the panel.

PLATE 3 *The Nurture of Jupiter*, back of the panel. The cross-grain channels made to receive the battens were made no wider than was necessary to span the panel join, rather than the more usual practice of extending them to the full width of the panel.

FIG. 2 *The Birth of Jupiter*, X-radiograph detail showing ridged, multi-directional brushstrokes from the application of the priming layer.

the nineteenth century, and much information has therefore been lost. However, the wooden support of the Royal Collection *Nurture of Jupiter* remains in a nearly undisturbed state (FIG. 1), and can be assumed to share a common construction method with its once neighbouring scene. It too was painted on vertical pine planks, and the construction was reinforced with two tapered cross-grain pine battens, let into dovetailed channels cut into the reverse of the structure. The inserted battens (PLATE 3), which have been subsequently thinned, were no longer than was necessary to adequately span the planks across the panel join furthest from the side of their insertion, and do not cross the entire width of the panel.

The constructed panels were prepared with a gesso ground, over which was applied a warm biscuit-coloured priming consisting of lead white, carbon black, and brown and orange earth pigments, bound in linseed oil; as expected, samples from both the National Gallery and Royal Collection panels show no significant differences in the composition of this layer, which is in accordance with descriptions in contemporary written sources.[7] This priming was applied in a rapid and rather crude manner; ridged brushstrokes from its application, running in several different directions, remain readily visible in the X-radiographs, and with the naked eye, through the subsequent layers of paint and varnish (FIG. 2).

Thus prepared, the panel was ready for the application of the drawn composition. As in much contemporary central Italian painting, study of the drawing on the panel must begin with consideration of its source – in this case, Giulio's highly finished, wholly autograph drawing now in the Devonshire Collection at Chatsworth House (FIG. 3).[8] A similar compositional drawing, now in the British Museum, also exists for the Royal Collection *Nurture of Jupiter* (FIG. 4). It too is a highly finished work which accords with the painted composition in almost every detail, with little if any deviation between the two versions. The widespread contemporary view of such drawings as being the purest expression of the inventive powers of the artist takes on even greater significance in the context of Giulio's sprawling workshop, in which technical evidence suggests that delegation of the finished work from the master's designs took place more

comprehensively than usual. Giulio was greatly admired as a draughtsman by his contemporaries, for his sure execution as well as for his fluency with a wide range of classical and contemporary motifs; Armenini, for instance, writes:

> Giulio Romano was so gifted and dextrous that whoever knew him affirmed that when he drew something extemporaneously, one could say that he was copying a subject in front of his eyes rather than composing from his own ideas. His style was so near to, and in conformity with, the ancient sculpture of Rome, to which he had studiously devoted much time while he was a youth, that what he placed and formed on paper seemed to be exactly drawn from those works.[9]

An aspect of Giulio's facility in composing is demonstrated in the *Birth of Jupiter* by his quota-

tion of Michelangelo's *Sleeping Cupid*. This sculpture, now lost but then in the Gonzaga collection, was itself probably derived from an antique source.[10] Interestingly, Armenini also describes Giulio's apparently unique method of producing finished ink drawings of the type used for the *Birth* and *Nurture of Jupiter*, which employed a tracing technique. His first rough sketch, executed in lead or charcoal, was covered in charcoal on the reverse. Giulio would then trace the finalised contours onto a fresh sheet, which would then be executed in pen and wash, after which the charcoal marks would be rubbed away, accounting for the remarkable sureness and lack of revision in many of his ink drawings.[11]

The British Museum drawing (FIG. 4) shows traces of squared lines, executed in black chalk on

FIG. 5 *The Birth of Jupiter*, infrared reflectogram mosaic detail, showing the schematic description of contours characteristic of the transfer of the underdrawn design from a cartoon.

top of the pen and ink study, and it is clear that the squaring provided the basis for the execution of a larger-scale cartoon, the design of which was in turn directly transferred onto the primed panel. The Chatsworth study for the National Gallery painting (FIG. 3) shows no apparent remains of squaring, although there can be little doubt that it was also faithfully enlarged in order to produce a cartoon for the painting. Like the Royal Collection *Nurture of Jupiter*, the National Gallery *Birth of Jupiter* carefully reproduces the drawn composition in almost every detail. Infrared reflectography of the panel's underdrawing is entirely consistent with the transfer of an image from a cartoon (FIG. 5); the traced design is essentially a schematic and reductive placement of forms more carefully rendered in the drawing on paper. In the absence of the lost cartoons, a simple enlargement of the original drawings shows an extraordinary alignment of the principal forms, especially given the dramatic increase in scale between the initial drawings and the final paintings (FIGS 6 and 7). Furthermore, Armenini specifically mentions having seen evidence of the squaring method of enlargement used in the production of cartoons from drawings by Raphael and many of his more illustrious assistants, including Perino del Vaga, Daniele da Volterra, and Giulio himself. Giulio's documented use of a tracing method to produce the drawings themselves also implies a preference for use of the same technique to transfer the enlarged cartoon image to the panels.[12]

FIG. 6 (ABOVE) *The Birth of Jupiter*
FIG. 7 (BELOW) *The Nurture of Jupiter*
If the contours of the drawing are re-scaled and laid over an image of the final painting, the resulting alignment of forms strongly suggests the use of an intermediary cartoon.

The only significant change between the transferred cartoon image and the final painting in the National Gallery panel paradoxically suggests the rigidity of the approach with which the drawing was followed. The two groups of background musicians or Corybantes to the left and right of the principal foreground protagonists are placed in more or less the same spatial plane, but the group on the right is significantly larger in scale in both the preparatory drawing and the analogous section of the first underdrawn image (PLATE 4 and FIG. 8). This basic infelicity is less telling in the smaller format and highly limited chromatic range of the drawing, but must have been more glaring in the context of the larger surface and more convincing aerial perspectives afforded by the rich palette of the painting itself. Armenini advocates the making of full-scale cartoons as an intermediary stage prior to painting precisely to avoid this kind of error: 'Practice shows that great defects remain hidden in little drawings, whereas in large drawings every little error becomes obvious.'[13] Nonetheless, in this case, the original discrepancy in scale was faithfully executed on the cartoon – which suggests that Giulio played little if any part in its production. The error was then carried out to near completion in the painting before being altered. This change was revealed during the recent restoration, where the removal of discoloured nineteenth-century retouchings unfortunately exposed an early harsh overcleaning which had greatly damaged the correcting layers.

If further evidence of Giulio's heavy dependence on his workshop were needed – beyond the rather pedestrian quality of much of the paint handling – then the dutiful execution in paint of the poorly scaled musicians suggests the participation of artists lacking either the ability or authority to correct the initial error. It is easy to imagine that the need to re-scale this area would have been quickly grasped by the sorely pressed Giulio during a near-final round of inspection. While the corrected figures are now badly abraded, it is evident that they were painted directly onto the repainted blue of the water and it is not inconceivable that they were sketched in by Giulio as part of a more comprehensive retouching and editing final phase. This sort of process, albeit in fresco, is alluded to by Vasari as he describes some of the decoration of the Palazzo del Te:

> ...they were painted from the great cartoons of Giulio by Benedetto of Pescia and Rinaldo Mantovano, who carried into execution all the stories except the Bacchus, the Silenus, and the two children suckled by goat; although it is true

PLATE 4 *The Birth of Jupiter*, detail, after cleaning, before restoration. An old overcleaning clearly shows the earlier, larger scale of the figure group, which was nearly completed before the revision of scale.

that the work was afterwards retouched almost all over by Giulio, so that it is very much as if it had been all painted by him. This method, which he had learned from Raffaello, his instructor, is very useful to young men, who in this way obtain practice and thereby generally become excellent masters. And although some persuade themselves that they are greater than those who keep them at work, such fellows, if their guide fails them before they are at the end, or if they are deprived of the design and directions for the work, learn that through having lost or abandoned that guidance too early they are wandering like blind men in an infinite sea of errors.[14]

A combination of Vasari's text and other documents from Mantua provides an enormous list of painting assistants: Benedetto Pagni da Pescia, Figurino da Faenza, Rinaldo and Giovan Battista Mantovano, Fermo Ghisoni, Fermo da Caravaggio, Bozino, Anselmo de Ganis, Agostinoda Mozzanegra, Girolamo da Pontremoli, Luca Tedesco, and other carvers, gilders, sculptors and *stuccatori*.[15] Whatever inaccuracies may exist in Vasari's attribution of hands in Giulio's workshops, he was undoubtedly essentially correct in his description of a wide distribution of labour within the workshop, often deducible within individual paintings themselves. Vasari's disparaging remarks about the inappropriate ambition of some of Giulio's assistants also seems to describe an essential truth about his organisational methods, albeit indirectly; as has been mentioned elsewhere, Giulio

FIG. 8 *The Birth of Jupiter*, infrared reflectogram mosaic of the figure group at right, showing the transferred underdrawing from the cartoon of the first, larger version of the group, along with further drawing for the re-scaled second version.

seems to have been a highly controlling employer who was little interested in cultivating initiative from his assistants, who were effectively there as mere 'mechanical executants of his will'.[16] Vasari's stated preference for Giulio's drawings to his painting is perhaps better understood as a comment on the often uneven results of his studio's painted production than on the master's own abilities: 'It can be affirmed that Giulio always expressed his concepts better in drawings than in his finished works or paintings, since in the former we see more vivacity, boldness, and emotion.'[17]

From this perspective, many of the more ungainly features of the National Gallery and Royal Collection panels make more sense. As noted above, the pentimento of the figure group in the *Birth of Jupiter* is most plausibly explained by the assistants having made uncritical use of the cartoon furnished to them. The *Nurture of Jupiter* also shows technical evidence of systematic final retouching, presumably by Giulio or at least under his direction.

While both the National Gallery and Royal Collection panels show extensive use of natural azurite (the specific impurities of which suggest an identical source[18]), the Royal Collection painting also makes use of an artificially made azurite, the so-called blue verditer, in parts of the landscape.[19] The particles of this pigment display the distinctive round shape characteristic of its manufacture, as viewed in cross-section and with the scanning electron microscope (SEM), and it appears to be a very

early occurrence of the material. The likelihood of the pigment having been used as a retouching material from an early restoration is small, as in some samples it appears within paint layers that are unquestionably original (PLATE 5). In the hills of the distant landscape at the left of the picture, however, it is employed as the principal constituent of a final glaze that is laid over two distinctly fluorescing varnish layers which are therefore by implication also original (PLATE 6). While it was not possible to obtain a sample large enough to identify the exact composition of the intermediary varnishes, they appear very similar under ultraviolet examination to the lowermost and therefore oldest varnish layers seen elsewhere on the Royal Collection and National Gallery paintings, consisting of linseed or walnut oil-containing varnishes.[20] It is not inconceivable that the varnishes seen between the paint layers of the Royal Collection painting could have been applied considerably later and seeped between flaking layers of original paint, but the preservation of neat and distinct varnish layers in the surrounding paint structure makes this unlikely (PLATE 7).[21] It is more easily explained as further circumstantial evidence of the systematic revision of the nearly completed paintings described by Vasari and implied by the evidence of the revisions discovered on the *Birth of Jupiter*. Although no evidence of either blue verditer or intermediary varnish layers was found in analogous distant landscape sections of the National Gallery panel, it is worth noting that it is precisely these areas that contained most of

PLATE 5 *The Nurture of Jupiter*, cross-section of sky, showing the use of artificially manufactured blue verditer pigment, with characteristic smooth, spherical particle shape, within the unambiguously original uppermost dark blue paint layer. The lower lighter blue layers contain natural azurite. Original magnification 500×; actual magnification 225×.

PLATE 6 *The Nurture of Jupiter*, cross-section of sky, showing a final glaze of blue verditer over presumably original varnish layers. Original magnification 440×; actual magnification 200×.

PLATE 7 *The Nurture of Jupiter*, cross-section illustrated in PLATE 6 under ultraviolet light, showing the preservation of evidence of two distinct varnish layers within the paint structure. Original magnification 440×; actual magnification 200×.

the worst damage from early restorations (PLATE 8). Were similar intermediary varnish layers to have existed in those parts of the National Gallery landscape they would certainly have rendered them far more vulnerable to the harsh cleaning methods of early restorers, the unfortunate results of which became plainly visible during the recent restoration.

The most cursory stylistic examination also reveals something of the division of labour within the two pictures. The figure painting in both is quite similar, and can reasonably be suggested to have been painted by the same hand.[22] Considerable differences exist within the landscape painting, however. It is not possible to make any useful comparison between the beautifully rendered aerial perspective of the distant landscape of the Royal Collection panel and that of its National Gallery counterpart, because of the damaged condition of the latter. More identifiable differences do exist, however, in the rendering of foliage. While hardly naturalistic in intent, the carpet of grasses, flowers and reeds among which the protagonists of the *Birth of Jupiter* are placed is painted with a highly evolved decorative sense of rhythm, pattern and spacing, while the leaves of the overhanging grapevine are wonderfully fluent, rapid passages of painting (PLATE 9). Similar sections of the Royal Collection foliage, although certainly effective, are rather more mechanical and repetitive by comparison (PLATE 10). Without advancing a strict Vasarian delineation of specific hands, visual analysis is nevertheless consistent with technical and literary evidence in suggesting a comprehensive delegation of work to members of the workshop, with results that were often uneven in quality.

As has been suggested earlier, within the rich decorative scheme of the room as a whole these distinctions would have been of secondary importance to contemporary viewers. Writing less than ten years after Giulio's death, Vasari gives several specific examples of Giulio's delegation of labour that are certainly not pejorative in intention. Giulio was justly celebrated for the inventiveness of his creations and the totality of his enterprise, and when the paintings were first dispersed and sold from the palace their reputation must have been as firmly based on their associations within that context as much as on their intrinsic qualities.

Whether by his association with Raphael, or the result of the promulgation of Vasari's *Vite*, or the spread of engravings after his works by Marcantonio Raimondi (particularly a highly prized set of erotic prints with accompanying text by Pietro Aretino), Giulio's fame was certainly well established in Britain by the seventeenth century; he is the only Renaissance artist Shakespeare cites by name:

> That rare Italian Master, Iulio romano, who (had he himselfe Eternitie, and could put Breath into his Worke) would beguile Nature of her Custome, so perfectly he is her ape.[23]

Giulio's paintings feature prominently among the extraordinary collection of works obtained by Charles I at the time of the dispersal of the Gonzaga Collection in the early seventeenth century. Some measure of the esteem in which the monarch held Giulio can be seen from the fact that the *Birth of Jupiter* was among six paintings which Charles had hung in the second room of his privy chambers, alongside eight pictures attributed to Titian and

PLATE 8 *The Birth of Jupiter*, after cleaning, before restoration. While the network of vertical losses is primarily the result of nineteenth-century panel treatment, the picture shows the worst cleaning damage in the sky and distant landscape; the intermediary varnish layers on the *Nurture of Jupiter* were found on an analogous area.

PLATE 9 *The Birth of Jupiter*, detail of foliage.

PLATE 10 *The Nurture of Jupiter*, detail of foliage.

four works by another of Raphael's celebrated pupils, Polidoro da Caravaggio.[24]

Most of Charles I's acquisitions were sold by the Commonwealth government after his death. Although many were reacquired during the Restoration, including most of the panels by Giulio, a considerable number of works were never recovered. The next firm documentary evidence relating to the *Birth of Jupiter* is a 1727 inventory of the Orléans Collection (where it is catalogued as having been previously owned by the Abbé de Camps). There are further references to the painting as an 'ex-Orléans' picture in two sale catalogues at the

Lyceum in London in 1798 and 1800, and it seems to have returned to France around this time. The picture then passed through at least two French collections, those of Lapeyrière and Erard, before it was acquired by the English collector Lord Northwick, in 1833.[25] Northwick included the picture among a group put up for sale in 1838, but the reserve price was placed so high as to suggest that he was more interested in testing the market than in making a sale, and the painting remained in his collection until his death in 1859.[26]

The eminent art historian Gustav Friedrich Waagen saw the painting while it was in

Northwick's possession, and included it in his 1838 comprehensive survey of prominent English collections, the *Works of Art and Artists in Great Britain*, where it was described in this manner:

> A rich, noble landscape, with a view of the sea, forms the background. In this spirited composition, the bold, poetical enthusiastic character of Giulio is entirely manifested. The execution, too, is careful; the colouring very powerful, and unusually clear. This picture, about 3ft. in high, and 5ft. 9in. wide, came from the Orleans gallery, and was afterwards in the well known collection of Mr Erard, at Paris.[27]

An 1858 catalogue of 'some of the principal paintings' in Northwick's collection, the *Hours in Lord Northwick's Picture Galleries*, also enthusiastically describes the *Birth of Jupiter* :

> The sheet of glass which protects this picture testifies the estimation in which it is held. It was originally painted on panel, but its present noble possessor has had it transferred to canvass (sic). Previous to its removal to Thirlstaine House, we believe Lord Francis Egerton endeavoured, by an offer of fifteen hundred guineas, to become its purchaser, but in vain. It is elaborately painted, and has such a truly exquisite tone, as to challenge, in this respect, a comparison with the choicest works of Corregio. The scene is supposed to be an enchanted island, wherein the infant god is represented cradled in the midst of luxuriant vegetation, his mother, Rhea, being in the act of lifting up the veil which covers him. Two river nymphs are in attendance, and, at some distance, on either side, are the *Corybantes*, priests of Cybele, who, with various musical instruments, are presumed to be fulfilling their important mission, of endeavouring to drown the cries of the new-born babe. In the distance is Mount Ida, and beyond, to the line of the horizon, appears a long line of coast interspersed with promontories and bays. The drawing of the principal figures is considered highly graceful, and the colouring of the whole exceedingly rich.[28]

Waagen's second edition of *Treasures of Art in Great Britain*, published in 1854, contained another description of the panel, but one that was clearly more disinterested and rather less laudatory: 'The Corybantes raising a noise with their weapons, in order that Saturn should not hear the cries of the infant Jupiter. Spirited, but very much injured.'[29]

In his Director's report to the National Gallery Trustees of 19 July 1859, Sir Charles Eastlake recommends the purchase of the painting among several he wished to obtain from the Northwick sale, describing it quite accurately as 'somewhat injured but capable of being put in order. A fine specimen, formerly in the Orleans Gallery'.[30] After securing the Trustees' approval, Eastlake was able to report on 5 August of the same year that it had been purchased for the not inconsiderable sum of £920. In a more private letter of 8 August to Ralph Nicolson Wornum, then Keeper of the National Gallery, Eastlake mentions having been recommended the purchase of the *Birth of Jupiter*, presumably some time beforehand, by Mr William Buchanan, an important dealer of old master paintings through whom the Gallery made many notable acquisitions. He also mentions having received an account of the picture's recent restoration, when it had been in the Lapeyrière collection, by a restorer referred to only as 'old Reinagle', who was under the interesting misapprehension that the picture was by Dosso Dossi. Eastlake relates that in thanking Reinagle he stated that although the colouring was worthy of Dosso Dossi, 'the classic taste and style of design belong to Giulio alone';[31] he also directs that Reinagle was not to see his old restorations until the picture was toned. Rather than a comment on Reinagle's abilities as a restorer – at least one outright copy of a Van Dyck by Reinagle was owned by Northwick[32] – Eastlake's wish to have the picture toned may have been the result of more recent problems with the structure of the work. It seems that the familiarity allowed by a few months' ownership offered a much fuller appreciation of its condition; by the time of the meeting of the Board of Trustees on 30 November 1859 the new purchase was bluntly described as 'considerably injured', and 'the picture was by Sir Charles Eastlake's order entrusted, with the sanction of the Trustees, to Mr C. Buttery, to be repaired'.[33]

It is interesting to speculate whether, in a pre-photographic era when many pictures were shown with heavily toned varnishes, a combination of the favourable 1838 description by Waagen (he was respected enough in England to be asked to give evidence before the Royal Commission on the condition and future of the National Gallery in 1853) and the advocacy of Buchanan may have carried more weight with Eastlake than would have been the case had today's routine investigative technology of X-radiographs, ultraviolet and infrared examination been available. It is also likely that the picture's undeniably prestigious provenance – the Gonzaga, Royal, and Orléans collections – also

weighed in its favour. It is also very possible that the picture suffered a considerable decline in its physical condition in the period between Waagen's two publications.

The curious but inaccurate reference to the picture's transfer to canvas which occurs in the 1858 viewer's guide to Northwick's collection is probably best explained as a misunderstanding of a different, and only slightly less injurious, treatment which seems to have occurred at about this time. Northwick's 1839 catalogue contains several glowing references to the structural treatments carried out on many of his paintings – including a transfer from panel to canvas of a Giorgione – by 'that ingenious artist Mr. Francis Leedham'.[34] The Leedham stamp appears on the reverse of the cradle that was applied to the *Birth of Jupiter*, and it is not unreasonable to suggest that Leedham carried out this treatment during Northwick's ownership. During this operation the panel was also drastically thinned and therefore became more responsive to changes in relative humidity, resulting in dimensional changes in the wood that the cradle could not accommodate. The stresses caused by this misguided but then-fashionable structural treatment are almost certainly responsible for the majority of the extensive vertically oriented paint losses (PLATE 8), flaking which may well have begun almost immediately after treatment in the unregulated environment of a nineteenth-century country house.

The picture was not treated again after Buttery's work until 2000, when a comprehensive cleaning and restoration was undertaken. When this work was begun the picture had been in the lower floor galleries for many decades, and the continuing degradation of its numerous varnish layers, some of which had been deliberately toned, had rendered the picture extremely diffucult to read (PLATE 11).

If the decline in the picture's reputation began with the proper appreciation of its condition, which must have become apparent during Buttery's 1859 restoration, more abstract changes in taste may have also played a role in the picture's relative neglect as the twentieth century progressed. Removed from the decorative scheme of the ducal apartments, the painting's obscure textual source, arcane classically referenced imagery and wilfully unnatural setting must have seemed increasingly alien in the context of growing post-Romantic interest in the more personally expressive and painterly qualities of an artist's output. Furthermore, the undeniable reduction in quality of execution resulting from Giulio's delegation to his workshop results in a somewhat

PLATE 11 *The Birth of Jupiter*, detail, showing initial cleaning test.

awkward and flawed image – particularly when seen as an independent, stand-alone painting on a modern gallery wall and viewed by a comparatively less literary and more visual culture.

Yet in spite of these weaknesses we may still enjoy the qualities that Eastlake cited – 'the classic taste and style [that] belong to Giulio alone' – aspects which would have been at least as highly regarded by Giulio's contemporaries. Neither a sublime painterly achievement nor an inconsequential ruin, the *Birth of Jupiter* is rather a noteworthy and charming episode in a key moment in the history of Renaissance palace interiors – when proper consideration is given to its original context – and as such has an important funtion within the Gallery collection. While Giulio was certainly capable of producing autograph paintings of as high a quality as any painted in the Cinquecento, the greatest source of his fame remains the comprehensive architectural and decorative programme produced for the Gonzaga court at the Palazzo del Te and the Palazzo Ducale. It is therefore appropriate, and indeed fortunate, that Giulio Romano should be represented within the National Gallery by a picture which formed a part of that most remarkable achievement.

Acknowledgements

I would like to thank Nicholas Penny, Senior Curator of Sculpture and Decorative Arts at the National Gallery of Art, Washington, for both initiating the recent restoration and encouraging further research, and Carol Plazzotta, Myojin Curator of Sixteenth-Century Italian Painting at the National Gallery, for her invaluable insight and guidance in the preparation of the text.

Notes and references

1 See Cecil Gould, *National Gallery Italian Catalogues; the Sixteenth Century Italian Schools*, London 1987, pp. 118-20.

2 Guido Rebechini, *Burlington Magazine*, in press.

3 Giorgio Vasari, *Lives*, ed. D. Ekserdjian (trans. De Vere), Vol. 2, New York 1996, pp. 119–23 and 124–5; Giorgio Vasari, *Vite (nelle redazioni del 1550 e 1568)*, ed. R. Bettarini, Florence 1991, Vol. 5, pp. 59–61 and 64–5; Giovanni Battista Armenini, *De' veri precetti della pittura*, Ravenna 1586, p. 217, (trans. Edward Olszewski, *On the True Precepts of the Art of Painting*, New York 1977, pp. 284–5). For a modern critical study of Giulio's Roman activity with Raphael, see Sylvia Ferino Pagden, 'Giulio Romano pittore e disegnatore a Roma', in *Giulio Romano* exh. cat. Palazzo del Te and Palazzo Ducale, Mantua, 1989, pp. 65–95.

4 Vasari ed. Ekserdjian, cited in note 3, Vol. 2, pp. 127–29, and F Hartt, *Giulio Romano*, 2 vols, New Haven 1958, Vol. 1, pp. 91–161. See also Amedeo Belluzzi and Kurt Forster, 'Giulio Romano architetto alla corte dei Gonzaga', in *Giulio Romano*, exh. cat., cited in note 3, pp. 177–227, and Gianna Suitner and Chiara Tellini Perina (English trans. Christopher Evans), *Palazzo Te in Mantua*, Milan 1994.

5 Rebechini, cited in note 2.

6 See John Shearman, *The Pictures in the Royal Collection of Her Majesty the Queen: The Early Italian Pictures*, Cambridge 1983, pp. 126–31.

7 For contemporary written sources see Raffaello Borghini, *Il riposo*, Florence 1584, p. 174; the preface to the 1568 edition of Giorgio Vasari's *Lives* (ed. G. Milanesi), Florence 1878, vol. I, p. 186; *Vasari on Technique* (preface to the original 1568 edition; translated and edited by Louisa Maclehose), reprinted 1960, pp. 230–1; Armenini, cited in note 3, p. 125 (trans. Olszewski, New York 1977, p. 192.

8 Michael Jaffe, *The Devonshire Collection of Italian Drawings*, 1992, p. 105, Philip Pouncey and J.A. Gere, *Italian Drawings: Raphael and his Circle*, Department of Prints and Drawings, British Museum, London 1962, p. 65, Hartt, cited in note 4, Vol. 1, pp. 212, 305, and Vol. 2, fig. 456.

9 Fu parimente Giulio Romano cosí copioso e facile, che chi lo conobbe affermava che quando egli dissegnava da sé qualcosa si fosse, che si potea piu presto dire che egli imitasse e che avesse inanzi a gli occhi ciò che faceva, che ch'egli componesse di suo capo, perciò che era la sua maniera tanto conforme e prossimana alla scolture antiche di Roma che, per esservi stato studiosissimo sempre mentre era giovane, che ciò che deponeva e formava pareva esser proprio cavato da quelle. Armenini, cited in note 3, p. 76 (trans. Olszewski, p. 147–8).

10 See Gould, cited in note 1, p. 119.

11 Armenini, cited in note 3, p. 76 (trans. Olszewski, p. 148). See also Hartt, cited in note 4, Vol 1, pp. XVII and 85–6.

12 …e questi sono i modi ch'io ho veduti e considerati piú volte sopra a i dissegni e ne i cartoni di Raffaelle, di Perugino, di Giulio, di Danielle e di Tadeo Zuccaro… Armenini, cited in note 3, p. 102 (trans. Olszewski, pp. 172–3). For a comprehensive study of Giulio's working methods with drawings and cartoons for frescoes in Mantua, see Konrad Oberhuber, 'Giulio Romano pittore e disegnatore a Mantova', in *Giulio Romano*, exh. cat., cited in note 3, pp. 135–75.

13 Armenini, cited in note 3, p. 102: ci é manifesto per le prove che ne i dissegni piccoli vi stanno ascosi i gran diffetti e ne i grandi ogni minimo errore che vi sia (trans. Olszewski, p.173).

14 Vasari, ed. Ekserdjian, cited in note 3, Vol. 2, pp. 128–9; Vasari, ed. Bettarini, cited in note 3, pp.67–8: elle furono dipinte con i cartoni grandi di Giulio da Benedetto da Pescia e da Rinaldo Mantovano, i quali misero in opera tutte queste storie, eccetto che il Baccho, il Sileno et i due putti che poppano la capra: ben è vero che l'opera fu poi quasi tutta ritocca da Giulio, onde è come fusse tutta fatta da lui. Il qual modo, che egli imparò da Raffaello suo precettore, è molto utile per i giovani che in esso si esercitano, perché riescono per lo più eccellenti maestri: e se bene alcuni si persuadono essere da più di chi gli fa operare, conoscono questi cotali, mancata la guida loro prima che siano al fine, o mancando loro il disegno e l'ordine d'operare, che per aver perduta anzi tempo o lasciata la guida si trovano come ciechi in un mare d'infiniti errori.

15 Vasari gives a lengthy list of the assistants he thought were among Giulio's best: see Vasari, ed. Ekserdjian, p. 140; Vasari, ed. Bettarini, p.82; Hartt, Vol.1, pp. 79–80, all cited in note 3. Numerous specific citations of collaborators and assistants can also be found in *Archivo di Stato di Mantova, Giulio Romano, Repertorio di fonti documentarie* (ed. Daniela Ferrari), Mantua 1992.

16 Hartt, cited in note 4, p. 80.

17 Vasari, ed. Ekserdjian, cited in note 3, Vol. 2, p. 121; Vasari, ed. Bettarini, cited in note 3, Vol. 5, p. 80: …benché si può affermare che Giulio esprimesse sempre meglio I suoi concetti nei disegni che nell'opere o nelle pitture, vedendosi in quelli più vivacità, fierezza et affetto.

18 Rachel Grout, National Gallery Scientific Department, report dated August 2001.

19 Ashok Roy (ed.), *Artist's Pigments: A Handbook of their History and Characteristics*, Vol. 2, Washington 1993, pp. 23–33.

20 Catherine Higgitt and Raymond White, National Gallery Scientific Department, report dated 6 February 2002.

21 Rachel Grout, cited in note 18.

22 John Shearman's opinion of the Royal Collection picture is that 'the figure painter is among the weakest in Giulio's workshop, but the landscape may be by a different and more independent artist'; unfortunately he makes no specific comparison with the National Gallery painting. See Shearman 1983, cited in note 6, p. 127.

23 William Shakespeare, *A Winter's Tale*, act V, scene 2, cited in Lucy Whitaker, 'L'accoglienza della collezione Gonzaga in Inghilterra', in *Gonzaga. La celeste Galeria: L'esercizio del collezionismo* exh. cat. Palazzo del Te, Mantua 2002, p. 236. See also Gould, cited in note 1, p. 118.

24 Lucy Whitaker, cited in note 23, p. 244.

25 Gould, cited in note 1, p. 119. See also David Robertson, *Sir Charles Eastlake and the Victorian Art World*, Princeton 1978, pp. 188–90.

26 Oliver Bradbury and Nicholas Penny, 'The picture collecting of Lord Northwick: Part 1', *Burlington Magazine*, CXLIV, September 2002, p. 495.

27 Gustav Friedrich Waagen, *Works of Art and Artists in Great Britain*, 3 vols, London 1838, Vol. 2, p. 396.

28 *Hours in the Picture Gallery of Thirlestaine House*, Cheltenham 1858, pp. 45–6.

29 Gustav Friedrich Waagen, *Treasures of Art in Great Britain*, 3 vols, London 1854 (2nd edn.), Vol. 3, p. 198.

30 Charles Eastlake, Director's Report to the Trustees of the National Gallery, 19 July 1859. See also O. Bradbury and N. Penny, 'The picture collecting of Lord Northwick: Part 2', *Burlington Magazine*, CXLIV, November 2002, p. 616.

31 '…Reinagle will probably be curious to see how his old restorations look and it will be important not to show the picture to him until it is toned… You can easily make some excuse for not showing the picture, nor should it be said that the delay is in consequence of needful restoration.' Charles Eastlake, letter to Ralph Nicolson Wornum dated 8 August 1859, in National Gallery archives.

32 *Catalogue of the late Lord Northwick's extensive and magnificent Collection of Ancient and Modern Pictures, etc*, London 1859, lot 935: 'Reinagle, *St John after Van Dyck*.' The artist in question is almost certainly Ramsay Richard Reinagle (1775–1862), a Royal Academician who was often employed as a copyist and restorer. In 1848 he was forced to resign his Royal Academy diploma in consequence of exhibiting another artist's work as his own, although he continued to exhibit there until 1857. Lot 268 from the same sale is described as 'Reinagle, *Rocky Landscape*', while lot 154, *The Sermon, from 'Tristram Shandy'* , is given to P. Reinagle, Ramsey's father. See also *The Dictionary of Art*, ed. J. Turner, London 1996, Vol. 26, pp. 124–5.

33 Minutes of the meeting of the National Gallery Board of Trustees, 30 November 1859, in the National Gallery archives.

34 Bradbury and Penny, cited in note 26, p. 495.

The 'Two Tax-Gatherers' by Marinus van Reymerswale: Original and Replica

PAUL ACKROYD, RACHEL BILLINGE, LORNE CAMPBELL AND JO KIRBY

THE PAINTING of 'Two Tax-Gatherers' (NG 944) in the National Gallery is usually attributed to Marinus van Reymerswale (PLATE 1). Another version of the composition, of almost exactly the same dimensions, is in the Louvre (PLATE 2). Comparison of the infrared reflectogram mosaic of the London picture (FIGS 3 and 4) with infrared photographs of the version in Paris (FIGS 1, 2, 5 and 6) had led us to believe that the Paris picture must have been executed before the London panel. By a happy coincidence, when the National Gallery painting was being cleaned, the Paris picture, previously inaccessible in a government office, was put on exhibition in the Louvre. Having decided to investigate further the relationship between the two paintings, we received much help from our

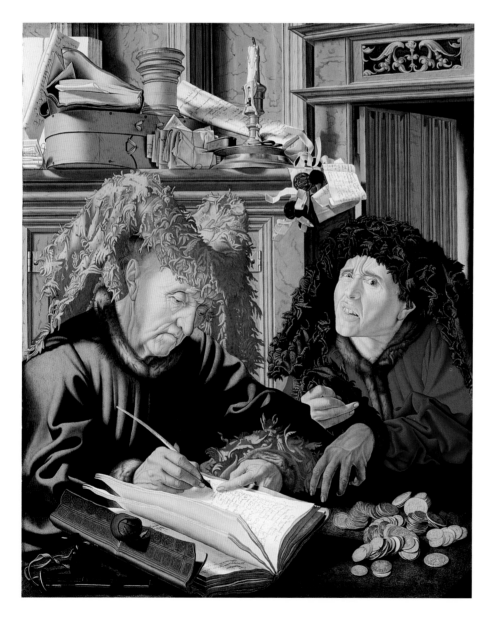

PLATE 1 Workshop of Marinus van Reymerswale, 'Two Tax-Gatherers' (NG 944), 1540s? Oak, 92.0 × 74.6 cm.

colleagues in Paris and from Dr Adri Mackor, a Dutch art historian who, by a second happy coincidence, is making the first detailed study of Marinus and his work. It rapidly became clear that the London picture is a replica of the Louvre painting; we have endeavoured to establish how and by whom the replica was made and to find out more about the working practices of Marinus and his collaborators. The detailed examination of the London picture has revealed an interesting use of pigments – for example madder and kermes lakes.

Marinus van Reymerswale

Nothing is known for certain about Marinus' life. He signed several almost identical paintings of *Saint Jerome in his Study*, several nearly identical pictures of *The Banker and his Wife* and two very similar paintings of *The Lawyer's Office*. Usually he signed simply 'Marinus' but the *Saint Jerome* in the Real Academia de Bellas Artes de San Fernando in Madrid is inscribed 'Opus Marini de Reymerswaele a° 1533',[1] while on the versions of *The Banker and his Wife* in Copenhagen, the Escorial and Munich the word 'Reymerswale' precedes 'Marinus'.[2] The dates on the signed pictures range between 1533 and 1545.[3] Some unsigned pictures are so like the signed paintings that they have been attributed with confidence to Marinus: among them are the *Virgin and Child* in the Prado, of which no other version is known;[4] the *'Two Tax-Gatherers'* in the National Gallery, the subject of this article,[5] and the nearly identical picture in the Louvre.[6]

Many of these paintings include representations of manuscripts and deeds. The writing is frequently, perhaps always, legible and in the texts many refer-

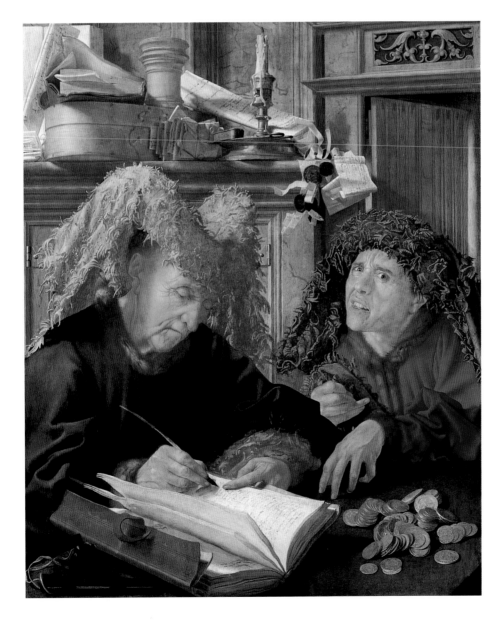

PLATE 2 Marinus van Reymerswale, *'Two Tax-Gatherers'*, 1540s? Oak, 94.1 × 77.0 cm. Paris, Musée du Louvre, on loan from the Ministère de Finances. © RMN Paris.

51

ences have been found to the town and inhabitants of Reymerswale, which has disappeared beneath the waters of the Ooster Schelde. It was once part of the island of Zuid-Beveland, west of Bergen-op-Zoom and south of the island of Tholen. After the Saint Felix Flood of 1530, Reymerswale became a separate island, which was abandoned in 1631 and later totally submerged.

In about 1500, Reymerswale was reckoned to be, after Middelburg and Zierikzee, the third most important town in Zeeland. At that time salt-refining was an important industry in Zeeland, centred around Reymerswale, Zierikzee, Goes and other towns – the salt sack of Zeeland was to become the dominant measure, over that of Flanders – and sea-salt was an important item of Reymerswale trade. Zeeland was, however, most renowned for the cultivation of madder. Until the rise of the French madder industry during the second half of the eighteenth century, Zeeland was the principal madder-producing region for north-western Europe. Trade in madder was well established in the fourteenth century and references to its cultivation and processing in Zierikzee, Reymerswale and other parts of the region occur from quite early in the fifteenth century. That the Zeeland madder industry was highly developed and sophisticated by this time is demonstrated by the Reymerswale madder regulations of 1480. From these it is clear that, for example, different grades of madder root were available; the amount of earth that each grade was permitted to contain was defined; and drying of the root in the *stoven* was permitted only between 15 August of one year and 1 May of the next. Madder, like salt, was among the goods regularly exported from the town.[7]

In Reymerswale, the painters and sculptors were members of the carpenters' guild.[8] Marinus probably spent much of his life there and must certainly have maintained contacts with the town. Van Mander mentioned 'Marinus de Seeu Schilder van Romerswalen' (Marinus the Zeelander, painter, of Reymerswale), who was a contemporary of Frans Floris (1519/20–1575) and whose works were once numerous in Zeeland.[9] No certain reference to Marinus in contemporary sources has been published.[10] His work has many affinities with that of Quinten Massys and his son Jan Massys.

The London painting and its versions

The National Gallery painting entered the collection in 1876 as part of the Wynn Ellis bequest

(PLATE 1); the picture in the Louvre is the only known version that is nearly identical (PLATE 2). Simplified versions are in Antwerp[11] and Warsaw;[12] there exist a very great many versions, further simplified, of the already simplified Antwerp and Warsaw composition.[13]

Both the London and the Paris pictures show, behind the two men, a wooden cupboard on top of which are piled documents, an oval deed-box, a ledger, a turned wooden sand-box and a brass candlestick; across its base lies a pair of snuffers. The folded document above the head of the man on our right is a deed issued, according to the inscription, in 1515 by two aldermen of Reymerswale. The name of the first is concealed by the folding of the document; the second, Cornelis Danielsz., was indeed an alderman in 1514–15.[14] The man on the left is writing in his ledger an account of the income of a town over a period of seven months – from the excise duties on wine and beer, the 'fish-bridge', the weigh-house, the 'hall', the ferries, fees for deeds, charges raised for specific expenses, loans and the civic mills. It is clear that the town was Reymerswale, where there were a 'fish-bridge' – a fish-market on a bridge – a cloth-hall and a butchers' hall and from where ferries ran to Venusdam on Tholen and to the mainland at Bergen-op-Zoom and Antwerp. The mills were water- and windmills.[15] It would seem that Marinus owned a copy of the interim account of the Reymerswale excise duties. One of the papers in the background of the Escorial *Banker and his Wife*, signed and dated 1538, is inscribed with the beginning of a very similar text.[16] In the Paris picture, the fifth item in the account is the *byerberye* – the barrow from which beer was sold: this entry does not occur in the London account. In the London ledger but not in the Paris ledger, *die fijne* – another tax – is entered as the ninth item, between the *ommeslach* – a tax levied to meet specific municipal expenses – and the *molerije* or fees for milling. Otherwise there is an almost exact correspondence between the inscriptions on the Paris and London paintings.[17] The inscription on the half-concealed recto page of the same ledger concerns someone called Voxen, whose first name is hidden but who would have been a member of the prominent Voxen family of Reymerswale.[18] This inscription duplicates part of the writing on the folded deed resting behind the candlestick, which appears to be a list of annual charges, perhaps annuities, payable by the town.

The writing man wears an elaborate heart-shaped hat of a kind worn by fashionably dressed

women in the mid-fifteenth century. It may be relevant that Bruegel's personification of *Avarice* in his drawing of 1556 (British Museum) is a woman wearing a heart-shaped hat.[19] The hat worn by the writing man is 'dagged' or cut in the style of the early fifteenth century as it might have been misunderstood by someone used to the slashed clothes of the mid-sixteenth century. The man on the right wears a hat similarly 'dagged' but of a shape fashionable for men during the first half of the fifteenth century.[20] His sneering grimace and the grasping fingers of his left hand must indicate the extent of his avarice. In the lower left corner are a pen-case and ink-well. The coins in the lower right corner include French *écus d'or au soleil* and two *Joachimsthalers*, silver coins minted from 1519 by the Counts Slik (Schlick) at Jachymov (Joachimsthal) in Bohemia.[21] The man on our left is a municipal official (in the Warsaw version his ring is ornamented with the coat of arms of the town of Reymerswale).[22] He is writing an account of the revenues from various imposts put out to farm. He may be the Treasurer or Tax-Collector of Reymerswale and his companion may be one of the other collectors or tax-farmers. Alternatively the writing man may be the 'Counter-Book-Keeper', employed to keep a check on the activities of the Treasurer.[23] Their extraordinary clothes remove them from reality, though the legible documents assert a connection with everyday life in Reymerswale.

It is not easy to date the London and Paris pictures but they are connected with and probably later than Marinus' paintings of *The Banker and his Wife*, the signed versions of which are dated 1538, 1539, 1540 and 1541.[24] Exaggerated facial expressions, such as that of the man on our right, are not found in Marinus' pictures of the 1530s but become more apparent in the two signed examples of *The Lawyer's Office* dated 1542 (Munich)[25] and 1545 (New Orleans).[26] Perhaps during the 1540s Marinus was becoming more inclined to depict the grotesque extremes of facial expression. For such reasons, it seems plausible to suggest that the London and Paris pictures were painted in the 1540s.

Many of the simplified versions seem to have been painted in Marinus' workshop. In several of them (for example those in Antwerp, at Hagley Hall (near Birmingham), formerly in the Mautner von Markhof collection in Vienna, and in Munich and Warsaw), the texts in the ledgers were copied from the same account that was reproduced in the Paris and London pictures; but slight variations were – apparently capriciously – introduced.[27] In the Hermitage version, however, the text in the ledger records payments of annual charges and corresponds with a text that reappears in the Escorial *Banker and his Wife*, signed by Marinus and dated 1538.[28] The still lifes in some of these versions of the '*Tax Gatherers*' include objects, for example candles and candlesticks, which reappear in the same form in some of Marinus' pictures of the *Banker and his Wife* but which are different in the Paris and London paintings.[29] The artists who produced the simplified versions seem to have had access to Marinus' pattern drawings and other reference material. They would have found such things in his workshop or perhaps with his heirs and successors if, after his death, they continued to run his business. The simplified versions are difficult to date but one of the latest of them, '*The Misers*' in the Royal Collection, was executed after 1548, perhaps before 1551 and certainly before 1563.[30] Various of these simplified versions, including '*The Misers*', bear inscriptions in French rather than in Dutch. Two at least of the inscriptions concern 'La Gabelle de lan 1549' – a tax for the year 1549 – and were presumably painted in or after 1549.[31] Marinus' successors may have been supplying an international market; or perhaps one or two of them moved south into the French-speaking areas of the Low Countries. All this would indicate that versions of Marinus' design continued to be produced during the ten or fifteen years after his presumed death around 1545–6. Many other versions, some of them of abysmal quality, may be very much later, manufactured at times when one or two of the earlier versions, like '*The Misers*', enjoyed unmerited notoriety under false attributions to Quinten Massys.[32]

Interpretations of the original and the versions

Many of the objects depicted in the London picture reappear in the various signed versions of *The Banker and his Wife*. The banker himself looks like a rejuvenated twin of the writing man in the '*Two Tax-Gatherers*': they wear very similar hats and clothes and are seated at similar tables in similar interiors. In the '*Two Tax-Gatherers*', however, the man on our right twists his features into a grotesque sneer and advances his claw-like left hand in a very much more aggressive way than the banker's wife, who splays her talon-like fingers in a similar but more elegant gesture. The two men, dressed in their ridiculous clothes, are criticised for their bureaucratic and legalistic greed. It must not be forgotten

FIG. 1 Infrared photograph of Marinus van Reymerswale, 'Two Tax-Gatherers', Paris. © Laboratoire de Recherche des Musées de France. Photo: Marc de Drée.

FIG. 3 Infrared reflectogram mosaic of Workshop of Marinus van Reymerswale, 'Two Tax-Gatherers' (NG 944).

FIG. 2 Infrared photograph of Marinus van Reymerswale, 'Two Tax-Gatherers', Paris. Detail showing the head of the man on the left. © Laboratoire de Recherche des Musées de France. Photo: Marc de Drée.

FIG. 4 Infrared reflectogram mosaic detail of Workshop of Marinus van Reymerswale, 'Two Tax-Gatherers' (NG 944), showing the head of the man on the left.

FIG. 5 Infrared photograph of Marinus van Reymerswale, 'Two Tax-Gatherers', Paris. Detail showing the hands of the man on the left. © Laboratoire de Recherche des Musées de France. Photo: Marc de Drée.

FIG. 6 Infrared photograph of Marinus van Reymerswale, 'Two Tax-Gatherers', Paris. Detail showing the head of the man on the right. © Laboratoire de Recherche des Musées de France. Photo: Marc de Drée.

that tax-collectors, who were paid percentages of the revenues that they collected, had many incentives to extort every last mite from the tax-payers. According to a popular rhyme of the period,

Een woekereer,
Een meuleneer,
Een wisseleer,
Een tolleneer,
Zijn de vier evangelisten van Lucifer.

(A usurer, a miller, a money-changer and a tax-collector are Lucifer's Four Evangelists.)[33]

The very large numbers of versions show that the composition was highly successful.[34] The fact that the texts in the ledgers change from version to version must indicate that they were interpreted in different ways. In at least two of the versions (Florence, Museo Stibbert, and formerly Paris, Cailleux collection), the French texts in the ledgers are warnings against avarice, which may be freely translated: 'The avaricious man is never sated with money... Have no care for unjustly gained riches, for they will be of no profit to you on the day of reckoning and vengeance. Be therefore without avarice ...'[35] The clothes worn by the two men are archaic in style in all versions but only in the Paris, London, Antwerp and Warsaw pictures does the writing man wear a woman's hat. In the Warsaw painting and in many other, later, versions, he wears spectacles – perhaps as a sign of spiritual myopia or blindness.[36] All the versions of the 'Two Tax-Gatherers' may be interpreted as attacks on avarice.

Technical examinations of the London and Paris paintings

Panel construction

The materials and construction of both panels are typical for panel painting production in the Netherlands in the sixteenth century. Both panels are formed from three vertical oak boards. The London panel measures 92.0 × 74.6 cm while the Paris panel measures 94.1 × 77.0 cm.[37] The difference in size is due to the fact that the Paris panel retains unpainted borders, where it was fitted into its original frame, while these have been removed from the London panel up to the edges of the paint. The image size of the Paris picture is 91.5 × 74.8 cm, almost identical to that in London. Apart from the trimming of the edges, the London panel is virtually in its original condition: the reverse shows rough marks of tooling suggesting that it has not been thinned; it varies in thickness from 5 mm at the edges where it is at its thinnest to about 10 mm in the middle. The only conservation work carried out on the panel has been the re-gluing of the right-hand join, which took place at some time before the painting was bequeathed to the Gallery. By contrast the Paris panel has been thinned to approximately 3 mm; a 4 mm veneer of oak has been attached and a

55

cradle then applied.[38] The London panel has been examined by the dendrochronolgist Peter Klein, who found that the oak is from the Baltic/Polish region. All three boards are from the same tree; the measured heartwood rings were formed between 1335 and 1513. This would suggest that the painting was created in or after 1530.[39] No similar examination has been made of the Paris painting.

Preparation and underdrawing

Like most Northern paintings of the period, both pictures have white grounds, identified as chalk on the London panel.[40] Cross-sections from the London painting have shown that a thin pinkish-grey priming (containing lead white, a little vermilion and black) was applied over the ground. No similar samples are available from the Paris picture.

Infrared examinations reveal extensive underdrawings in both versions, though they are very different in character. The underdrawing in the Paris painting is freehand (FIG. 1). Contours are defined in a loose, sketchy way and there is much hatching. Diagonal lines give generalised indications of areas of shadow, for example in the door. The structure of the red hat is defined in terms of light and shade by hatching and cross-hatching; while scribbled, curving lines give approximate suggestions for the dagging. The older man's face is fully outlined; the contour of the fur collar against his neck is indicated by a wavy line (FIG. 2). Hatching suggests the structure of his near eye socket and the shadows cast across his face by his hat and by his nose. The infrared photographs and examination with infrared reflectography reveal a great many differences between the underdrawing and the final painting. Some of these are relatively small: the horn of the hat over the left eye of the writing man was made a little higher and broader during painting; a small area of cupboard which showed between the back of the man's head and the scarf of his hat was concealed behind dagging; the man's ear was enlarged over the dark paint of his hair; the positions of his hands and the arrangement of the pages of the book were adjusted (FIG. 5); and several elements of the still life above his head were altered. The paper inserted between the pages of the book on top of the deed-box is a late addition; in the underdrawing there is something, probably another folded document, under the top cover which would have helped to hold it open. The figure on the right has undergone more significant changes. These are

more difficult to follow and interpret, partly because the green paint used for his hat is not easily penetrated by infrared and much of the drawing is hidden or difficult to see. What is clear, however, is that the younger man's head has been completely repositioned. The green paint of the hat in its first position remains under the surface paint (although it may have been partly scraped away in places) and shows dark in the infrared photographs (FIGS 1 and 6). The first hat seems to have extended much further towards the middle of the painting and up into the area where the papers now project from the cupboard; a scarf hung across what became the man's left eye, cheek and ear. It has not been possible to identify any underdrawing for the face which would have been under the hat in this first position. All the changes, both large and small, were made during painting, without further underdrawing. The only exception to this is the face of the man on the right which does have basic underdrawing for the new positions of the eyes, nose and mouth, perhaps necessary to establish how the new face would relate to the first hat and whether areas of green paint would need to be scraped away. The freehand nature of the underdrawing, and the presence of alterations, show clearly that the Paris picture is not a copy – the artist is perfecting his composition as he paints.

In contrast, the underdrawing revealed by infrared reflectography of the London picture is very careful and precise (FIGS 3 and 4).[41] There is virtually no hatching: only outlines are indicated, though every detail in the red hat is delineated. Examined closely, the lines, drawn with brushes, look continuous; occasionally it is possible to see faint traces of other lines defining the same contours. These are signs that the underdrawing has been reproduced from a tracing. The artist has then 'fixed' the traced lines by going over them in a liquid medium. The underdrawing is faithfully followed in the painting. There are a few, very minor, changes in the shapes of the cut decorations on the hat worn by the writing man; in the bundle of papers above his head, the drawing for the loop formed by the string is smaller than, and further to the left of, the painted loop.

When a tracing on acetate of the London painting was laid over the Paris picture, all the main compositional elements corresponded exactly in size and layout. It was necessary, however, to move the tracing to match each element (see PLATES 3–6). In PLATE 3, the tracing has been placed so that the face of the man on the left, his shoulders and most of his

False coloured overlay of the Paris picture with a tracing of the London painting.

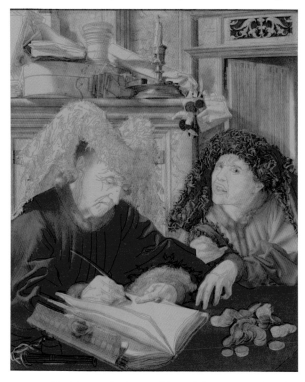

PLATE 3 Position 1, the face and hat of the man on the left are aligned.

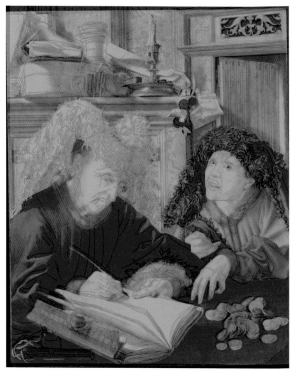

PLATE 5 Position 3, the face and hat of the man on the right are aligned.

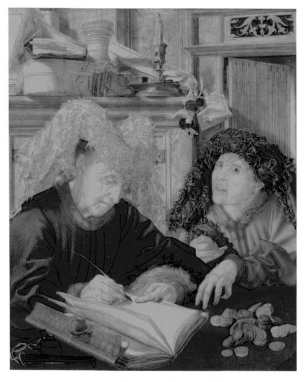

PLATE 4 Position 2, the hands and book of the man on the left are aligned.

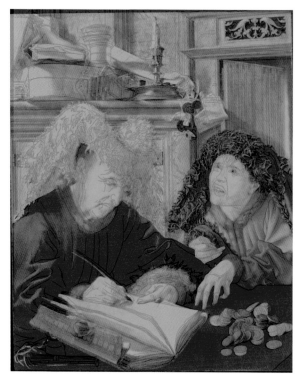

PLATE 6 Position 4, the hands of the man on the right, and the coins, are aligned.

hat are perfectly aligned; but his hands and the book are higher in the tracing, the face of the other man is further to the left and his hands and the coins are both higher and to the left. PLATE 4 shows the tracing repositioned so that the hands and book match perfectly; the face of the writing man is now too low in the tracing, as is the face of the other man, which is also too far to the left. His hands now line up well in the vertical dimension but are still displaced to the left. PLATES 5 and 6 show the tracing positioned over the man on the right, first aligning his face and then his hands, revealing the same exact correlations of the heads and hands and similar related displacements. The exact correlations confirm the hypothesis that a tracing of the Paris painting has been used to make the London picture. The slight displacements of the different elements could have been caused by the slipping of the tracing; but the consistent way in which the displacements match in horizontal bands suggest that they are not entirely random. It is likely that the tracing was on several separate sheets of paper and that these were slightly misaligned as each new sheet was used. A slight overlap between two sheets, one bearing the tracing of the head on the left, the other the head on the right, could explain why the two faces in the London painting are slightly closer together than their counterparts in Paris. Though we cannot know whether the slight contraction of the composition was intended by the copyist or an accident of the method used to transfer the design, the artist may have been forced to use several sheets. He is unlikely to have had a single sheet of paper large enough for a tracing of the whole painting.

PLATE 7 Workshop of Marinus van Reymerswale, 'Two Tax-Gatherers' (NG 944). Photomacrograph of purple drapery on left. At the edge, where the red glaze has been protected from light by the frame, it is a more intense colour.

Paint layers

The recent cleaning of the London painting has revealed that it is in remarkably good condition: there are no significant areas of paint loss; small losses are confined to the right-hand join. There is evidence that the red lake glazes have faded a little and the greens have suffered some discoloration. The Paris picture, on the other hand, is less well preserved. There are more extensive paint losses, especially along the joins; the paint surface appears more abraded; and consequently more retouching has been necessary. There is less evidence, however, of fading of the red glazes or discoloration of the greens.

The range of pigments and the medium used in the London picture are typical for late fifteenth- and early sixteenth-century Netherlandish paintings.

The basic technique is traditional in its dependence on modelled opaque underlayers finished with translucent glazes. The medium is linseed oil, without heat bodying and without the addition of any resin.[42] Pigments identified include lead white, vermilion, red lakes, azurite, a copper green (probably verdigris), lead-tin yellow, various earths and black.[43] In the purple coat of the man on the left, the underlayer is based on mixtures of azurite and lead white, the amount of azurite increasing according to the depth of shadow. A small amount of red lake is added to the mixture only in areas of deep shadow. The modelling of the robe is thus broadly conveyed by these lighter and darker underpaint layers. The purple colour has been achieved by applying a red lake glaze evenly over the entire drapery. In areas of deep shadow at least, this glaze consists of a thin layer of a translucent orange-red

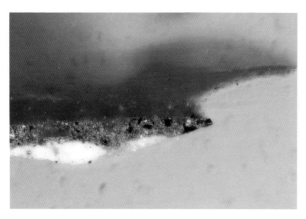

PLATE 8 Workshop of Marinus van Reymerswale, 'Two Tax-Gatherers' (NG 944). Cross-section of a sample from the red garment of the man on the right. Two layers of red lake glaze are visible. Original magnification 500×, actual magnification 440×.

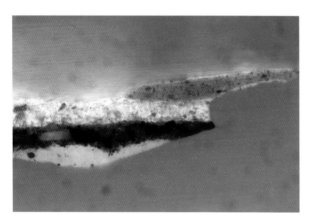

PLATE 9 Cross-section in PLATE 8 photographed in ultraviolet light. Two different red lake pigments are visible, one of which consists of madder and has a characteristic orange fluorescence. Original magnification 500×, actual magnification 440×.

lake, over which is applied a thin layer of a rather deeper red. Where the purple robe has been protected by the frame rebate and therefore has not faded, the glaze is a stronger red (PLATE 7). Originally, this drapery would have been a richer, redder purple.

Close examination of the London painting reveals a degree of sophistication in the selection of pigments and their use, particularly in the reds. At first glance the opaque red of the coat of the man on the right seems to have a typical opaque vermilion-based underlayer with a thin red lake glaze. In the X-radiograph, however, the left sleeve appears much darker than the rest of the red, which shows that this particular area is not absorbing X-rays and indicates a lack of vermilion or lead white (FIG. 7). Samples have confirmed that the lit areas of red – the upper body and shoulder (which appear light in

the X-radiograph) – do indeed have an underpaint consisting mainly of vermilion. In the shadowed part of the arm, the area which looks dark in the X-radiograph, the underpaint is mainly red earth, with only a little vermilion, plus coarsely ground black. As in the purple robe, the tonal contrasts of the red garment are thus already defined in the underpaint. Both underlayers are then glazed with a red lake, slightly orange and not very strong in colour. Areas of deeper shadow have a further glaze applied on top, a lake of a stronger, darker colour (PLATE 8). It is easier to see this under ultraviolet illumination (PLATE 9) where the upper layer appears pink while the lower layers are a pale fluorescent orange, with small amounts of the darker lake mixed in (and showing pink in the plate). Analysis shows that two different dyestuffs have been used to prepare the lake pigments: the lower layers contain madder dyestuff, while the top layer contains the dyestuff from the scale insect kermes (Kermes vermilio Planchon).[44] The madder lake is in fact a very suitable colour for use alone as a glaze over the mid-toned areas of the robe, reserving the darker, more intensely coloured kermes lake for the deeper shadows. A similar use of two different red lakes is seen in the red hat of the man on the left. Here an opaque underpaint consists of white and the stronger-coloured red lake; several layers of red lake lie over this, the uppermost deeper red layer containing kermes dyestuff, while the lower layers contain madder.

The madder lake is very typical of those identified on other Northern European paintings of the fifteenth and sixteenth centuries in its translucency and rather low dyestuff content. The pigment is best described as translucent, rather than transparent, as, although the substrate of the lake contains hydrated alumina, there is a great deal of calcium-containing silicaceous material present. This, too, appears to be quite common in lake pigments, quite frequently madder-containing, from this period.[45] It seems probable that this lake was cheaper than that prepared from the expensive kermes dyestuff and the use of a lake with extender beneath one without, or of a madder lake beneath a kermes lake, whether for reasons of colour or economy, is not uncommon.[46]

A simple technique of opaque underlayers and transparent glazes is given a further degree of sophistication in the green hat of the man on the right. Microscopic examination of the surface and analysis of cross-sections reveal a complicated layer structure. A monochrome undermodelling of lighter

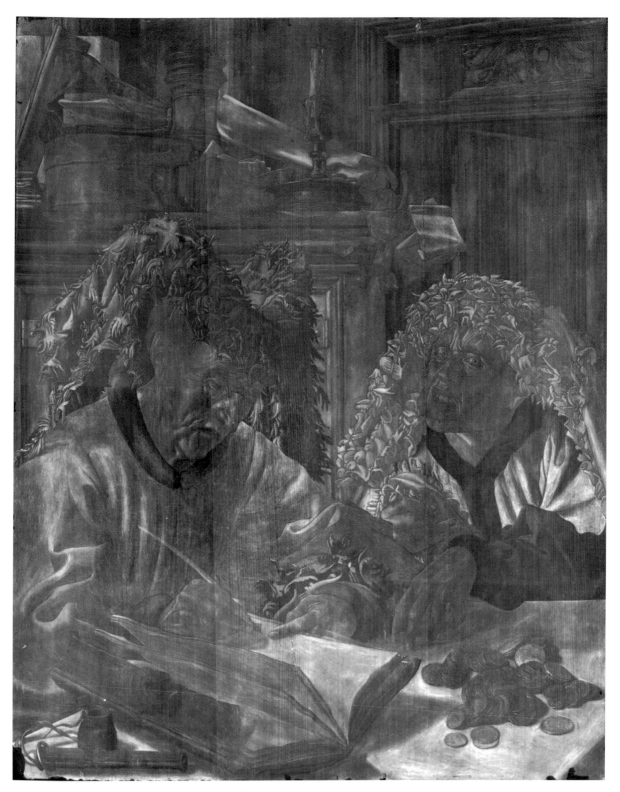

FIG. 7 Composite X-radiograph of Workshop of Marinus van Reymerswale, 'Two Tax-Gatherers' (NG 944).

and darker shades of grey establishes the structure of the hat. Over this is applied a dark transparent green glaze, probably containing verdigris, to give the overall green colour. On top of that is further modelling, consisting of mainly azurite for the darks and mixtures of lead-tin yellow, verdigris and white for the highlights. All this is covered by a final unifying green glaze (PLATE 10).

No samples were taken from the flesh, but an examination of the surface under a stereo-binocular microscope has shown varying mixtures of lead white, vermilion, red lake and black, with scattered

PLATE 10 Workshop of Marinus van Reymerswale, 'Two Tax-Gatherers' (NG 944). Photomacrograph of an area of the green hat of the man on the right. The complex layer structure here is discussed on pp.59–60.

PLATE 11 Workshop of Marinus van Reymerswale, 'Two Tax-Gatherers' (NG 944). Detail showing the fingers of the right hand of the man on the left.

azurite particles – more noticeable in the hands of the older man.

Although both men are wearing clothes of the same colours in the Paris and London pictures, only the red of the costume of the younger man actually looks similar in the two finished paintings. In the Paris picture, the purple coat has been painted with a mixture of black and red, rather than the blue and red of the London painting. The use of black and red has resulted in a dark, rather brown colour. Although these two garments look dissimilar now, they would probably have been closer in hue when first painted.[47] The red hat in the Paris picture is more simply painted than that in the London version. It does not appear to have an opaque undermodelling; this is particularly apparent in the deeper shadows, where the red lake glazes seem to have been applied directly onto the preparation.

Generally, the paint in the London version is applied fairly thickly. Raking light shows pronounced ridges of paint at the contours where the artist has meticulously followed the underdrawing. There is a strikingly strong correlation between the London painting and its X-radiograph (FIG. 7), due to the way in which the modelling is achieved and the care with which shapes are separated, often by minute areas of exposed priming. The close attention to outline, especially in the folds of the drapery and the creases and wrinkles in the men's faces, tends to produce convoluted surface patterns. The detail has been over-emphasised, particularly in the teeth and in the veins and wrinkles of the hands (PLATE 11). In contrast, less attention has been given to modelling, which is lacking in subtlety and is dependent on the application of simple linear highlights that give the forms a hard appearance.

Purely from a visual inspection, the paint layers in the Paris version appear to be more thinly and freely applied, perhaps with less reliance on the multiple layering of colours than in the London picture. Because of an economical use of the white ground to provide luminosity in the glazed shadows and a more discreet use of highlights, a finer and more realistic modelling is achieved in the Paris painting. One of the most disconcerting features of this picture, however, is the pink-orange colour of the flesh of both figures. This is probably the original colour, which does not appear to have altered significantly and which must always have differed from the flesh colours of the London painting.

Conclusions

The Paris picture is the original from which derive all the versions. The London painting is a replica, made from a tracing of the finished Paris picture and corresponding fairly exactly in colour. Presumably it was Marinus himself who was responsible for the important changes made during the execution of the Paris painting. Many of the versions are by artists who had access to patterns used by Marinus in his signed works. These artists were probably under the direction of Marinus and employed by him. In the case of the London picture, the tracing process required a very direct connection with the Paris painting but it differs so greatly in technique from the Paris painting that it must be largely by a second artist, presumably an assistant working under Marinus' supervision.

A valuable contribution to this area of study would be the examination of more paintings attributed to Marinus, particularly those with signatures,

to try to establish the distinctive characteristics of a painting by Marinus himself. Until more is known about Marinus' life, until more paintings by him, his collaborators and imitators have undergone intensive technical examinations, and until more can be discovered or deduced about his assistants and their working practices, the circumstances surrounding the creation of the London painting and its relationship with the rest of Marinus' work must remain elusive.

Acknowledgements

We are exceedingly grateful to Jacques Foucart, Patrick Le Chanu and Cécile Scailliérez for allowing us to examine the Louvre painting and for giving every assistance in our research. Thanks are also due to Troels Filtenborg, Susan Farnell and Lizet Klaassen for providing information. Our colleagues Marika Spring and Catherine Higgitt have put at our disposal and discussed with us their work on the pigments and media. A preliminary and now outdated report of our findings was included in the exhibition catalogue *Art in the Making: Underdrawings in Renaissance Paintings*, ed. D. Bomford, London 2002, pp.170–5.

Notes and references

The abbreviation Friedländer stands for M.J. Friedländer, *Early Netherlandish Painting*, trans. H. Norden, 14 vols, Leiden and Brussels 1967–76.

1 Friedländer, vol. XII, No. 162g; J.M. de Azcárate y Ristori et al., *Guia del Museo de la Real Academia de San Fernando*, Madrid n.d., p. 120.

2 Friedländer, vol. XII, Nos 170c, 170, 170a.

3 The date 1533 is on the *Saint Jerome* in the Academia de San Fernando; it is often read as 1535 but see A. Mackor, 'Marinus van Reymerswale: Painter, Lawyer and Iconoclast?', *Oud Holland*, CIX, 1995, pp. 191–200, p. 200 n. 24. The date 1545 is on *The Lawyer's Office* in New Orleans: see A. Monballieu, 'The Lawyer's Office by Marinus van Reymerswael in the New Orleans Museum of Art', *Jaarboek van het Koninklijk Museum voor Schone Kunsten, Antwerpen*, 1972, pp. 101–41. A signed *Saint Jerome* in the Prado (No. 2100) is dated 1521 but the signature ('Mdad') has been altered and the date, which seems to have been retouched, may originally have been 1541 (see Friedländer, vol. XII, No. 162; Mackor, cited above, p. 199 n. 6). Another almost identical *Saint Jerome*, also in the Prado (No. 2653), is often claimed to be dated 1547 but the last digit is more convincingly read as 1 and the date is once again 1541 (Friedländer, vol. XII, No. 162a; Mackor, cited above, p. 199 n. 6). A third signed version in Antwerp is without any question dated 1541 (Friedländer, vol. XII, No. 162c).

4 Friedländer, vol. XII, No. 161.

5 Friedländer, vol. XII, No. 168; M. Davies, *National Gallery Catalogues, The Early Netherlandish School*, 3rd edn, London 1968, pp. 83–5.

6 R.F.1989–6; sold at Sotheby's, Monaco, 2 December 1988, lot 618.

7 G.A. Fokker, 'De oudst bekende keur op het bereiden van en den handel in meekrap in Zeeland', *Archief: Vroegere en latere mededelingen voornamelijk in betrekking tot Zeeland*, II, vi, 1866–9, pp. 317–28; C. Wiskerke, 'De geschiedenis van het meekrapbedrijf in Nederland', *Economisch-Historisch Jaarboek*, XXV, 1952, pp. 1–144, esp. pp. 10–22; W.S. Unger and J.J. Westendorp Boerma, 'De steden van Zeeland, IV. De steden van de Bevelanden en van Tolen', *Archief: Vroegere en latere mededelingen voornamelijk in betrekking tot Zeeland uitgegeven door het Zeeuwsch Genootschap der Wetenschappen*, 1957, pp. 1–42, esp. pp. 1–5 and references; H. van der

Wee, *The Growth of the Antwerp Market and the European Economy*, The Hague 1963, Vol. 1, pp. 96, 288–95. For examples of goods exported from Reymerswale to London see H.S. Cobb (ed.), *The Overseas Trade of London, Exchequer Customs Accounts 1480-1*, London 1990, pp. 22, 44, 58–9, 98, 136, 141. Apart from salt and madder, other items exported included teazles, bricks, paving tiles and hats.

8 R. Fruin, *Het Recht der stad Reimerswaal* (Werken der Vereeniging tot uitgave der bronnen van het oude vaderlandsche recht gevestigd te Utrecht, Tweede reeks, No. 7), The Hague 1905, pp. 54–7; R. Huybrecht, 'Rechtsbronnen der stad Reimerswaal', *Stichting tot uitgaaf der bronnen van het Oud-Vaderlandse recht, Verslagen en mededelingen*, nieuwe reeks, I, 1978, pp. 47–143, esp. pp. 96–102. No registers of the guild or other lists of members' names have survived.

9 C. van Mander, *Het Schilder-Boeck*, Haarlem 1604, fol. 261v.

10 The biography constructed for him by H. Hymans, 'Marin le Zélandais, de Romerswael', *Bulletins de l'Académie royale des sciences, des lettres et des beaux-arts de Belgique*, 3e sér., VII, 1884, pp. 211–20, has been shown to be largely fictitious (see Mackor, cited in note 3). Dr Mackor followed Hymans in identifying Marinus as the 'Moryn Claessone, Zeelander' who was apprenticed in 1509 to a glass-painter of Antwerp; Mackor further equated him with a 'Marinus Nicolai de Romerswalis' who matriculated in 1504 at the University of Louvain. Dr Mackor has recently discovered, but has not yet published, evidence that from 1540 Marinus lived at Goes (like Reymerswale on the island of Zuid-Beveland) and that he died there in about 1546.

11 Friedländer, vol. XII, No. 167.

12 Reproduced and discussed in A. Mackor, 'Are Marinus' Tax Collectors collecting taxes?', *Bulletin du Musée National de Varsovie*, XXXVI, Nos 3–4, 1995, pp. 3–13.

13 They are classified in L. Campbell, *The Early Flemish Pictures in the Collection of Her Majesty The Queen*, Cambridge 1985, pp. 115–17.

14 M.P. Neuteboom-Dieleman, *Reymerswale, Burgemeesters en Schepenen 1513–1631* (Nederlandse Genealogische Vereniging, Afd: Zeeland, Prae 1600 Club, Werkgroep voor de Studie van Middeleeuwse Genealogische en Historische Bronnen), Goirle 1989, p. 5.

15 Compare the transcript of the 1573 account published by M.P. Neuteboom- Dieleman, *Reymerswale, De stadsrekening van 1573* (Nederlandse Genealogische Vereniging, Afd: Zeeland, Prae 1600 Club, Werkgroep voor de Studie van Middeleeuwse Genealogische en Historische Bronnen), Goirle 1990.

16 Behind the man, hanging from the shelf, on our right: En[de] ... e.../ Item den byer e.../ toe zeve[n] mae[n]den/ Item den wijn .../ is waerd... Adri Mackor generously gave the authors of this present study a copy of his transcript of the Escorial inscriptions.

17 Similar inscriptions are found on the Antwerp picture and on a version sold in Vienna (Dorotheum), 16 December 1919, lot 39, and afterwards in the Mautner von Markhof collection in Vienna, but both differ from the Paris and London pictures in placing the revenues from beer before those from wine. Like the London picture, the Antwerp and Vienna ledgers include in fifth place the revenues from the 'hall'; whereas in the Paris painting, the fifth item in the ledger is the income from the beer-barrow.

18 B.F.W.v.B. Fock, 'Uitgestorvene Zeeuwsche geslachten – Het geslacht Vocxen te Reimerswale', *Maandblad van het Genealogisch-heraldiek genootschap De Nederlansche Leeuw*, VII, 1889, pp. 5–6, 9–10. Jan Adriaensz. Voxen was Treasurer of Reymerswale in 1534.

19 N.M. Orenstein, ed., *Pieter Bruegel the Elder, Drawings and Prints* (exh. cat., Museum Boijmans Van Beuningen, Rotterdam, and Metropolitan Museum of Art, New York), New York 2001, p. 146 (No. 42).

20 Compare the clothes represented in the 'Devonshire Hunting Tapestries': G. Wingfield Digby and W. Hefford, *The Devonshire Hunting Tapestries*, London 1971, plates 9, 22, etc.

21 The coins were issued in the names of Louis II (died 1526) and Ferdinand I, Kings of Bohemia; Ferdinand himself took control of the mint in 1527: see E. Fiala, 'Das Münzwesen der Grafen Schlick', *Numismatische Zeitschrift*, XXII, 1890, pp. 165–264; XXIII, 1891, pp. 195–288. The reverses of the coins, showing the lion of Bohemia, are not accurately enough represented for the legends to be deciphered or for the coins to be allocated to Louis or Ferdinand and so dated. By an ordinance of February 1542, *Joachimsthalers* were banned from circulation in the Low Countries: see *Liste chronologique des édits et ordonnances des Pays-Bas, Règne de Charles-Quint (1506–1555)*, Brussels 1885, p. 257. If, as seems likely, the Paris and London pictures were painted in about 1540, it may be relevant that *Joachimsthalers* were evidently suspect coins.

22 Mackor 1995 (cited in note 12).

23 This is the opinion of Mackor in the article cited in note 12.

24 Friedländer, vol. XII, No. 170.

25 Friedländer, vol. XII, No. 169.

26 See Monballieu's article cited in note 3 above.

27 See Campbell 1985 (cited in note 13), pp. 115–17, and, for the Mautner von Markhof picture, note 17. Adri Mackor has been kind enough to send copies of his transcripts of many of these inscriptions.

28 For the Hermitage picture, see N. Nikulin, *Netherlandish Paintings in Soviet Museums*, Oxford and Leningrad 1987, plates 150–1; Adri Mackor kindly sent copies of his transcripts of these inscriptions.

29 In the Warsaw picture, for example, the candle and the candlestick resemble those in the Escorial and Prado paintings of *The Banker and his Wife*.

30 The exchange rates noted in the ledger came into force on 11 July 1548 and were superseded on 16 December 1551; a boxwood relief dated 1563 derives from *'The Misers'* or from the closely related composition now in Moscow. See Campbell (cited in note 13), pp. 116, 118.

31 Campbell 1985 (cited in note 13), p. 116.

32 Campbell 1985 (cited in note 13), pp. 114–15, 117.

33 Quoted in C. Huysmans, 'Een onuitgegeven hekelschrift van het einde der 16e eeuw', *Tijdschrift voor Nederlandsche taal- en letterkunde*, XVI (n.r. VIII), 1897, pp. 44–70, p. 50.

34 Campbell 1985 (cited in note 13), pp. 115–17.

35 Campbell 1985 (cited in note 13), p. 116. The Cailleux picture is discussed and reproduced by L. van Puyvelde, 'Un portrait de marchand par Quentin Metsys et les percepteurs d'impôts par Marin van Reymerswale', *Revue belge d'archéologie et d'histoire de l'art*, XXVI, 1957, pp. 3–23; the Stibbert picture is reproduced by L. Collobi Ragghianti, *Dipinti fiamminghi in Italia 1420–1570, Catalogo*, Bologna 1990, p. 95 (No. 167).

36 Spectacles, however, were one of the attributes of Temperance: compare Bruegel's drawing of *Temperance* dated 1560 (Rotterdam), reproduced in Orenstein 2001 (cited in note 19), p. 190.

37 The dimensions of the London panel are 92.0 × 74.6 cm. The joins (measured at the top edge) are at 23.9 and 51.3 cm giving three planks of widths 23.9, 27.4 and 23.3 cm. The Paris panel measures 93.9 cm at the left edge, 94.1 cm on the right × 77.0 cm. The joins are at 25.0 and 48.8 cm giving three planks of widths 25.0, 23.8 and 28.2 cm. The joins in both panels have been reinforced with wooden dowels visible in the X-radiographs.

38 The date of this treatment is uncertain but certainly predates the acquisition of the painting by the Louvre in 1989.

39 Report dated 29 August 1997 in the Gallery files: 'Regarding the sapwood statistic of Eastern Europe an earliest felling date can be derived for the year 1522, more plausible is a felling date between 1526...1528...1532 + x. With a minimum of 2 years for seasoning an earliest creation of the painting is possible from 1524 upwards. Under the assumption of a median of 15 sapwood rings and a minimum of 2 years for seasoning a creation is plausible from 1530 upwards.'

40 Calcium carbonate confirmed by EDX

41 Infrared reflectography was carried out using a Hamamatsu C2400 camera with an N2606 series infrared vidicon tube. The camera is fitted with a 36mm lens to which a Kodak 87A Wratten filter has been attached to exclude visible light. The infrared reflectogram mosaics were assembled on a computer using an updated version of the software (VIPS ip) described in R. Billinge, J. Cupitt, N. Dessipris and D. Saunders, 'A note on an improved procedure for the rapid assembly of infrared reflectogram mosaics', *Studies in Conservation*, 38, ii, 1993, pp. 92–8.

42 Organic analysis using FTIR spectroscopy and GC–MS was conducted by Raymond White and Jenny Pilc. In samples from four different areas linseed oil was found, with no indication of the presence of resin. In three samples the oil was not heat-bodied but in the red lake glaze on the coat of the man on the right it was apparent that the oil had been heat-bodied.

43 Inorganic pigments were identified microscopically and by EDX analysis by Marika Spring;

44 High performance liquid chromatography (HPLC) was used for analysis of the lake pigment dyestuffs. For details of the equipment and method see L. Campbell, J. Dunkerton, J. Kirby and L. Monnas, 'Two Panels by Ercole de' Roberti and the Identification of *"veluto morello"'*, *National Gallery Technical Bulletin*, 22, 2001, pp. 29–41, esp. pp. 32, 38 and 39, n. 13. The gradient conditions used were slightly different to those published: starting concentration of the acetonitrile eluent (B) 5%; 5–30% B in 100 mins; 30–45% B in 45 mins; 45–75% B and flow rate reduced from 20 µl min^{-1} to 16 µl min^{-1} in 140 mins, then held for 30 mins; 75–95% B and flow rate restored to 20 µl min^{-1} in 10 mins and held for 20 mins; 95–5% B in 10 mins.

45 See, for example, 'Methods and materials of Northern European painting in the National Gallery, 1400–1550', L. Campbell, S. Foister and A. Roy, eds, *Early Northern European Painting*, National Gallery Technical Bulletin, 18, 1997, pp. 37–8 and n. 142, p. 51.

46 The use of a red lake from an insect dyestuff over a madder lake has been observed in works by Lorenzo Lotto, Raphael and Garofalo (see, for example, J. Dunkerton, N. Penny and M. Spring, 'The Technique of Garofalo's Paintings at the National Gallery', *National Gallery Technical Bulletin*, 23, 2002, pp. 20–41, esp. pp. 34, 36 and 41). The madder lake is also typical in that little, if any, alizarin is present in the dyestuff: the principal constituent is pseudopurpurin. (Pseudopurpurin is 1,2,4-trihydroxyanthraquinone-3-carboxylic acid, from which purpurin may be formed by, for example, decarboxylation over time: if the ground root is left exposed to the air for a period, perhaps. The fact that very little purpurin is present in many fifteenth- and sixteenth-century madder lakes examined, including those identified here, suggests that the root may have been used relatively soon after it was ground, or it was packed in such a way that air was largely excluded. Very little purpurin, either free or as a glucoside, is itself present in the root of *Rubia tinctorum* L. madder.) The apparent lack of alizarin is a common feature of madder lakes in both northern European and Italian paintings of the fifteenth and sixteenth centuries, but why it should be so is not clear: it may be connected with the temperature at which the dyestuff was extracted, but there are several other possible explanations. This point is discussed further in J. Kirby, 'Observations on some Aspects of Medieval and Renaissance Lake Pigment Technology', paper presented at the 21st Meeting of Dyes in History and Archaeology, Avignon, October 2002, in course of publication. Similar results were obtained some years ago from the analysis of red lake pigments in several German paintings using thin layer chromatography at the Instituut Collectie Nederland (formerly the Centraal Laboratorium voor Onderzoek van Voorwerpen van Kunst en Wetenschap), Amsterdam: Dr Judith H. Hofenk de Graaff, personal communication. Other parameters to be considered include the amount of alizarin precursor (the glucoside ruberythric acid) in the original root, its successful hydrolysis to give alizarin and the relationship between the pigment and the dyed textile. With all the possible variables and the presence of a sophisticated madder industry, the postulation of the use of wild madder, *R. peregrina* L., which has a very low alizarin content, seems unnecessary.) Unlike madder lakes, where the link between their preparation and the textile dyeing industry is presumed rather than definite, it is clear that scale insect dyestuff lakes, such as those prepared from kermes, were usually prepared from shearings of dyed textile or other textile waste rather than directly from the insect. The principal constituent of the kermes dyestuff is kermesic acid, with a variable amount of flavokermesic acid, but kermes lakes from the fifteenth and sixteenth centuries frequently have a high kermesic acid content with little, if any, flavokermesic acid and the indirect method of preparation may be one explanation for this (Kirby, cited above). The lake used in the London version of the *'Two Tax-Gatherers'* is, however, unusual in that it contains some flavokermesic acid and an unexpectedly substantial amount of sulphur and potassium, as well as aluminium, in the substrate. Lakes with a similar substrate pattern and dyestuff profile have been identified in other sixteenth-century paintings and it is possible that the connection between the pigment and the textile bath is rather different, and possibly more direct, in these cases (Kirby, cited above; Dunkerton, Penny and Spring 2002, cited above, p. 34 and n. 33 p. 39, referring to a madder lake with a similar substrate profile).

47 The use of black and red for deep purples was not unusual in the sixteenth century. See L. Campbell and J. Dunkerton, 'A famous Gossaert rediscovered', *Burlington Magazine*, CXXXXVIII, 1996, pp. 164–73.

The Triptych of *Saint Catherine and the Philosophers* attributed to Goossen van der Weyden in Southampton City Art Gallery

RACHEL BILLINGE AND LORNE CAMPBELL

Oᴜʀ ɪɴᴛᴇʀᴇsᴛ in the triptych of *Saint Catherine and the Philosophers* (ᴘʟᴀᴛᴇ 1) was fired by the discovery that the overpainted coats of arms on the reverses of the wing panels had never been mentioned in the literature and by the fact that the triptych is attributed to Goossen van der Weyden (1465–after 1538). Since the collection at the National Gallery does not include a picture by Goossen, we wanted to try to identify one of his patrons and to find out how closely his painting technique resembled that of his famous grandfather Rogier. (The five pictures in the National Gallery attributed to Rogier van der Weyden and his workshop were studied in an article published in Volume 18 of the *Technical Bulletin*.) Since the National Gallery is fortunate in having well-developed facilities for the technical study and analysis of old master paintings, examination of the triptych presented an opportunity to cooperate with a regional gallery on a most rewarding project of interest to both institutions.

Goossen van der Weyden

Goossen was a grandson of the great Rogier van der Weyden (*c.*1399–1464). Goossen's father, Pieter van der Weyden, born in 1437, was the only one of Rogier's three sons who became a painter. Pieter

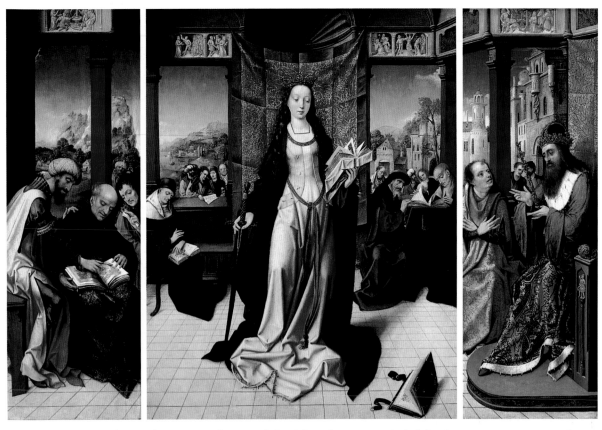

ᴘʟᴀᴛᴇ 1 Goossen van der Weyden, *Saint Catherine and the Philosophers*, *c.*1510. Oak, left wing 110.2 × 37.5 cm, central panel 110.2 × 86.0 cm, right wing 110.0 × 37.4 cm. Southampton City Art Gallery, purchased through the Chippendale Fund in 1958, Accession no. 1/1958. Photo The National Gallery, London.

inherited Rogier's houses in Brussels[1] and with them his workshop. Presumably Rogier bequeathed to Pieter his equipment, stock, pattern drawings and other reference material; Pieter doubtless continued to employ some or all of his father's assistants. In January 1465,[2] seven months after Rogier's death, Pieter married Catharina van der Noot, who died in 1510. She came of a younger branch of one of the most eminent families in Brussels.[3] Pieter van der Weyden was still alive in 1514.

Goossen would have been trained in his father's workshop in Brussels, but by about 1492 he was active in Lier, where in 1497 he became a burgess.[4] In 1498–9 he purchased burgess's rights in Antwerp,[5] where between 1504 and 1513 he owned a house in the Huidevettersstraat[6] (Quinten Massys lived in the same street) and where he was Dean of the Guild of St Luke in 1514 and 1530.[7] He must have run a large workshop, as he registered ten apprentices between 1503 and 1522, including a Portuguese (Symon Portugaloys in 1504) and a Spaniard (Allonse Crasto in 1522). None of his apprentices became a master of the Antwerp guild.[8] Goossen's principal patrons were Antonius Tsgrooten and Arnout Streyters, abbots of Tongerlo, a Premonstratensian foundation south-east of Antwerp. From 1514, Goossen was the concierge of their residence in Antwerp.[9] Goossen seems to have worked for Portuguese and perhaps for other foreign clients.[10] He was still alive in January 1538.[11]

Although Goossen was born after his grand-father's death, he commemorated him in a vast triptych of the *Death and Assumption of the Virgin* commissioned in 1533 for the abbey church at Tongerlo, completed in 1535 but lost during the Revolutionary period. On one wing-panel he repre-sented himself and the famous Rogier; above them an inscription described Goossen as seventy years of age and the imitator in art of his grandfather Rogier, the Apelles of his time.[12]

Two of the paintings that Goossen executed for Tongerlo have been identified: the small triptych of *Christ with the Instruments of the Passion*, painted for the Abbot Tsgrooten and paid for in 1507 (Antwerp),[13] and the *Donation of Kalmthout*, deliv-ered between 1511 and 1515 (Berlin).[14] A large triptych of the *Life of Saint Dympna*, painted for Tongerlo in 1505 and now cut into its component scenes, eleven of which survive, is reasonably attrib-uted to Goossen (Antwerp, on loan from the collection of Dr Paul and Mevrouw Dora Janssen).[15]

Several paintings are so similar to the two docu-mented pictures and to the *Life of Saint Dympna* that they are unanimously attributed to Goossen: the triptych of the *Marriage of the Virgin*, also known as the 'Colibrant triptych', painted in about 1517 for the Sint-Gummaruskerk at Lier, where it remains;[16] the triptych of the *Crucifixion*, painted in or shortly after 1517 for Marcus Cruyt, abbot of the Cistercian monastery of St Bernard on the Schelde at Hemiksem, and now at Springfield, Massachusetts;[17] the *Adoration of the Kings* in the Royal Collection;[18] and the triptych of *Saint Catherine and the Philosophers* which is the subject of this article and which is so similar in style to the *Donation of Kalmthout* and the Lier *Marriage of the Virgin* that it too may be dated during the 1510s.

The triptych of *Saint Catherine and the Philosophers*

In the nineteenth century the triptych was in the collection of Henry Danby Seymour (1820–1877) and afterwards in that of Sir John Charles Robinson (1824–1913), from whom it was bought in 1876 by Sir Francis Cook (1817–1901). It remained in the Cook Collection until 1958, when it was sold by the Cook Trustees to the Southampton City Art Gallery.[19] The triptych illustrates more or less accu-rately the story of Saint Catherine as it is narrated in the *Golden Legend*. Catherine, the young and beautiful daughter of King Costus, has argued with the Emperor Maxentius and with fifty erudite men summoned by him from the ends of the earth to his palace at Alexandria. She has confounded them all and converted the fifty philosophers to Christianity. Further episodes from the saint's life are represented in the frieze above the philosophers' heads.[20] The extraordinary statue depicted in the background of the right wing represents a naked woman holding a snake and sitting on the shoulders of a naked man; this curious travesty of Adam and Eve may perhaps refer to the idols worshipped by Maxentius.

Goossen frequently 'quoted' from the work of his grandfather. In the *Donation of Kalmthout*, the figures of the Virgin and Child are taken from a Rogierian source previously exploited by the Master of the Legend of Saint Catherine.[21] In the *Saint Catherine and the Philosophers*, the figure of the saint seems to derive from a Rogierian 'pattern' which would have resembled the Virgin in the small *Virgin and Child* (Vienna) and which appears to have been used by the Master of the Embroidered Foliage for his *Saint Catherine* (Rotterdam).[22]

FIG. 2 Infrared reflectogram mosaic detail of the central panel, showing background on left.

FIG. 1 Infrared reflectogram mosaic detail of the central panel, showing upper half of Saint Catherine.

Technical examination

The triptych consists of a central panel measuring 110.2 × 86.0 cm, formed from three oak boards with the grain running vertically. Three dowels reinforce each join. The panel is 15 mm thick, which is probably the original thickness. The reverse has narrow rebates, 5 mm deep, on all four sides. Both wings measure about 110 × 37.5 cm and each is formed from two boards.[23] All three panels have been trimmed and have lost some or all of the unpainted edges; but traces of a barbe found at various points on all the panels indicate that originally the triptych had an engaged frame.

The main focus of the technical examination of the triptych was to discover more about the reverses of the wings (see below) but the opportunity was taken to examine the inside with a microscope and to make a full examination with infrared reflectography and X-radiography.

The paintings on the interior

The technique and materials used for the paintings on the three internal faces are entirely in keeping with those of Netherlandish paintings of the late fifteenth and early sixteenth centuries: the panels are prepared with white chalk grounds; the pigments identified include azurite, a copper-based

FIG. 3 Detail from the infrared reflectogram mosaic of the left wing, showing upper half of figures.

green (probably verdigris), red lake, vermilion, red and brown earths, lead-tin yellow, lead white and black; all are applied in heat-bodied linseed oil.[24]

Examination with infrared reflectography revealed extensive freehand underdrawing, probably in a dry material such as black chalk.[25] The drawing is linear and quite schematic, especially in the faces, where eyes are indicated with circles or arcs and the brows are often defined by parallel hatching across the areas above the eyes (FIG. 3). Elsewhere parallel hatching is used to indicate areas of shadow. The

FIG. 4 X-radiograph detail of the central panel showing area of background on left.

composition was clearly worked out in advance. The main figures show few changes: the only change in Saint Catherine is in her book, to which a *chemise* has been added during painting (FIG. 1) – the underdrawing clearly shows the ends of the fingers, which are now hidden by the cloth, and the book without its cloth cover. The hands of the other principal figures are often drawn with rather short fingers which have been extended during painting, the reserves following the drawing more closely. Other smaller details such as hats were also changed (the figure in the left wing, for example, had a simple hat turned into a turban, while the seated figure at the left of the central panel had his hat altered from a turban into a simpler, straight-sided, blue hat). More significant changes have occurred in the background scenes outside the building, especially on the left of the central panel (FIG. 2). Here the underdrawing shows a different group of spectators, while behind them larger buildings were planned, more in scale with those on the right, and there was a procession of smaller figures advancing towards the palace. Painting had started on this first scene before the changes were made. At least one of the front figures was sufficiently far advanced for his hands and sleeves to be visible on top of the wall in the infrared reflectogram mosaic; a wall and tower were painted in the middle-ground and the procession shows because it too had been partly painted. The final positions for the figures and the background behind them were not redrawn but painted directly. The X-radiograph of this area (FIG. 4) shows a figure on the right of this group with the

long folds of a sleeve or cloak falling inside the room, but it is not clear whether he was intended to be standing inside or leaning in from outside.

The reverses of the wings

The reverses of the wings (PLATE 2) are covered in brown paint. In raking light, the shape of a shield set into ornamental decoration can be made out on each of the wings. Someone has made a clumsy attempt to remove the brown overpaint from areas of the shield on the left wing and has revealed that two coats of arms are present, one painted on top of the other. Not realising that the upper coat of arms lies above a first coat, he has exposed areas of both. X-radiographs and infrared reflectogram mosaics of the shield areas on both wings have been made. The reflectogram mosaics (FIGS 5 and 6) give good images of the second shields on each wing but less information about the first shields. X-radiography, which penetrates all layers, yields information about the obverses of the panels as well as the reverses. Most useful is the X-radiograph of the left wing,

PLATE 2 Goossen van der Weyden, *Saint Catherine and the Philosophers*: reverse of left wing (left) and right wing (right). Southampton City Art Gallery.

FIG. 5 (BELOW) Infrared reflectogram mosaic detail of reverse of left wing, showing area of shields.

FIG. 6 (RIGHT) Infrared reflectogram mosaic detail of reverse of right wing, showing area of shields.

which shows clearly the basic lay-out of the first shield (FIG. 7). The colours used in the various layers were established by surface examination using a stereo-binocular microscope and, where possible, pigment identification was confirmed by analysis of paint samples.

Cross-sections from both wings were found to have a similar basic structure, analysis of which has enabled us to make a number of deductions about the history of the shields. Samples from the shield areas, the architectural ornament and an undecorated area all have, at the bottom, a layer of brownish-red paint containing red lead, red and yellow iron oxide, lead white and a little black.[26] This layer appears to have been applied over the whole surfaces of the reverses and is acting as a

ground onto which the first shields and the decorative ornament are painted. In all the samples taken from the area of the shields (but not in samples from other areas), a relatively thick creamy-white layer (lead white in heat-bodied linseed oil) lies over the paint of the first shield (PLATE 3). In some cross-sections there are traces of dirt and possibly a thin surface coating between the paint of the first shield and this white layer, which could indicate that it was applied some time later to block out the coats of arms. Over the white blocking-out layer is a thin, transparent, yellowish-brown proteinaceous layer, probably animal glue, which in places runs into cracks in the white layer. It may have been applied some time after the white. As this proteinaceous layer was also found in several samples from the

FIG. 7 Composite X-radiograph, left wing (as seen from the reverse).

PLATE 3 Cross-section of a sample from the shields on the right wing. The thick, lead white, blocking-out layer is visible in the middle of the section on top of the black paint of the first shield. The black paint of the second shield lies over a thin, yellowish-brown proteinaceous layer which covers the white, and is in turn covered by several layers of brown paint. Original magnification 280×, actual magnification 240×.

background beyond the blocked-out shields, it was possibly applied as a general surface coating. The paint of the second shields lies on top of these two layers and is covered in turn by the opaque brown surface paint.[27]

The background of both wings was a creamy yellow.[28] The ornamental shapes surrounding the shields, visible in the X-radiographs, were clearly painted at the same time as the first pair of coats of arms. The style of the architectural ornament, entirely different from the ornament on the reverses of the wings of Goossen's triptychs at Antwerp and Springfield,[29] allows the ornament, and therefore also the first pair of shields, to be dated during or after the 1550s – several decades after the scenes on the interior of the triptych.[30]

It has not been possible to establish with certainty how the exteriors of the wings would have looked when the triptych was first painted. The red-brown layer which lies under all the other paint layers of the reverses could have been applied in Goossen's workshop, but it appears to have been painted directly onto the wood. This is unusual and not in keeping with the technique of the rest of the triptych, which has a chalk ground. The outside surfaces of the wings may have been left as bare wood, though that is very unlikely. Alternatively, the wings may have had some kind of decoration, perhaps marbling or plain black, which was later completely scraped away to allow the new owners to have their coats of arms painted in its place.

The first two shields

On the left wing, the lower and earlier coat of arms is that of the University of Oxford: *azure, on an open book proper, leathered gules, garnished and having on the dexter side seven seals or, between three open crowns of the last, the words DOMINUS ILLUMINATIO MEA* (see PLATE 5).[31]

The shapes of the crowns and the open book can clearly be seen in the X-radiograph (FIG. 7). The field is blue (azurite and lead white); the crowns are gold leaf applied on a yellowish mordant; their interiors are red. The pages of the book are silver leaf with gold edges (all on the same yellowish mordant) and the cover is red. The seven seals attached on the left are also gold. The presence of the inscription is confirmed by the letter D visible in the infrared reflectogram mosaic (FIG. 5).

On the right wing, the lower and earlier coat of arms is: *gules an annulet or within a bordure sable; over all, a canton argent* (see PLATE 6). These arms are the most difficult to distinguish. Stereo-binocu-

lar microscopy, sampling, X-radiography and examination in raking light have established that the shield has a central field of red (vermilion), around which is a black border. The canton is silver leaf and the ring (*annulet*) is gold leaf. There are traces of gold in several places on the border, which could very well have been ornamented with golden objects. Because of the overlying paint, it is impossible to determine whether the silver canton carries any decoration. Though it is likely that it did carry a device or charge, no trace of one has been found. The arrangement of shapes and colours, however, is so unusual and so complex that it seems plausible to identify the coat of arms as that of a White family from Berkshire, who used very similar arms.[32] Sir Thomas White (1495–1567), born in Reading, a merchant tailor of London and founder in 1555 of St John's College, Oxford, bore *gules an annulet or, on a bordure sable eight estoiles or; over all, on a canton ermine a lion sable.*[33] If the black *bordure* of the Southampton shield was charged with golden stars (*estoiles*) and if the *canton argent* was, in fact, a *canton ermine* charged with a black lion (the proper representation of ermine was, in fact, silver with black ermine-tails), then the arms are those of Sir Thomas White, which were afterwards used by St John's College (PLATE 4).

The second two shields

On the left wing, the upper and later coat of arms is that of a Heron or Herne family: *quarterly: 1 and 4, sable a chevron ermine between three herons argent* (Heron or Herne); *2 and 3, gules on a chevron between three garbs(?) or three billets(?) sable* (possibly Flatman: PLATE 7).[34] The basic shapes can be made out quite well in the infrared reflectogram mosaic (FIG. 5). The fields of the first and fourth quarters are black, the birds are basically white and the chevron is white, with the ermine-tails in black and with grey edges. The second and third quarters have red fields. The three shapes that could be interpreted as wheat-sheaves (*garbs*) are gold, as are the chevrons. The rectangles (*billets*) on the chevrons are black, the red edges on the right and at the bottom making them appear slightly three-dimensional.

On the right wing, the upper coat of arms is that of the same Heron or Herne family, unquartered: *sable a chevron ermine between three herons argent*. This shows clearly in the infrared reflectogram mosaic (FIG. 6), where the birds can be seen to be slightly modelled to show details such as the wings

PLATE 5 Diagram showing lower shield on left wing.

PLATE 6 Diagram showing lower shield on right wing. Yellow spots in border indicate where gold leaf was identified.

PLATE 7 Diagram showing upper shield on left wing.

PLATE 8 Diagram showing upper shield on right wing, including the crescent, mark of cadency, which was painted out.

and to give an appearance of roundness to the necks. Like its counterparts on the left wing, the chevron has grey edges. The painter at first included a white crescent in chief (see PLATE 8 and FIG. 8) – the mark of cadency of a second son – but afterwards painted over it in black.[35] The crest above the shield is that of Heron or Herne: *a heron's head and neck erased argent, ducally engorged or.*

The same Heron arms appeared on the tomb of Sir John Heron, who died in 1522.[36] Many of his descendants used this coat,[37] as did members of a family named Heron or Herne settled in London and in Norfolk. The Hernes, who were doubtless related to Sir John, at first differenced the arms.[38] In 1664, John Herne (1619–1665) of Arminghall in Norfolk was using a crescent as his difference. He died in 1665 and on his tomb, erected by his widow Mary (née Pitt, died 1698), appear the undifferenced arms.[39] This John Herne had been a student at St John's College in Oxford, where he matriculated on 24 July 1635;[40] in 1645 he accompanied to the scaffold Archbishop Laud, who had studied at St John's and who had been President of the College from 1611 to 1621.[41] Francis Herne, John's third son, was a London merchant in the Spanish trade and died in 1722.[42] He had married, at St Martin's in the Fields on 16 July 1702, Franck Flatman (1675–1725), daughter of the painter, poet and barrister Thomas Flatman (1635–1688).[43] The coat of arms quartered with the Herne coat on the reverse of the left wing of the triptych is remarkably like the Flatman arms as they appeared on the tombstone at St Bride's, Fleet Street, of Thomas Flatman (1673–1682), the poet's eldest son: *a chevron between three garbs.*[44]

It is therefore possible to argue that the second (later) shields refer to Francis Herne (1703–1776),

son of Francis Herne and Franck Flatman. The connection with St John's College, Oxford, and so with the first two shields, is provided by his grandfather John Herne, whose heir he was in the male line; the fact that his branch of the family had once used the crescent as a mark of cadency but later used the undifferenced arms may explain why a crescent was at first included on the reverse of the right wing and then painted over; his connection with the Flatmans might explain the quarterings on the left wing. Both shields would refer to the same person, Francis Herne, who would have been entitled to quarter the Flatman arms or to use the Herne arms without quarterings.

The history of the triptych

The history of the triptych may be reconstructed as follows: painted by Goossen van der Weyden, probably in the 1510s, for an unknown patron, it would have been acquired by Sir Thomas White and given by him during the 1550s to his foundation, St John's College, Oxford. Sir Thomas must have considered himself fortunate to have discovered a painting of an unusual subject but one eminently suitable for a university. He would have been responsible for having the reverses of the wings decorated with architectural ornament and the first two shields, with the arms of the University of Oxford and those borne by himself and by his College. At a time when it was dangerous to have associations with religious images, these shields would have been obliterated with white paint. Unfortunately it has not been possible to discover any reference to the triptych in the early inventories in the College archives, in the Bursars' Accounts or in the College Registers.[45]

FIG. 8 Composite X-radiograph, right wing (as seen from the reverse).

Subsequently the triptych would have passed into the possession of the Herne family, possibly through John Herne, who was a student at St John's. The second two shields are perhaps to be connected with John Herne's grandson Francis Herne, Member of Parliament for Bedford (1754–68) and Camelford (1774–76), who inherited (1751) and later (1763) sold the estate of Luton Hoo and who died unmarried.[46] His property passed to his sister Mary Herne (died 1792) and subsequently to the stepsons of their sister Anne Herne or Page (buried 1741).[47] It may have been one of the Pages who sold the triptych.

Summary

Using infrared reflectogram mosaics and X-radiographs and studying paint samples in conjunction with repeated microscopic examinations of the paint surface, we have been able to reveal something about Goossen's painting technique as well as much about the provenance of the triptych and its unexpected significance for the history of religious images during and after the English Reformation. Goossen's painting technique shows him to have been well schooled in the Netherlandish traditions of which his grandfather had been an unequalled master. That he was proud of the family connection is clear, but by setting Rogierian figures in Italianate buildings he showed that he was also open to new ideas. Although we have had to abandon our hopes of identifying the patron for whom the triptych was painted, we have established that it belonged to St John's College in Oxford and that it was probably given to the College by its founder, Sir Thomas White, at the time of its foundation in 1555. England was then ruled by Mary Tudor, who had married Philip II of Spain in 1554. The country was by this time more closely in touch with continental Europe and with artistic trends there than during the previous and succeeding reigns and it was safe once more to make and exhibit religious images.

Acknowledgements

For their assistance in the preparation of this article, we are grateful to our colleagues at the National Gallery, to Professor Robert Tittler, Concordia University, Montreal, and to Anthony Wells-Cole, Temple Newsam House. At Southampton City Art Gallery, Tim Craven, Acting City Art Gallery Manager, Rebecca Moisan, Conservation Officer, and Godfrey Worsdale,

formerly Art Gallery Manager, have been unfailingly helpful. In Oxford, we have received much advice and information from Dr John Jones, Balliol College, from Dr Andrew Hegarty, Magdalen College, and particularly from Dr Malcolm G.A. Vale, Keeper of the Archives at St John's College.

Notes and references

1 A. Pinchart, 'Roger de le Pasture dit van der Weyden', *Bulletin des Commissions royales d'art et d'archéologie*, Vol. VI, 1867, pp. 408–94, esp. pp. 461–7, 472–4; see also the monograph by G. Passemiers, *Goossen van der Weyden (1465–1538/45), Peintre de l'École anversoise*, Brussels 1987.

2 P. Lefèvre, 'À propos de Roger van der Weyden et d'un tableau peint par lui pour l'église Sainte-Gudule, à Bruxelles' in *Mélanges Hulin de Loo*, Brussels and Paris 1931, pp. 237–44, p. 239 note.

3 H.-C. van Parys, F. de Cacamp et al., 'Généalogie des familles inscrites au lignage Steenweegs en 1376', *Brabantica*, Vol. VI, ii, 1962, pp. 559–686, esp. pp. 603–4.

4 J.B. Stockmans, 'Lyrana', *Académie royale d'archéologie de Belgique, Bulletin*, 1908, pp. 267–313, esp. pp. 268–70.

5 Pinchart 1867, cited in note 1, p. 469.

6 L. de Burbure, 'Documents biographiques inédits sur les peintres Gossuin et Roger Vander Weyden le jeune', *Bulletins de l'Académie royale des sciences, des lettres et des beaux-arts de Belgique*, 2ᵉ série, Vol. XIX, 1865, pp. 354–83, esp. pp. 355–6.

7 P. Rombouts and T. Van Lerius, *Les Liggeren et autres archives historiques de la Gilde anversoise de Saint-Luc*, vol. I, Antwerp and The Hague 1864–76, pp. 81, 114, 116 note.

8 Ibid., pp. 59, 60, 66, 68, 77, 78, 80, 89, 100.

9 De Burbure 1865, cited in note 6, pp. 356–7; W. van Spilbeeck, *De voormalige abdijkerk van Tongerloo en hare kunstschatten*, Antwerp 1883, passim; Passemiers, cited in note 1, pp. 42–7, and passim; M. Koyen and L.C. Van Dyck, 'Abbaye de Tongerlo' in *Monasticon belge*, VIII, *Province d'Anvers*, Liège 1992–3, Vol. I, pp. 263–375, esp. pp. 317–27.

10 A triptych of the *Presentation in the Temple* (Lisbon) may have been commissioned by or for Emmanuel, King of Portugal (reigned 1495–1521), whose arms and device of the armillary sphere appear in the left wing: see M.-L. Lievens-De Waegh, *Les Primitifs flamands*, I. *Corpus ...*, 16, *Le Musée national d'art ancien et le Musée national des carreaux de faïence de Lisbonne*, Vol. I, Brussels 1991, pp. 196–231. It is just conceivable that the large *Adoration of the Kings* in the Royal Collection may have belonged to Cardinal Wolsey and Henry VIII (L. Campbell, *The Early Flemish Pictures in the Collection of Her Majesty The Queen*, Cambridge 1985, pp. 121–3). Goossen had Scottish relations (ibid., pp. xxxi–xxxii and references) and may perhaps have worked for Scottish patrons.

11 De Burbure 1865, cited in note 6, p. 357.

12 A. Heylen, *Historische verhandeling over de Kempen*, revised edn, Turnhout 1837, p. 160; van Spilbeeck, cited in note 9, pp. 12–14.

13 A. Monballieu, 'Het Antonius Tsgrooten-triptiekje (1507) uit Tongerlo van Goossen Van der Weyden', *Jaarboek van het Koninklijk Museum voor Schone Kunsten, Antwerpen*, 1967, pp. 13–36.

14 G. H[ulin] de Loo, 'Ein authentisches Werk von Goossen van der Weyden im Kaiser-Friedrich-Museum', *Jahrbuch der königlich preussischen Kunstsammlungen*, XXXIV, 1913, pp. 59–88, esp. pp. 76–84.

15 Ibid., pp. 63–7. We are grateful to Richard Charlton-Jones for enabling us to study the paintings before they were sold at Sotheby's in London on 12 July 2001 (lot 14). The centre panel was made up of three of the surviving paintings and a lost *Martyrdom of Saint Dympna*, separated by scrolls bearing explanatory inscriptions; it measured approximately 262 × 163 cm.

16 Stockmans 1908, cited in note 4, pp. 290–313.

17 A.I. Davies, *16th- and 17th-Century Dutch and Flemish Paintings in the Springfield Museum of Fine Arts*, Springfield, Mass., 1993, pp. 146–9; for Marcus Cruyt, see F. Marcus, 'Abbaye de Saint-Bernard sur l'Escaut à Hemiksem' in *Monasticon belge*, VIII, *Province d'Anvers*, Liège 1992–3, Vol. I, pp. 31–79, esp. pp. 60–1.

18 Campbell 1985, cited in note 10, pp. 121–3.

19 M.W. Brockwell, *A Catalogue of the Paintings at Doughty House Richmond & Elsewhere in the Collection of Sir Frederick Cook, Bt.*, Vol. III, London 1915, pp. 76–7 (No. 455); C. Wright, *Renaissance to Impressionism, Masterpieces from Southampton City Art Gallery*,

20 London 1998, p. 119.

21 Jacobus de Voragine, *The Golden Legend*, trans. W. G. Ryan, 2 vols, Princeton 1993, Vol. II, pp. 334–41.

22 C. Deroubaix, 'Un triptyque du Maître de la Légende de Sainte Catherine (Pieter van der Weyden?) reconstitué', *Bulletin de l'Institut royal du patrimoine artistique*, XVII, 1978/79, pp. 153–74; D. Martens, 'Identification du "Tableau de l'Adoration des Mages" flamand, anciennement à la Chartreuse de Miraflores', *Annales d'histoire de l'art et d'archéologie*, XXII, 2000, pp. 59–92.

23 M.J. Friedländer, *Early Netherlandish Painting*, trans. H. Norden, 14 vols, Leyden and Brussels 1967–76, Vol. II No. 7 and Vol. IV No. 86.

24 Measurements (in cm): left wing 110.2 (left) – 110.3 (right) × 37.4 (top) – 37.5 (bottom), thickness 5 mm; right wing (in cm): 110.0 (left and right) × 37.4 (top and bottom), thickness 6 mm.

25 Inorganic pigments were identified microscopically and by EDX analysis by Marika Spring; organic analysis using FTIR spectroscopy and GC–MS was conducted by Catherine Higgitt.

26 Infrared reflectography was carried out using a Hamamatsu C2400 camera with an N2606 series infrared vidicon tube. The camera is fitted with a 36 mm lens to which a Kodak 87A Wratten filter has been attached to exclude visible light. The infrared reflectogram mosaics were assembled on a computer using an updated version of the software (VIPS ip) described in R. Billinge, J. Cupitt, N. Dessipris and D. Saunders, 'A note on an improved procedure for the rapid assembly of infrared reflectogram mosaics', *Studies in Conservation*, 38, ii, 1993, pp. 92–98.

27 All identified with EDX, the yellow having distinctive needle-shaped particles.

28 Containing lead white, earth pigments and bone black. There are one or two slightly more grey-black particles which seem, from EDX analysis, to be manganese black (Mn only detected, not in combination with Fe). Some of the earth particles are umber (Fe, Mn and Si detected by EDX).

29 Lead white, lead-tin yellow and a silicaceous yellow earth.

30 See notes 13 and 17 above.

31 See A. Wells-Cole, *Art and Decoration in Elizabethan and Jacobean England, The Influence of Continental Prints, 1558–1625*, New Haven and London 1997. Mr Wells-Cole was kind enough to give his opinion, in a letter of 10 July 2002, that 'this ornament ... could, I believe, have been painted in the late 1550s as you suggest'.

32 J.P. Brooke-Little, 'The Arms of Oxford University and its Colleges', *The Coat of Arms, An Heraldic Quarterly Magazine*, Vol. I, 1951, pp. 158–61, 198–200, 235–8.

33 An early sixteenth-century armorial gives for one Roger White the arms *gules a bordure sable semé of estoiles or; over all, on a canton argent a lion sable* (College of Arms MS Vincent 152, cited in T. Woodcock, J. Grant and I. Graham, eds, *Dictionary of British Arms, Medieval Ordinary*, Vol. II, London 1996, p. 206). A second armorial of the same period gives for a White family, not otherwise identified, *gules a bordure sable semé of estoiles or; over all, on a canton ermine a lion rampant sable* (College of Arms MS L 1).

34 Compare the description of his coat of arms in B.L., MS Harl. 5846 (a copy made in 1632 of a mid-sixteenth-century armorial), fol. 114 ('G a qᵗ Ermyn. a Lyon Rampant s. Armed and langued g a bordure s semy starrs wᵗ vj poynts or his difference An Annulet or his crest an Eagle close ar ...'); his arms on the 1562 Statutes of St John's College, reproduced by W.H. Stevenson and H.E. Salter, *The Early History of St. John's College Oxford* (Oxford Historical Society publications, n.s. Vol. I), Oxford 1939, plate between pp. 142–3; or the shield in the portrait of Sir Thomas belonging to the Worshipful Company of Merchant Taylors, reproduced by F. M. Fry, *A Historical Catalogue of the Pictures, Horse-Cloths & Tapestry at Merchant Taylors' Hall*, London 1897, frontispiece (described on pp. 93–6). Sometimes the annulet appears in chief rather than in the centre of the shield (Stevenson and Salter, p. 392; Brooke-Little 1951, cited in note 31, p. 200).

34 See below.

35 A sample taken from this area shows the light grey paint of the crescent lying over the two layers which divide the two shields (the white blocking-out and the thin proteinaceous layer). Over the crescent is a thin black layer similar in composition to the black used for the field of the shield.

36 A. P. Newton, 'The King's Chamber under the Early Tudors', *English Historical Review*, XXXII, 1917, pp. 348–72. For the tomb, see the notes by the herald Nicholas Charles, c.1610, in B.L., MS Lansdowne 874, fol. 119v; Richard Newcourt, *Repertorium Ecclesiasticum*

Parochiale Londinense, 2 vols, London 1708–10, Vol. I, p. 617: 'One ... Heron, Esq; is taken by some to be the Founder of it, by his Arms engraven in Stone upon every Pillar of the same, which is a Cheveron-Ermin, between three Herons, but I rather think he was a very great Benefactor to the New-Building or Repairing of this Church, for which Reason his Arms is on every Pillar; and in the North-Isle thereof, in a Tomb of white Free-Stone, but without any Inscription, his Body lies.'; Daniel Lysons, *The Environs of London*, Vol. II, London 1795, p. 461: 'Between each arch of the nave are the arms of Heron carved in stone. The same arms occur on one side of the chancel window; on the other side are the arms of Urswick.' In a footnote, Lysons describes the arms as 'Sable a chevron Erm. between 3 herons Argent'. See also W. Robinson, *The History and Antiquities of the Parish of Hackney, in the County of Middlesex*, 2 vols, London 1842–3, Vol. II, pp. 6–7; J.R. Daniel-Tyssen, 'Will of Sir John Heron, 1521', *Miscellanea Genealogica et Heraldica*, n.s. Vol. I, 1874, pp. 50–3; R. Simpson, *Some Notices of the Life of Henry, Lord Percy, sixth Earl of Northumberland, and of the Parish Church of St. Augustine, afterwards St. John at Hackney*, Guildford 1882, pp. 3, 55.

37 For example his grandson the painter-stainer Thomas Heron, who died in 1603: see the copy of the grant of arms of 1600 copied in B.L., MS Add. 5533, fol. 115 (printed in 'London Pedigrees and Coats of Arms', *Miscellanea Genealogica et Heraldica*, 5th ser., Vol. V, 1923–5, pp. 268–72, esp. p. 269); or, in 1634, James Heron of Panffield Hall (Walter C. Metcalfe, ed., *The Visitations of Essex*, 2 vols, Harleian Society publications XIII and XIV, London 1878 and 1879, Vol. I, p. 417). Other descendants quartered or varied the arms: James's father, Sir Edward Heron, who died in 1609, seems on occasion to have used the arms *sable on a fess ermine a rose or, between three herons argent* (W. Bruce Bannerman, ed., *The Visitations of Kent Taken in the Years 1530–1 by Thomas Benolte, Clarenceux and 1574 by Robert Cooke, Clarenceux*, Part I, Harleian Society publications LXXIV, London 1923, p. 64) and at other times to have quartered *sable a chevron ermine between three herons argent* with Pickenham (B.L., MS Harl. 1550, Visitations of Lincolnshire 1564 and 1592, with later additions, fol. 90; MS Harl. 1551, fol. 40, printed in G. J. Armytage, ed., *Middlesex Pedigrees as collected by Richard Mundy*, Harleian Society publications LXV, London 1914, p. 183). Sir Edward's descendants, the Herons of Cressey Hall, are said to have borne *sable a chevron ermine between three herons or* (A.R. Maddison, *Lincolnshire Pedigrees*, vol. II, Harleian Society publications LI, London 1903, p. 487: a fairly complete account of Sir John's descendants is given on pp. 486–9). The arms were sometimes mistakenly appropriated for other persons named Heron: for example on the funeral certificate of Ralph Coppinger, who died in 1620 and who had married Susan Heron (G.S.S., 'Pedigree of Heron, of Addiscombe, Surrey', *Collectanea Topographica & Genealogica*, Vol. II, 1835, pp. 166–7).

38 Nicholas Herne of London bore in 1634 *sable a chevron ermine between three herons argent, a mullet in chief*. His grandfather Nicholas Herne, who came from Tibenham in Norfolk, cannot have been a descendant of Sir John Heron but was probably related to him. See J.J. Howard and J.L. Chester, eds, *The Visitation of London Anno Domini 1633, 1634, and 1635*, Vol. I, Harleian Society publications XV, London 1880, p. 378.

39 For the Herons or Hernes at Arminghall or Ameringhall, see F. Blomefield, *An Essay towards a Topographical History of the County of Norfolk*, Vol. V, London 1806, pp. 420–2. In 1664 John Herne of Ameringhall bore *Sable a chevron ermine between three herons close argent, legged or, a crescent for difference* (A.W. Hughes Clarke and A. Campling, eds, *The Visitation of Norfolk Anno Domini 1664 made by Sir Edward Bysshe, knt. Clarenceux King of Arms*, Vol. I, A-L (Norfolk Record Society, Vol. IV), London 1934, pp. 98–9). The undifferenced arms appear on the tomb at Arminghall of the same John Herne, who died in 1665 (Blomefield, pp. 420–1).

40 J. Foster, *Alumni Oxonienses, The Members of the University of Oxford, 1500–1714, E-K*, Oxford and London s.d., p. 697.

41 See the letter of 1 March 1703 n.s. written by John Herne's son John to his brother and printed in F. Peck, *Desiderata Curiosa*, 2 vols, London 1732–5, Vol. II, Lib. XIV, pp. 52–3. John's father, another John Herne (died 1649), had defended Laud and had taken communion with him in the Tower of London before his execution. Laud had given gold coins to John Herne II, from which his son John Herne III (born c.1648) wished to make a commemorative medal. The medal was indeed made and was acquired in 2002 for St John's College, Oxford.

42 Will dated 15 June 1719 and 8 April 1722, proved 10 May 1722: PRO, PROB 11/585, sig. 97.

43 G. Saintsbury, *Minor Poets of the Caroline Period*, Vol. III, Oxford 1921, pp. 277–422.

44 W. Berry, *Supplement to Encyclopoedia Heraldica or Complete Dictionary of Heraldry*, London 1840, f. 2H2: 'FLATMAN, [London, 1682,] quarterly; first and fourth a chev. ... betw. three garbs; second and third, paly of six and a chev.' (misquoted in J. W. Papworth and A.W. Morant, *An Alphabetical Dictionary of Coats of Arms ... forming an extensive Ordinary of British Armorials*, London 1874, p. 429, who gratuitously intruded the word *argent*: ' ... arg. a chev. ... betw. three garbs ...'). The quartering was probably for the poet's wife Hannah, who was an heiress: her surname is not known. For the tombstone, which was decorated with a coat of arms, an epitaph and a poem, see A. J. Jewers, 'Monumental Inscriptions in City Churches', Guildhall Library, London, MS 2480/2, p. 375, who in 1913 was working from descriptions, written by a former parish clerk, of floor slabs since hidden under a new floor. Even in 1720, the verses were 'almost worn out and gone' (J. Stow, *A Survey of the Cities of London and Westminster*, ed. J. Strype, London 1720, Vol. I, Book III, p. 266).

45 Dr Malcolm Vale, Keeper of the Archives, most generously checked these records (his letter of 23 September 2002).

46 L. Namier and J. Brooke, *The House of Commons 1754–1790*, Vol. II, Members A-J (The History of Parliament), London 1964, pp. 614–15.

47 J.S. Cockburn and T.F.T. Baker, eds, *A History of the County of Middlesex* (The Victoria History of the Counties of England), Vol. IV, Oxford 1971, pp. 206, 209–10, 213, and passim.

Pigment-medium Interactions in Oil Paint Films containing Red Lead or Lead-tin Yellow

CATHERINE HIGGITT, MARIKA SPRING AND DAVID SAUNDERS

DURING THE ROUTINE EXAMINATION of paintings, translucent white lumps or inclusions are often observed in oil paints containing red lead or lead-tin yellow 'type I'. These lumps vary in size, but are usually most easily visible under the microscope, either in cross-sections of paint samples or on the paint surface. In some cases – for example in the *Portrait of Don Andrés del Peral* by Francisco de Goya (NG 1951, PLATE 1) – they are large enough to be seen with the naked eye. In this painting the lumps are in the ground layer (which contains red lead) but are so large that they protrude through the paint layers and above the surface, giving the whole painting a pronounced gritty texture. They are

FIG. 1 Francisco de Goya, *Portrait of Don Andrés del Peral* (NG 1951). Detail of X-radiograph in which the inclusions are visible as small white dots.

visible in the X-radiograph of the painting as small white dots (FIG. 1).

The same phenomenon has also been observed in samples from wall paintings executed in an oil medium.[1] However, the extremely damp environmental conditions to which wall paintings are often subjected can also lead to a more dramatic lightening of red lead-containing paint films due to conversion to lead carbonate, not only in oil but in a variety of binding media.[2] This related, but mechanistically different, deterioration process is the subject of a separate investigation.[3]

Inclusions have been noted in descriptions of paint samples published as early as the 1970s.[4] They have variously been interpreted as interstices or 'bubbles' within the film, resulting from the use of an aqueous binding medium such as egg tempera, or as indicative of the use of a mixed medium or emulsion (with the inclusions being protein or other non-glyceride material).[5] It has also been suggested that the lumps are a coarse grade of lead white deliberately added to the paint to give it texture.[6] It is only relatively recently, with the advent of Fourier transform infrared (FTIR) microscopy, that it has been possible to analyse them reliably. A number of studies have been published.[7] These include Plahter and White's FTIR analysis of inclusions in the

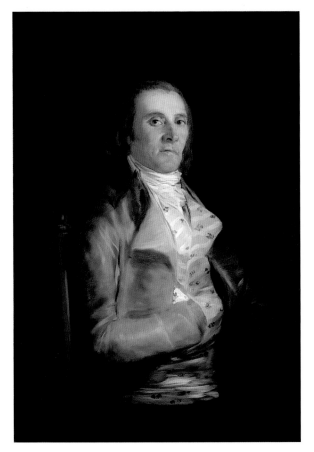

PLATE 1 Francisco de Goya, *Portrait of Don Andrés del Peral* (NG 1951), before 1798. Poplar, 95 × 65.7 cm.

PLATE 2a Detail of *The Virgin and Child with Saint John*, German, 16th century, on the reverse of *Saints Peter and Dorothy* (NG 707), by the Master of the Saint Bartholomew Altarpiece, probably 1505–10. Oak, 125.7 × 71.1 cm.

ground of *The Young Christ among the Doctors* by Teodoer van Baburen (Nasjonalgalleriet, Oslo),[8] White's analysis of a lead-tin yellow-containing paint from *William Feilding, 1st Earl of Denbigh* by Van Dyck (NG 5633)[9] and analysis by Noble et al. of Rembrandt's *Anatomy Lesson of Dr Nicolaes Tulp* (Mauritshuis, The Hague).[10] The common conclusion of these analyses was that the inclusions contain lead carbonate and lead carboxylates (lead fatty acid soaps) formed by reaction of the pigment with the oil medium.

The above analyses relate to Northern European seventeenth-century paintings. The phenomenon is not, however, confined to this period, but is ubiquitous in oil paintings from all over Europe during the period in which red lead and lead-tin yellow 'type I' were used as pigments. Here, we present detailed

PLATE 2b Cross-section from the reverse of NG 707; highlight of the Virgin's crown. Large translucent white inclusions are visible within the lead-tin yellow paint layer. Original magnification 500×; actual magnification 440×.

PLATE 2c Cross-section from the reverse of NG 707; highlight of the Virgin's crown, ultraviolet light. Original magnification 500×; actual magnification 440×.

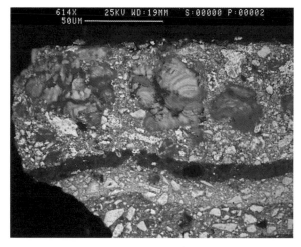

FIG. 2a Reverse of NG 707. Back-scattered electron image of the cross-section from the Virgin's crown (shown in PLATES 2b and c).

FIG. 2b Detail of the back-scattered image in FIG. 2a.

analyses of inclusions in works ranging in date from the thirteenth to the eighteenth centuries. In addition, the records of examination of cross-sections held in the Scientific Department of the National Gallery (which date back to the 1950s) confirm that these inclusions are common in paint films containing a significant proportion of red lead or lead-tin yellow. Analysis of samples from some thirty-five of these paintings was carried out by optical microscopy, energy dispersive X-ray analysis (EDX) in the scanning electron microscope (SEM), X-ray diffraction (XRD), FTIR microscopy and gas chromatography–mass spectrometry (GC–MS). Here the results of the analysis of a larger group of paintings showing this phenomenon than has previously been examined are presented, to provide a broader view of the occurrence of lead soap inclusions and hence a deeper understanding of the mechanism and consequences of their formation. The paintings, and a summary of the results, are listed in Table 1.

Microscopic appearance of the inclusions

PLATE 2b shows a cross-section of a sample from a painting of *The Virgin and Child with Saint John* by an unknown sixteenth-century German painter (PLATE 2a), on the reverse of *Saints Peter and Dorothy* (NG 707) by the Master of the Saint Bartholomew Altarpiece. Rounded white opalescent inclusions between 30 and 50 microns in size are visible in a yellow paint layer containing only lead-tin yellow of the 'type I' form. The inclusions are fluorescent under ultraviolet light and can be seen to be inhomogeneous, as there is variation in the strength of the fluorescence within the inclusion, distinguishing them from ordinary coarse particles of lead white (PLATE 2c). This inhomogeneity is even clearer in the back-scattered image in the SEM (FIGS 2a and 2b). There are highly scattering (lighter grey) lead-rich regions with a lamellar structure, mostly towards the centre of the inclusions, surrounded by less scattering areas that correspond to the regions which fluoresce more strongly under ultraviolet light. These regions relate to a rather more subtle variation in translucency that is visible under normal light (PLATE 2b). EDX analysis in the SEM detected only lead in the inclusions.

Large white inclusions were also observed in the red paint of Saint Hippolytus' hose (a mixture of vermilion and red lead) in Moretto's *Virgin and Child with Saints* (NG 1165) of *c*.1538–40 (PLATES 3a and 3b). The inclusions have the same characteristic appearance under ultraviolet light (PLATE 3c),

and in the SEM as in the lead-tin yellow paint of the Virgin's crown in the painting of the Virgin and Saint John discussed above, but here the presence of red lead in the paint layer is responsible for their formation. The descriptions of the samples illustrated in PLATES 2 and 3 are typical of all those examined in this study.

Lead soap inclusions are quite commonly seen in the red ground layers of seventeenth-century Dutch paintings, which often contain some red lead (as a drier) mixed with red earth pigment (see Table 1). An example of this was observed on a painting by Bartholomeus van Bassen (*An Imaginary Church*, Brighton Museum and Art Gallery). In a cross-section from this painting illustrated in PLATE 4, one particularly large inclusion is visible in the red ground layer, which has erupted through the upper layers of paint. Unreacted red lead particles surround the white translucent pustule. The

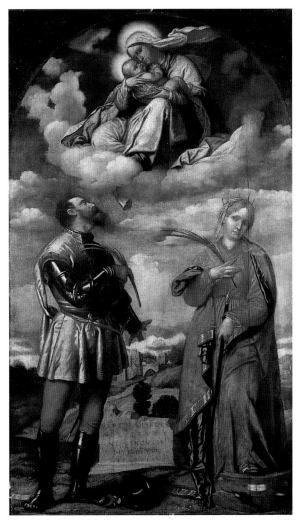

PLATE 3a Moretto da Brescia, *The Madonna and Child with Saints Hippolytus and Catherine of Alexandria* (NG 1165), *c*.1538–40. Canvas, 229.2 × 135.8 cm.

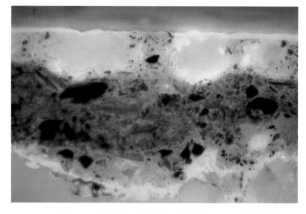

PLATE 3b Moretto da Brescia, *The Madonna and Child with Saints Hippolytus and Catherine of Alexandria*. Cross-section from the red hose of Saint Hippolytus. Two large white inclusions can be seen in the uppermost red layer, which contains red lead and vermilion. Original magnification 400×; actual magnification 350×.

PLATE 3c Moretto da Brescia, *The Madonna and Child with Saints Hippolytus and Catherine of Alexandria*. Cross-section from the red hose of Saint Hippolytus, ultraviolet light. Original magnification 400×; actual magnification 350×.

PLATE 4 Bartholomeus van Bassen, *An Imaginary Church*, 1627. Brighton Museum and Art Gallery. Cross-section from the brown foreground. The lower red ground layer contains red earth and red lead, over which is a second brownish-grey ground layer (lead white, black, brown and red lead). A very large inclusion originating in the lower red ground layer is visible. Original magnification 280×; actual magnification 275×.

painting is on panel and so the gritty texture caused by the inclusions is particularly evident on an otherwise smooth surface. Another painting in which lead soap inclusions were observed in the red ground layer (a mixture of red lead and red earth) is the *Portrait of Charles I* by Daniel Mytens (Royal Collection). Like the painting by van Bassen, the white translucent inclusions are embedded in a matrix of red earth pigment, but have unreacted red lead around them from which they originate (PLATE 5). Again, as is often the case, the growth of the inclusion has distorted the surrounding paint layers and ruptured the surface of the film. The lamellar structure that is frequently seen in inclusions is particularly well developed in this sample (FIG. 3).

Red lead is also often a component of oil mordants used for gilding, again because of its ability to aid the drying of oil. Several examples of inclusions in this type of mordant are listed in Table 1. These include the gilding on Pilate's robe in *Christ before Pilate* (NG 2154) by the Master of Cappenberg, and the gilded decoration on the canopy of the early English *Thornham Parva Retable* (St Mary's Church, Thornham Parva).

The *Westminster Retable*, which was painted in England in the thirteenth century, is the earliest painting in which inclusions have been observed. Relatively small white lumps have formed in the red lead paint of the orange lining of Saint John's cloak (PLATE 6). Since early English paintings on both panel and wall were frequently executed in oil, and often contain red lead, this is not an isolated example; several others in works from this period are listed in Table 1.[11]

We have not attempted to cover nineteenth- and twentieth-century examples of this phenomenon; the latest painting in this study, Goya's *Don Andrés del Peral* (NG 1951), dates from the last decade of the eighteenth century. The inclusions in the ground layer of this painting are around 200 microns at their largest and so, as mentioned earlier, are visible with the naked eye. They are more opaque in appearance than the previous examples illustrated, but the characteristic fluorescence and inhomogeneity are still visible in ultraviolet light (PLATES 7a and b, and FIG. 4).

PLATE 5 Daniel Mytens, *Portrait of Charles I*, 1628. Royal Collection. Cross-section from a red drapery in the background, showing the large lead soap inclusions in the red ground layer (red earth, red lead and a little black). Unreacted red lead is visible around the white inclusions. Original magnification 200×; actual magnification 175×.

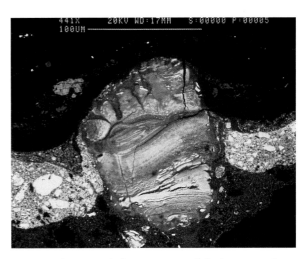

FIG. 3 Back-scattered electron image of the large pustule in the cross-section in PLATE 5, showing the pattern of precipitation of lead carbonate within an inclusion.

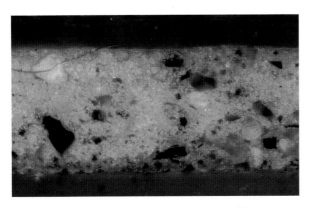

PLATE 6 English School, *The Westminster Retable* (Scene IIIa), *c.*1260–80. Westminster Abbey. Cross-section from the orange lining of Saint John's robe, showing small white relatively homogeneous inclusions within the red lead paint layer. Original magnification 500×; actual magnification 440×.

PLATE 7a Francisco de Goya, *Portrait of Don Andrés del Peral* (NG 1951), before 1798. Cross-section from the black background. The pale orange ground layer contains red lead, lead white and silica. A large relatively opaque inclusion which has broken through the upper layers of paint can be seen in the middle of the sample. Original magnification 126×; actual magnification 110×.

FIG. 4 Francisco de Goya, *Portrait of Don Andrés del Peral* (NG 1951). Back-scattered electron image, paint cross-section from the black background, illustrated in PLATES 7a and b.

PLATE 7b Francisco de Goya, *Portrait of Don Andrés del Peral*. Cross-section from the black background, ultraviolet light. Original magnification 126×; actual magnification 110×.

PLATE 8 Meindert Hobbema, *The Avenue at Middelharnis* (NG 830), 1689. Cross-section from the lead-tin yellow highlight of the small tree in sunlight, showing relatively homogeneous inclusions. Original magnification 500×; actual magnification 440×.

FIG. 6 Meindert Hobbema, *The Avenue at Middelharnis* (NG 830), 1689. Back-scattered electron image of the cross-section shown in PLATE 8, in which the inclusions appear relatively homogeneous.

Analysis of the inclusions

FTIR microscopy

The results of FTIR analysis of the samples listed in Table 1 are remarkably consistent, showing that the composition of the inclusions is very similar in all the examples studied. In every case they were found to comprise lead carboxylates (lead fatty acid soaps) and lead carbonate (in the basic and/or neutral form). Using a FTIR microscope and a micro compression diamond cell, it was possible to obtain good-quality transmission spectra of the inclusions. The lead soaps were identified by comparison with the literature and standards of various lead soaps prepared in the laboratory (see Appendix, p.94).[12]

The upper trace in FIG. 5 shows the infrared spectrum of an inclusion in a lead-tin yellow high-light in *The Avenue at Middelharnis* by Meindert Hobbema (NG 830). For comparison, the middle and lower traces show spectra for standards of lead palmitate and lead stearate prepared in the laboratory (see Table 2 in the Appendix). Palmitic and stearic acids are the major monocarboxylic fatty acid components of aged drying oils.[13] The strong, sharp bands at 2918 and 2849 cm^{-1} correspond to the C–H stretches of the fatty acid portion of the lead soaps.[14] The asymmetric carboxylate stretch of the lead fatty acid soaps appears as a doublet at *c*.1540 and 1513 cm^{-1} and the symmetric stretch at *c*.1419 cm^{-1}. The regular pattern of small peaks in

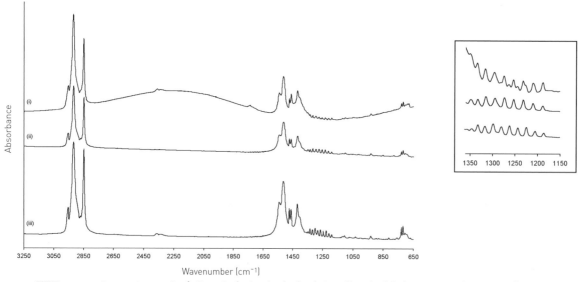

FIG. 5 FTIR spectra (3250–650 cm^{-1}) of: (i) an inclusion in the lead-tin yellow highlight on a tree from Meindert Hobbema, *The Avenue at Middelharnis* (NG 830) [upper trace]; (ii) a standard sample of lead palmitate [middle trace]; (iii) a standard sample of lead stearate [lower trace]. Inset: detail in the 1360–1150 cm^{-1} region. (The baseline roll in the upper trace is an artefact resulting from the use of a micro compression diamond cell in sample preparation.)

PLATE 9a Lorenzo Costa, *A Concert* (NG 2486), *c.*1485–95. Detail of the woman's sleeve and green bodice. The lumpy texture of the green paint is caused by inclusions in the lead-tin yellow underpaint.

PLATE 9b Lorenzo Costa, *A Concert*. Unmounted paint fragment from a lead-tin yellow highlight on the brocade of the woman's sleeve. Translucent 'haloes' can be seen around a more opaque core in the inclusions. Original magnification 500×; actual magnification 440×.

the 1350–1180 cm⁻¹ region corresponds to the vibrations associated with the long hydrocarbon chains of the fatty acids. This is an unusually clear example,[15] as the spectra are normally less well resolved and are complicated by peaks from other components such as lead carbonate and the oil binding medium. In this sample the inclusions contain less lead carbonate than many of the other examples. This is reflected in their more homogeneous appearance in normal light (PLATE 8) and in the back-scattered image in the SEM (FIG. 6).

There was some indication from the FTIR spectra that the amount of lead carbonate in the inclusions is variable, as might be expected given the variation in translucency observed in cross-sections

under the microscope. The pustule in the cross-section from the painting by Goya (PLATES 7a and 7b) seems to have a particularly high proportion of lead carbonate and is relatively opaque in comparison with the inclusions in the cross-section from Hobbema's painting (PLATE 8). The distribution of the components in the inclusions was investigated by FTIR microscopy on a sample of lead-tin yellow paint from Lorenzo Costa's *A Concert* (NG 2486), where the inclusions are relatively large (PLATE 9a). The inclusion analysed has a fairly opaque centre with a halo which is more translucent and which also fluoresces more strongly in ultraviolet light (PLATE 9b). Although the infrared bands for lead carboxylates and lead carbonates overlap in the

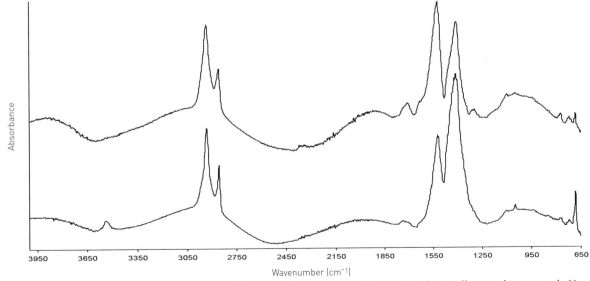

FIG. 7 Lorenzo Costa, *A Concert* (NG 2486). FTIR spectra (4000–650 cm⁻¹) from the inclusion illustrated in PLATE 9b. Upper trace: spectrum from the translucent 'halo' around the inclusion, which has a high proportion of lead-fatty acid soaps. Lower trace: spectrum from the more opaque centre of the inclusion, which has a high proportion of lead carbonate. (The baseline roll in the spectra is an artefact resulting from the use of a micro compression diamond cell in sample preparation.)

1400 cm[-1] region, the ratio of the peaks at c.1400 and c.1500 cm[-1] indicate that the haloes are rich in lead fatty acid soaps (FIG. 7, upper trace) and that the more opaque centres of the inclusions are rich in lead carbonate (FIG. 7, lower trace). This is consistent with the observation that the centre of the inclusion is more highly scattering (that is, lead-rich) in the back-scattered image in the SEM. Bands at 3535, 1400, 1045 and 682 cm[-1] demonstrate that the lead carbonate in Costa's *A Concert* is present in the basic or hydrocerussite form, $2PbCO_3 \cdot Pb(OH)_2$. The results of FTIR microscopy and XRD (see Table 1) show that this was the case in the majority of the samples examined in this study.

As will be described later, unexpectedly low levels of the dicarboxylic acid, azelaic acid (an autoxidation product of drying oils), have often been detected by GC–MS in paint films that contain inclusions. Azelaic acid is usually found in significant amounts in aged oil paint films, and is capable of forming lead soaps (see Appendix). All three of the lead soaps studied here (palmitate, stearate and azelate) can be distinguished when pure, but in the presence of the oil medium and lead pigments, it is very difficult to tell by FTIR alone precisely which lead soaps are present.[16] It is particularly hard to distinguish lead palmitate from lead stearate,[17] but the FTIR spectrum of pure lead azelate is rather different (see Table 2). As a result, if lead azelate is present it should, in some cases, be possible to detect it in a mixture of these three lead soaps. For example, in the very clear infrared spectrum obtained for the inclusion in the lead-tin yellow highlight in the Hobbema (upper trace, FIG. 5), the absence of lead azelate and the presence of a mixture of lead palmitate and stearate can readily be seen.[18]

GC–MS Analysis

Thermally assisted transmethylation GC–MS was used to investigate the presence of fatty acids and any dicarboxylic acids (produced by oxidative degradation) in the inclusions and surrounding material. The method employed here allowed all of the mono- and dicarboxylic fatty acids to be detected at once, whether they are present as free acids, as esters (glycerides) or as metal salts (soaps).[19] Analysis of inclusions separated from the bulk of the paint layer indicated that they contain palmitic and stearic acids (or their derivatives), and that this was consistent over all the samples in which the inclusions were large enough to analyse in this way. Although palmitate and stearate were found in

the ratio expected for the bulk oil medium (by comparison with samples from elsewhere in the same painting), generally very little azelaic acid (or its derivatives) was found in the inclusions. This finding is consistent with the FTIR spectra where there was no obvious sign of the presence of lead azelate.

In some of the samples, where inclusions form a large part of the paint layer, the whole sample also shows a reduced azelaic acid content (see Table 1). The discovery that the presence of lead soap inclusions can have this effect on the fatty acid ratios measured by gas chromatography (GC) is of particular interest and significance, since a low azelate to palmitate ratio is characteristic of egg fats.[20] On this basis, some previous analyses of the binding medium of red lead-containing paint films (before the era of FTIR microscopy) concluded that the binding medium was egg yolk. The red lead-containing paint from the wall paintings originally in St Stephen's Chapel, Westminster, listed in Table 1, which was previously analysed with GC, is an example.[21] If the binding medium is indeed egg yolk it must, of course, contain protein, which can now be detected using FTIR microscopy. Recent re-examination by the authors of the sample from the St Stephen's Chapel wall painting using FTIR microscopy indicated that there was no evidence for the presence of amide bands (at c.3290, 1658, 1633 and 1550 cm[-1]), which would be seen if proteins were present.[22] Instead, the large translucent inclusions seen in the red lead paint under the microscope yielded bands associated with lead soaps and basic lead carbonate. The binding medium of the paint in the samples from the St Stephen's Chapel wall painting is therefore oil. Every example listed in Table 1 where GC–MS gave a low azelate to palmitate ratio was also analysed by FTIR microscopy to check for the presence of protein, but none was found. The low azelate level must therefore be an effect associated with the red lead and lead-tin yellow pigments in these samples.

The 'low azelate effect' has been partly responsible for the idea that the inclusions are globules of protein, a theory that emerged from early attempts to analyse them in lead-tin yellow paints from Early Netherlandish paintings. Also perhaps responsible for this idea is the unfortunate coincidence that when cross-sections containing lead fatty acid soaps are treated with stains specific for proteins (such as amido black) they appear to give false positive results.[23] In addition, the fluorescence of the lead soap inclusions has in the past been interpreted as indicative of the presence of protein.[24]

Discussion

Examination of a large number of paintings makes it clear that inclusions are found in paint layers containing red lead or lead-tin yellow, or both. The results of analysis listed in Table 1 show that, in each case, the components of the inclusions are lead fatty acid soaps and lead carbonate, as has been found in previous studies. They are formed as a result of the reaction of a lead-containing pigment with the oil binding medium.

Red lead in linseed oil has been extensively studied because of its use as a corrosion-inhibiting paint for iron.[25] It has therefore long been known that lead(II) ions in red lead react with the fatty acids in linseed oil to form lead soaps. Red lead and lead-tin yellow 'type I' have very similar structures, so it is not surprising to find that the lead(II) ions in lead-tin yellow are also capable of reacting with oil to form lead soaps. Red lead (Pb_3O_4) has a structure with chains of lead(IV) ions, where each lead ion is surrounded by six oxygen atoms in an octahedral arrangement. The octahedra are joined by tetrahedrally coordinated lead(II) ions. In lead-tin yellow 'type I' (Pb_2SnO_4), Sn(IV) substitutes for Pb(IV) in the octahedra.[26] Dunn, reporting on the reactivity of lead pigments with oil, notes that 'red lead appeared to form the most soap, white lead a smaller amount, and chromated red lead the least amount'.[27] These results correlate with the reported availability of lead(II) ions in solution from corrosion inhibition studies.[28] This lower reactivity might explain why we have not, as yet, observed lead fatty acid soap inclusions in lead white-containing paint layers, although it is clear from FTIR spectra of samples of lead white paint from old master paintings that some lead carboxylate is formed.[29]

The component of the paint that is responsible for lead soap formation is not always immediately obvious. It may not be the major constituent of the mixture, or the only lead-containing species present. In Francisco Zurbarán's painting of *A Cup of Water and a Rose on a Silver Plate* (NG 6566), the off-white paint of the cup has a lumpy texture that is visible to the naked eye, which FTIR analysis confirmed is due to lead soap inclusions. The major component of the paint is lead white, but it also contains some lead-tin yellow, yellow earth and black. There are more inclusions in the warm grey shadows of the cup than in the whiter highlights, which suggests that it is the lead-tin yellow, rather than the lead white, that is responsible for the formation of the inclusions in this case. Lead soap

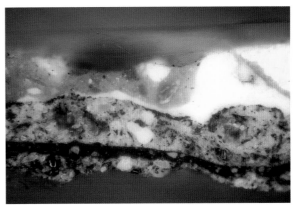

PLATE 10 Karel Dujardin, *Portrait of a Young Man (Self Portrait?)* (NG 1680), c.1655. Cross-section from the yellow brocade on the edge of the coat. Translucent inclusions of lead soap, surrounded by red lead particles, can be seen in the fourth paint layer (consisting of lead white, a coarse black pigment and red lead). By contrast, the second paint layer, which contains only lead white and a coarse black pigment, does not show lead soap inclusions. Original magnification 126×; actual magnification 110×.

inclusions embedded in a paint layer containing predominantly lead white were also seen in samples from Karel Dujardin's *Portrait of a Young Man (Self Portrait?)* (NG 1680). The fourth paint layer from the bottom in the cross-section illustrated in PLATE 10 consists of lead white, a coarse black pigment and red lead, which surrounds translucent inclusions of lead soaps. It is clear that here the lead soaps have formed from red lead, both because of the location of the soap inclusions in the layer, and because in the same cross-section there is another layer (the upper part of the double ground) consisting of lead white and coarse black, but without red lead and without lead soap inclusions. In *An Imaginary Church* by Bartolomeus van Bassen, discussed above, there are inclusions in the second ground layer, which is based on lead white, as well as in the first red ground layer (PLATES 4, 11a and 11b). In the lower ground layer, although some lead carbonate is now present inside the inclusions, lead white did not form part of the paint mixture. The lead soaps originate from the red lead seen around the perimeter of the pustules. The inclusions in the second ground layer are identical in appearance, with red lead particles around them, indicating that they also originate from red lead rather than lead white.[30]

By the nineteenth century, when the use of red lead was much reduced and lead-tin yellow had become obsolete, a large number of other lead-containing materials were being added to paint, primarily to improve its handling or drying

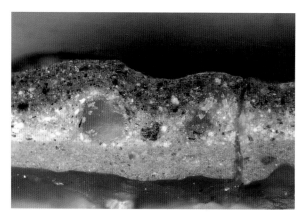

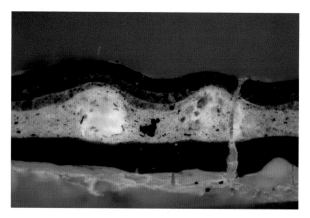

PLATE 11a Bartholomeus van Bassen, *An Imaginary Church*, 1627. Brighton Museum and Art Gallery. Cross-section from the brown foreground, showing large inclusions surrounded by red lead particles in the grey-brown second ground layer (lead white, black, brown and red lead). Original magnification 200×; actual magnification 175×.

PLATE 11b Bartholomeus van Bassen, *An Imaginary Church*. Cross-section from the brown foreground, ultra-violet light. The deformation of the three dark brown paint layers over the large inclusion in the grey-brown second ground layer can be seen clearly. Original magnification 200×; actual magnification 175×.

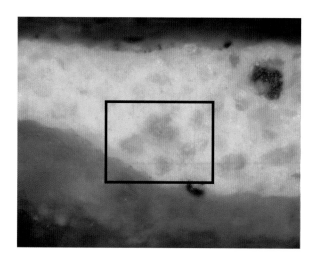

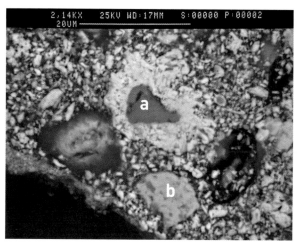

PLATE 12 Raphael, *Saint Catherine of Alexandria* (NG 168), *c*.1507–8. Cross-section from the yellow sunlit sky. Acid yellow tin-rich regions can be seen next to inclusions in the lead-tin yellow paint. Original magnification 400×; actual magnification 560×.

FIG. 8 Raphael, *Saint Catherine of Alexandria* (NG 168). Back-scattered electron image of a small area of the cross-section shown in PLATE 12 (marked with a box). Only tin was detected by EDX in the area labelled a. Both tin and lead were detected in the area labelled b (which is acid yellow in colour, see PLATE 12), but it is richer in tin than the rest of the lead-tin yellow matrix.

properties.[31] It seems likely that most of the occurrences of lead soap inclusions observed in nineteenth- and twentieth-century paintings derive from the interaction of these, often very soluble, lead compounds with the oil medium. For example, lead acetate (sugar of lead) was added to paint layers that now show paint defects, including ground staining, blooming and inclusions.[32] Zinc-containing pigments, which had been introduced by the nineteenth century, also readily react with fatty acids to form zinc soaps.[33]

The precise mechanism of the reaction between red lead and lead-tin yellow and the oil medium is not fully understood. If the lead(II) ions in the pigment are responsible for lead soap formation, it raises the question of what happens to the rest of the pigment. In lead-tin yellow it seems clear that only the metal ions in the +2 oxidation state are reacting with the fatty acids, since only lead is found in the inclusions by EDX analysis. With more careful EDX analysis of the matrix around the inclusions, tin-rich regions were located, as well as regions where only tin was detected. These regions may have formed as a result of depletion of lead

ions from the pigment during the formation of the lead soaps. The tin-rich regions have a distinctive acid-yellow colour, while the areas containing only tin appear white (PLATE 12). The location of these areas is also visible in the back-scattered image in the SEM (FIG. 8).[34]

The white, tin-containing regions in the sample, which are more translucent than lead white, are most likely a tin oxide of some kind. A tin white pigment, probably tin oxide, is referred to in several historical treatises on painting materials, including the seventeenth-century De Mayerne manuscript, where it is suggested that Van Dyck had tried it.[35] Tin oxide has also been reported in a yellow paint containing lead-tin yellow 'type I' on one of the paintings in *The Gonzaga Cycle* by Tintoretto (Munich, Alte Pinakothek). This was interpreted as an excess of tin oxide added during manufacture of the pigment, possibly deliberately, to lighten the tone.[36] The results of the EDX analysis of lead-tin yellow paints discussed above, however, seem to suggest that the tin oxide is a deterioration product. The extent to which the formation of lead soaps, lead carbonate and tin oxide, all of which are white, causes lightening of the yellow paint is difficult to assess. The acid-yellow regions that are depleted of lead (but not completely lacking in it) appear to be a stronger colour than the unchanged pigment, as far as can be judged from cross-sections viewed under the microscope, which may compensate for the white deterioration products. In any case, this effect is likely to be much more subtle than the change in texture caused by the formation of the lead soap inclusions.

For lead-tin yellow at least, the fate of the rest of the pigment seems clear, with the Sn(IV) ions remaining in the paint film as oxides or hydrated oxides. Sn(IV) compounds are relatively stable, but this is not the case for Pb(IV). Pb(IV) species are usually strong oxidising agents and are generally unstable with respect to Pb(II), except under highly oxidising or alkaline conditions.[37] Red lead-containing paints may not, therefore, behave in the same way as lead-tin yellow-containing oil paints in this respect.[38] Further study is required in this area before a reaction mechanism can be proposed.

From the analyses undertaken it is clear that most inclusions contain lead carbonate in addition to lead carboxylates. Studies conducted at the National Gallery using test films have indicated that, in the presence of carbon dioxide and under conditions of high relative humidity (70% RH or above), red lead in any binding medium can be converted to basic lead carbonate.[39] The lightening of red lead in oil due to conversion to lead carbonates has also been reported in the literature.[40] Indeed, lead carbonates (cerussite and hydrocerussite) appear to be the most thermodynamically stable species under a wide variety of conditions.[41]

It is possible that a reaction between red lead (and by analogy lead-tin yellow) and carbon dioxide is occurring in tandem with reaction of the pigment with fatty acids in the oil, yielding the lead carbonate found in the inclusions. It is also possible, however, that only lead soaps are formed initially and that these go on to react with carbon dioxide to form lead carbonate.[42] A third possibility is that the residue (probably Pb(IV)) of the red lead (after soap formation) converts to lead carbonate.[43] Obviously this has not happened in the lead-tin yellow examples, since no tin carbonate has formed. It should of course be noted that red lead and lead-tin yellow, although similar, are not chemically identical and that different reactions may be involved. In each case, carbon dioxide is required, which might diffuse into the paint layer from the atmosphere, or perhaps be generated by decarboxylation of a fatty acid or fatty acid soap.[44]

On balance, it seems likely that the lead carbonate associated with the inclusions forms via the lead soaps, because of the lamellar structure seen in some of the larger inclusions.[45] This results from the pattern of precipitation of lead carbonate within the inclusion, and is perhaps an argument in favour of the carbon dioxide being introduced by diffusion from the atmosphere.[46] The distinctive patterns (see FIGS 2b and 3) – sometimes concentric rings, or periodic bands, or a more complicated combination of the two – are very reminiscent of Liesegang patterns, which have long been observed where precipitation reactions occur in a gel.[47]

In a well-prepared oil paint film, pigment particles will be uniformly dispersed throughout the film. It might therefore be expected that metal soaps (formed by reaction between certain pigments and the medium) will also be evenly spread throughout the film.[48] However, the lead soaps we have observed in the paintings in this study have formed characteristic pustules or agglomerations. For the inclusions to form there must be slow migration of material through the paint film, leading to the formation of coagulated masses of lead soaps. This migration, and the subsequent growth of the inclusion, has in many cases led to distortion of the surrounding paint layers. It is not clear how quickly the inclusions form; it might be expected that lead soaps will

be most mobile when the paint film is young. Test samples of red lead in linseed oil painted out about ten years ago show soap formation, but these films have not yet formed inclusions. The process of pustule formation (as opposed to lead carboxylate formation) is therefore probably quite slow.[49]

Free fatty acids or metal carboxylates which have migrated through the paint have been observed on the surface of paintings, in the form of a bloom or efflorescence.[50] While this is clear evidence of their mobility, what is not so obvious is what drives the migration and aggregation. Williams suggests that increased cross-linking and changes in polarity during ageing can lead to incompatibilities between components that cause separation and blooming.[51] Van den Berg expands on this idea in his discussion of the migration of fatty acids (and the arguments are equally applicable to metal carboxylates), suggesting that a phase separation occurs when the less polar saturated fatty acids are driven out of the polar oil network.[52] Thus, the initially uniform distribution of lead soaps throughout a film may result in a stable system, but as the film ages, this arrangement ceases to be favourable and migration and aggregation occur.

There is also evidence that there may be a 'concentration factor' involved, with migration only occurring once fatty acids or metal carboxylates have reached a critical level.[53] The amount of free fatty acid present in a drying oil is dependent on the type of oil and how it has been prepared, and it seems likely that this will have an influence on the degree to which inclusions are formed.[54] An alternative to the phase separation theory has been suggested by Ordonez and Twilley,[55] based on the work of Whitmore et al.[56] They suggest two factors are important: (i) oil paintings may be subject to conditions of temperature and humidity such that the polymerised oil matrix is above its glass transition temperature but the free fatty acids are below their melting point; and (ii) the crystal morphology of free fatty acids may be such that when molecules assume a favourable orientation, they 'freeze' in position.[57] Although the soaps in the inclusions do not appear to be crystalline (indeed it is difficult to prepare crystalline samples of lead palmitate or stearate), there is likely to be a high degree of intermolecular order within these regions,[58] perhaps contributing to the driving force that separates the metal soaps from the more amorphous oil film matrix.

The main components of the inclusions have been shown to be the metal soaps of palmitic and stearic acids (both saturated monocarboxylic acids).[59] Lead soaps of other fatty acids that are found in drying oils, such as dicarboxylic acids and unsaturated monocarboxylic acids, are known,[60] but these species have not been found in inclusions or blooms;[61] it appears, therefore, that only the palmitate and stearate migrate through the film. In the inclusions they have coagulated together and concentrated, perhaps because they are the most hydrophobic of the soaps, and the agglomerations have grown to the point where they have displaced the surrounding matrix, including the less hydrophobic lead soaps.

The absence of unsaturated fatty acid soaps (such as oleate and linoleate) in inclusions may be because they are more likely to undergo cross-linking reactions or decomposition,[62] or because of the poor (solid-solution) 'miscibility' of the saturated and unsaturated fatty acids reported by Ordonez and Twilley.[63] Similarly, the fact that lead soaps of dicarboxylic acids (such as lead azelate) have not been detected in inclusions may be because the dicarboxylic acids (and by analogy their lead soaps) have very different chemical and physical properties to the saturated monocarboxylic acids (such as palmitic and stearic acids) or their lead soaps. The dicarboxylic species are much more polar (having much shorter hydrocarbon chains and difunctionality), so their incorporation into the inclusions will not be favoured. The shorter hydrocarbon chain and difunctionality also means that the dicarboxylates will not be readily compatible with the ordered lamellar structure that is likely to exist in regions containing long chain monocarboxylate soaps.[64] Further, the dicarboxylics have higher melting points and two carboxylic acid groups (increasing the chance of reaction), making them much less mobile than the monocarboxylics.[65]

If this model of inclusion formation is correct, it may help to explain the 'low azelate effect' mentioned earlier.[66] From the results presented in Table 1, it can be seen that where inclusions have been separated out from the bulk, low azelate to palmitate ratios are detected, but that for other whole samples, only slightly lowered, or sometimes normal, ratios are obtained. It seems likely that in the paint film as a whole, azelaic acid (and lead azelate) form normally as the oil dries, but that areas in the film containing pustules will become enriched in palmitate and stearate because of the migration of these species into the inclusions from elsewhere in the film. As a result, if a sample contains a high proportion of pustules, then

enhanced palmitate and stearate levels are detected and hence (apparently) lowered azelate to palmitate ratios. If a larger sample is examined, or one in which inclusions are only a small part, then normal ratios will be seen for the sample overall.

Conclusions

Translucent lead soap inclusions are commonplace in oil films containing red lead or lead-tin yellow. They comprise lead fatty acid soaps (of saturated fatty acids) and lead carbonate, and form as a result of reaction of the pigment with the oil binding medium. Although the paintings in this study are from a broad range of geographical locations and dates, demonstrating the widespread nature of this phenomenon, the results of analysis were extremely consistent, the main difference being the size, rather than the composition, of the inclusions. Some variation in the opacity of the inclusions can be accounted for by differences in the proportion of lead carbonate to lead soap in the inclusions. Inclusions have most commonly been noted in lead-tin yellow paint layers as this pigment is often used on its own.

In paintings dating from before the nineteenth century, the lead soap inclusions are not likely to be a deliberate addition to the original paint, as they serve no obvious purpose; they would have siccative properties but the lead pigments with which they are found are themselves good driers. The coarse and lumpy texture of the paint where inclusions are large is unlikely to be a deliberate effect intended by the artist, as has sometimes been thought. Instead, the inclusions will have formed over a period of time, after the painting was completed, by migration and agglomeration of the lead fatty acid soaps. Although the rate of formation of the inclusions is still unclear, the changes in the density and polarity of the paint film and the build-up of fatty acid soaps as it ages may be important factors.

The fatty acid ratios obtained from GC–MS analysis are vital to the identification of paint binding media. The level of azelaic acid present is particularly useful in distinguishing drying oils from materials containing non-drying fats, such as egg tempera. The presence of inclusions within a paint layer has been shown to affect the fatty acid ratios. Low levels of azelaic acid have regularly been found, which could lead (and have led in the past) to the erroneous conclusion that the binding medium of the paint is egg tempera, or that a mixed medium or emulsion has been used. FTIR microscopy has,

however, confirmed that none of the samples examined in this study contain protein. Thus, inclusion formation has consequences for the interpretation of the results of binding medium analysis, particularly if GC–MS is the only analytical technique employed.

The misidentification of the binder has a number of implications. For example, the widely held belief that Early Netherlandish painters used emulsions for lead-tin yellow highlights needs to be reassessed in the light of the findings in this paper. Inclusions may also pose a problem during cleaning of paintings, as the rather soft waxy lead soaps are vulnerable to mechanical damage. This is evident in Moretto's *Madonna and Child with Saints* (NG 1165) where the tops of the pustules have been flattened (PLATE 3b). However, lead soaps do not seem to be particularly soluble in commonly used cleaning agents.[67] The rough, gritty surface created by the inclusions can also cause problems during varnishing. Dirt sometimes becomes trapped in the soft lead soaps when they are exposed at the paint surface, which can be visually disturbing in light areas of paint; the white spots created by exposed pustules in dark paint are similarly very noticeable. Thus, a better understanding of the origin and chemistry of lead soap inclusions is important for the interpretation and conservation of the wide range of paintings that demonstrate this phenomenon.

Acknowledgements

We are grateful to Raymond White for his permission to use results of his GC–MS analyses, to Ashok Roy for XRD and EDX results, and to Rachel Grout for EDX analysis and for observation of tin-rich regions in lead-tin yellow paint samples. We would also like to thank Marie-Louise Sauerberg of the Hamilton Kerr Institute (HKI) and the Royal Collection for samples and photographs of the *Portrait of Charles I* by Daniel Mytens, Spike Bucklow of the HKI for samples from the *Thornham Parva Retable*, and Janet Brough of Brighton Museum and Art Gallery for samples from *An Imaginary Church* by Bartolomeus van Bassen. We are also grateful to Mark Malonely (Oxford University) and Mark R. St J. Foreman (University of Reading) for useful discussions about the chemistry and synthesis of lead carboxylates, and to M. John Plater and Ben de Silva (University of Aberdeen) and Thomas Gelbrich (EPSRC National Crystallography Service, University of Southampton) for the hydrothermal synthesis and crystallographic charac-

terisation of lead azelate. Thanks are also due to Janet Ambers of the British Museum Research Laboratory for assisting us with Raman microscopy.

Notes and references

1 H. Howard, *Pigments of English Medieval Wall Painting*, London 2003; P.C. van Geersdaele and L.J. Goldsworthy, 'The Restoration of Wallpainting Fragments from St. Stephen's Chapel, Westminster', *The Conservator*, 2, 1978, pp. 9–12.

2 A.J. Eikhoff, 'Pigmentation of Coatings', *Pigment Handbook, Vol. II: Applications and Markets*, ed. T.C. Patton, New York 1973, pp. 49–55; R.J. Gettens and G.L. Stout, *Painting Materials: A Short Encyclopedia*, New York 1942 (reprinted New York 1966), p. 153; E. West Fitzhugh, 'Red Lead and Minium', *Artists' Pigments: a Handbook of their History and Characteristics*, Vol. I, ed. R.L. Feller, New York 1986, pp. 109–39.

3 D. Saunders, M. Spring and C. Higgitt, 'Colour change in red lead-containing paint films', *ICOM–CC 13th Triennial Meeting*, Rio de Janeiro 2002, pp. 455–63.

4 L. Kockaert, 'Note sur les émulsions des Primitifs flamands', *Institut Royal du Patrimoine Artistique Bulletin*, XIV, 1973/4, pp. 133–9.

5 See Kockaert 1973/4, cited in note 4; J.R.J. van Asperen de Boer, M. Faries and J.P. Filedt Kok, 'Painting technique and workshop practice in Northern Netherlandish Art of the sixteenth century', in *Kunst voor de beeldenstorm*, Amsterdam 1986, p. 109; van Geersdaele and Goldsworthy 1978, cited in note 1; L.E. Plahter and U.S. Plahter, '*The young Christ among the doctors* by Teodoer van Baburen: Technique and condition of a Dutch seventeenth century painting on canvas', originally published in *Acta ad archaeologiam et artium historiam pertinentia*, Vol. III, 1983 and reprinted in *Conservare Necesse Est, for Leif Einar Plahter on his 70th Birthday*, IIC Nordic Group, Oslo 1999, pp. 42–65.

6 U. Plahter, 'Baburen re-examined', *Conservare Necesse Est*, cited in note 5, pp. 66–7.

7 Some of the preliminary work described in this article was presented as a paper (C. Higgitt, M. Spring and D. Saunders, 'Pigment-medium interactions in oil paint films containing red lead or lead-tin yellow') at the joint meeting of ICOM–CC Working Groups Paintings 1 and 2 and The Paintings Section, UKIC, *Deterioration of Artists' Paints: Effects and Analysis*, held at the British Museum, 10–11 September 2001 (pp. 21–6 of the extended abstracts). Other studies are listed below: K. Brunnenkant, 'Falscher Glanz? Technologische Untersuchung des "W.Kalf.1643" signierten Prunkstillebens im Wallraf-Richartz-Museum in Köln und Vergleich mit Werken aus der Pariser Periode Willem Kalfs (ca. 1619–1693)', *Zeitschrift für Kunsttechnologie und Konservierung*, 13, 1999, pp. 245–84; *Still Lifes: Techniques and Style, The Examination of Paintings from the Rijksmuseum*, ed. A. Wallert, Amsterdam 1999, p. 112; J.J. Boon, J. van der Weerd, K. Keune, P. Noble and J. Wadum, 'Mechanical and chemical changes in Old Master paintings: dissolution, metal soap formation and remineralization processes in lead pigmented ground/intermediate paint layers of 17th century paintings', *ICOM–CC 13th Triennial Meeting*, Rio de Janeiro 2002, pp. 401–6; J. van der Weerd, J.J. Boon, M. Geldof, R.M.A. Heeren and P. Noble, 'Chemical Changes in Old Master Paintings: Dissolution, Metal Soap Formation and Remineralisation Processes in Lead Pigmented Paint Layers of 17th Century Paintings', *Zeitschrift für Kunsttechnologie und Konservierung*, 16, 2002, pp. 36–51.

8 Plahter 1999, cited in note 6.

9 R. White, 'Van Dyck's Paint Medium', *National Gallery Technical Bulletin*, 20, 1999, p. 88.

10 N. Middelkoop, P. Noble, J. Wadum and B. Broos, *Rembrandt Under the Scalpel: The Anatomy Lesson of Dr Nicolaes Tulp Dissected*, exh. cat., Mauritshuis, The Hague and Amsterdam 1998, pp. 57–8; R.M.A. Heeren, J.J. Boon, P. Noble and J. Wadum, 'Integrating imaging FTIR and secondary ion mass spectrometry for the analysis of embedded paint cross-sections', *ICOM–CC 12th Triennial Meeting*, Lyon 1999, pp. 228–33; P. Noble, J. Wadum, K. Groen, R. Heeren and K.J. van den Berg, 'Aspects of 17th century binding medium: inclusions in Rembrandt's *Anatomy lesson of Dr Nicolaes Tulp*', *Art et Chemie, la couleur: Actes du Congrès*, Paris 2000, pp. 126–9.

11 Howard 2003, cited in note 1, and S. Bucklow, 'Technique', *The Thornham Parva Retable: Technique, Conservation and Context*, ed. A. Massing, London 2003, in press.

12 M.A. Mesubi, 'An Infrared Study of Zinc, Cadmium and Lead Salts of some Fatty Acids', *Journal of Molecular Structure*, 81, 1982, pp. 61–71;

L.J. Bellamy, *The Infrared Spectra of Complex Molecules*, Vol. 1, 2nd edn, Cambridge 1975; N.P.G. Roeges, *A Guide to the Complete Interpretation of Infrared Spectra of Organic Structures*, Chichester 1994; R. Matura, 'Divalent metal salts of long chain fatty acids', *Journal of the Chemical Society of Japan*, 86, 1965, pp. 560–72. It should be noted that in addition to the simple metal(II) (M^{II}) soap stoichiometry, M^{II}(monocarboxylate)$_2$ or M^{II}(dicarboxylate), other stoichiometries are possible, for example acidic and basic soaps. See M.S. Akanni, E.K. Okoh, H.D. Burrows and H.A. Ellis, 'The thermal behaviour of divalent and higher valent metal soaps: a review', *Thermochimica Acta*, 208, 1992, pp. 1–41; M.L. Lynch, F. Wireko, M. Tarek and M. Klein, 'Intermolecular Interactions and the Structure of Fatty Acid-Soap Crystals', *Journal of Physical Chemistry B*, 105, 2001, pp. 552–61; C.T. Morley-Smith, 'Zinc Oxide – A Reactive Pigment', *Journal of the Oil and Colour Chemists' Association*, 41, 1958, pp. 85–97; A. E. Jacobsen and W. H. Gardner, 'Zinc soaps in paints: zinc oleates', *Industrial and Engineering Chemistry*, 33, 1941, pp. 1254–6. Normal lead stearate ($Pb(C_{17}H_{35}COO)_2$, CAS No. 1072-35-1) and dibasic lead stearate ($2PbO·Pb(C_{17}H_{35}COO)_2$, CAS No. 12578-12-0) are available as PVC additives (infrared spectra available via FDM FTIR Spectra Database of Surfactants, Fiveash Data Management Inc., www.fdmspectra.com), and the basic and tribasic lead stearates are also known.

13 J.S. Mills and R. White, *The Organic Chemistry of Museum Objects*, 2nd edn, London 1994, pp. 33 and 171.

14 The C–H stretches are strong, sharp and well resolved in infrared spectra of the inclusions compared to those for the surrounding matrix. This suggests that the number of separate organic components present in the inclusion is more limited than in the matrix and that these components are not changing with time.

15 Similar clearly resolved lead carboxylate infrared spectra were also obtained from inclusions within a lead-tin yellow highlight and a red lead-containing underpaint in Dujardin's *Portrait of a Young Man (Self Portrait?)*, NG 1680 (see Table 1).

16 Raman spectroscopy was also used to investigate the components in the inclusions. Again, each of the three lead soaps could be distinguished in the pure form (with the lead palmitate and stearate being practically identical). However, in samples from paintings the soap bands were completely masked by the lead pigments present in the sample and/or fluorescence. Similar results were reported by L. Robinet and M.-C. Corbeil, 'The characterization of Metal Soaps', *Studies in Conservation*, 48, 2003, pp. 23–40.

17 E. Childers and G.W. Struthers, 'IR Evaluation of Sodium Salts of Organic Acids', *Analytical Chemistry*, 27, 1955, pp. 737–41. The authors note that, in some cases, the co-precipitated salts of a mix of organic acids will not give exactly the same infrared spectrum as is obtained by mixing the pure salts. They relate this observation to the crystal structure of the co-precipitated material.

18 The infrared spectrum obtained by the combination of the spectra of standards of lead palmitate and stearate gives a very close match to the spectrum for the inclusions in the Hobbema, even down to the fine structure in the 1350–1180 cm^{-1} region.

19 R. White and J. Pilc, 'Analyses of Paint Media', *National Gallery Technical Bulletin*, 17, 1996, p. 95.

20 Mills and White 1994, cited in note 13.

21 Van Geersdaele and Goldsworthy 1978, cited in note 1.

22 J. Pilc and R. White, 'The Application of FTIR-Microscopy to the Analysis of Paint Binders in Easel Paintings', *National Gallery Technical Bulletin*, 16, 1995, pp. 73–84; R.J. Meilunas, J.G. Bentsen and A. Steinberg, 'Analysis of Aged Paint Binders by FTIR Spectroscopy', *Studies in Conservation*, 35, 1990, pp. 33–51.

23 Kockaert 1973/4, cited in note 4. False positive results have been obtained when using amido black as a stain, with lead white being stained erroneously, J. Kirby, National Gallery, personal communication.

24 Plahter and Plahter 1983 (1999), cited in note 5.

25 Eikhoff 1973 and West Fitzhugh 1986, both cited in note 2; E.J. Dunn, Jr, 'Red Lead', *Pigment Handbook*, Vol. I: *Properties and Economics*, ed. T.C. Patton, New York 1973, pp. 837–42; J.E.O. Mayne, 'Pigment Electrochemistry', *Pigment Handbook*, Vol. III: *Characterisation and Physical Relationships*, ed. T. C. Patton, New York 1973, pp. 457–64; J.E.O. Mayne, 'The protective Action of Lead Compounds', *Journal of the Society of the Chemical Industry*, 65, 1946, pp. 196–204; J.E.O. Mayne, 'The Pigment/Vehicle Relationship in Anti-corrosive Paints', *Journal of the Oil and Colour Chemists' Association*, 34, 1951, pp. 473–9.

26 A.F. Wells, *Structural Inorganic Chemistry*, 5th edn, Oxford 1984, p. 559; R.J.H. Clark, L. Cridland, B.M. Kariuki, K.D.M. Harris and R. Withnall, 'Synthesis, Structural Characterisation and Raman Spectroscopy of the Inorganic Pigments Lead Tin Yellow Types I and II and Lead Antimonate Yellow: Their Identification on Medieval Paintings and Manuscripts', *Journal of the Chemical Society, Dalton Transactions*, 1995, pp. 2577–82.

27 E.J. Dunn, Jr, 'Lead Pigments' in *Treatise on Coatings, Vol. 3: Pigments, pt. 1*, eds R.R. Myers and J.S. Long, New York 1975, pp. 403–4. In addition, Dunn in 'White Hiding Lead Pigments', in *Pigment Handbook*, Vol. I, cited in note 25, p. 66, notes that 'white leads are chemically active pigments. They react with both the free acidic portions of vehicles and with the breakdown acids that develop from paint vehicles as paint films age. The reaction products, ... which are called lead soaps, reinforce the paint film. Fortunately these white lead reaction products are formed at a favorable (slow) rate that imparts the right type of plasticity to the paint film for good stabilisation.' See also L.A. O'Neill and R.A. Brett, 'Chemical reactions in paint films', *Journal of the Oil and Colour Chemists' Association*, 52, 1969, pp. 1054–74. The authors demonstrated that for pigments in linseed oil, appreciable reaction occurred with basic oxide pigments (red lead and zinc oxide), rather less with carbonates (lead white) and little or none with inert oxides.

28 Mayne 1946, cited in note 25. Lead, litharge (PbO) and red lead were found to reduce corrosion, while basic lead carbonate and lead chromate did not. Mayne links these findings to the relative amounts of lead(II) ions produced in solution.

29 Studies carried out at the National Gallery have shown that in ten-year-old test films containing lead white in oil, there is some lead carboxylate formation, but that these have a uniform distribution and are not present as inclusions. Pure lead white paint films from paintings give the same result.

30 It has been proposed in the literature (Boon et al. 2002, cited in note 7) that lead fatty acid soap inclusions form from the reaction of an unstable form of lead white with an oil medium. In all of the examples, other pigments are also present which could be the source of the lead soaps and, for the reasons discussed later in this text, seem more likely. Indeed, in more recent papers in the literature, this possibility has been acknowledged, see van der Weerd et al. 2002, cited in note 7.

31 L. Carlyle, 'Paint Driers Discussed in 19th-Century British Oil Painting Manuals', *Journal of the American Institute for Conservation*, 38, 1999, pp. 69–82; L. Carlyle, *The Artist's Assistant*, London 2001, pp. 41–54.

32 Examination by J. Zucker in 'From the Ground Up: The Ground in 19th-Century American Pictures', *Journal of the American Institute for Conservation*, 38, 1999, pp. 3–20, and by J.D.J. van den Berg in *Analytical Chemical Studies on Traditional Linseed Oil Paints*', PhD Thesis, University of Amsterdam, 2002, Chapter 7, of a primed canvas and an unfinished canvas belonging to the American painter Frederic Edwin Church revealed that each showed bloom formation, ground staining and protrusions. Zucker's and van den Berg's studies suggest that these three types of paint defect may be linked, and detailed analysis by van den Berg has revealed that the bloom and the protrusions contain primarily lead stearate and lead palmitate. In 1885, Church linked the ground staining that had appeared on his canvases to the inclusion of sugar of lead (lead acetate) in the ground preparation used by the canvas-maker Winsor & Newton (Zucker, pp. 11 and 13). A number of nineteenth-century writers warn of the problems of the use of lead acetate as a drier. For example, G. Field in *Chromatography; or A treatise on colours and pigments, and their powers in painting*, London 1835, p. 56 states: 'The inexperienced ought here to be guarded also from the highly improper practice of some artists, who strew their pictures while wet with the acetate of lead, ... which, though it may promote present drying, will ultimately effloresce on the surface of the work, and throw off the colour in sandy spots'. A.H. Church in *The Chemistry of Paints and Painting*, London 1890, p. 94, again warns: 'I have seen one of the results of this commingling of sugar of lead with the medium or the paint in the production of sugar of lead with the medium or the paint in the production of an immense number of small spots in the picture, sometimes appearing through the surface varnish in the form of a white efflorescence'. He continues his discussion, suggesting that the efflorescence attracts 'carbonic acid from the air and becomes lead carbonate' which he suggests could then darken to lead sulphide. These quotes are also discussed in Carlyle 1999 (p. 75) and Carlyle 2001 (p. 45), both cited in note 31.

33 J. Koller and A. Burmester, 'Blanching of unvarnished modern paintings: a case study on a painting by Serge Poliakoff', in *Cleaning,*

Retouching and Coatings: Technology and Practice for Easel Paintings and Polychrome Sculpture, eds J.S. Mills and P. Smith, London 1990, pp. 138–43. In addition, N. Heaton states in his *Outlines of Paint Technology*, London 1948, p. 73 that '...zinc oxide reacts with oil in an even more pronounced manner than white lead, owing to its basic character. The reaction with oil is somewhat different from that of lead, the acceleration of the drying not being so pronounced, and the film formed on drying being hardened in a pronounced manner. Zinc oxide paints, therefore, tend to dry hard and non-elastic, and are inclined to become brittle and crack on exposure to the weather'. See also O'Neill and Brett 1969, cited in note 27, and Morley-Smith 1958, cited in note 12. For examples where zinc soaps have been detected in paintings see M.-C. Corbeil, P.J. Sirois and E.A. Moffat, 'The use of a white pigment patented by Freeman by Tom Thomson and the Group of Seven', *ICOM–CC 12th Triennial Meeting*, Lyon 1999, pp. 363–8 (where zinc soaps were detected by FTIR and result from the reaction of the zinc white in the lead sulphate/zinc white mix), and J. van der Weerd, *Microspectroscopic Analysis of Traditional Oil Paint*, PhD Thesis, University of Amsterdam, 2002, Chapter 8.

34 Similar results are reported (based on laser microspectral analysis) for a lead-tin yellow highlight on Belshazzar's cloak in Rembrandt's *Belshazzar's Feast* (NG 6350), as illustrated in H. Kühn, 'Lead-Tin Yellow', *Artists' Pigments: a Handbook of their History and Characteristics*, Vol. II, ed. A. Roy, New York 1993, p. 91.

35 For a discussion of tin white see R.D. Harley, *Artists' Pigments c. 1600–1835*, 2nd edn, London 1982, pp. 172–3. Tin oxide has also been reported in a seventeenth-century painting by Jan Steen, but since it was found in a lead-tin-yellow-containing paint it is possible that it is there as a deterioration product. See M. Palmer and E.M. Gifford, 'Jan Steen's Painting Practice: *The Dancing Couple* in the Context of the Artist's Career', *Studies in the History of Art 57, Conservation research 1996/1997*, Washington 1997, pp. 127–56, especially p. 151.

36 A. Burmester and C. Krekel, '"Azurri oltramarini, lacche e altri colori fini": The Quest for the Lost Colours', in C. Syre, *Tintoretto, The Gonzaga Cycle*, Munich 2000, pp. 213–26. The identification of tin oxide is listed in Table 3, p. 206, and the interpretation is discussed in note 31, p. 210.

37 S. Giovannoni, M. Matteini and A. Moles, 'Studies and developments concerning the problem of altered lead pigments in wall paintings', *Studies in Conservation*, 35, 1990, pp. 21–5. N.N. Greenwood and A. Earnshaw, *Chemistry of the Elements*, Oxford 1984, Chap. 10. The authors observe that 'Because of the instability of Pb(IV), PbO$_2$ tends to give salts of Pb(II) with liberation of O$_2$ when treated with acids'. Further, in her article on red lead, West Fitzhugh 1986, cited in note 2, notes that PbO$_2$ is an oxidising agent and that it decomposes slowly due to the action of light or gentle heat.

38 Experiments conducted at the National Gallery have shown that, in the presence of carbon dioxide and moisture, PbO$_2$ in oil converts to basic lead carbonate (reported in Saunders et al. 2002, cited in note 3). It therefore seems likely that the Pb(IV)-containing residue from red lead (after lead(II) soaps have formed) reacts with carbon dioxide, moisture and/or other components of, or degradation products in, the oil film to form lead(II) species.

39 Saunders et al., cited in note 3. That the conversion of red lead to basic lead carbonate can also occur in media other than oil indicates that a direct reaction is possible (that is, lead carboxylate formation need not mediate the reaction). In the accelerated ageing studies on oil-containing films, it was not possible to recreate the pustule morphology described here. Lead fatty acid soaps were detected by FTIR (in addition to basic lead carbonate), but these appeared to be dispersed throughout the paint film and there was no evidence for the formation of large lead fatty acid soap inclusions. On test films painted out about ten years ago, no basic lead carbonate was detected for the control samples (kept in the dark). Instead, very fine whitish, opaque 'blooms' or 'patches' could just be made out on the surface, using a microscope, and lead fatty acid soaps were detected by FTIR. Again, no evidence of pustule formation was observed. Thus it seems likely that the development of lead fatty acid soap inclusions is a slower process, and only occurs if red lead is not more rapidly converted to lead carbonate by the action of high levels of moisture and light.

40 Eikhoff 1973 and West Fitzhugh 1986, both cited in note 2.

41 R.M. Garrels and C.L. Christ, *Solutions, Minerals and Equilibria*, London 1965, Chap. 7; Greenwood and Earnshaw 1984, cited in note 37. As discussed in note 30, lead white has been proposed as the source for lead fatty acid soap inclusions. In these studies, complex local chemical environments have been proposed to explain the authors'

observation of the formation of lead carboxylates and the 'remineralisation' of lead white, basic lead chloride and minium from a lead white film. Lead white is proposed to lose carbon dioxide and water to leave lead oxides and hydroxides that react with the oil medium components (reported by K. Keune, P. Noble and J. Boon in the paper 'Chemical changes in lead-pigmented oil paints: on the early stage of formation of the protrusions' presented at *Art 2002*, 7th International Conference on Non-destructive Testing and Microanalysis for the Diagnostics and Conservation of the Cultural and Environmental Heritage, Antwerp 2002). Keune suggested in her presentation that a highly acidic environment would be required to decompose lead white (this point is not very clearly stated in the preprints). The pH is then proposed to swing to highly basic conditions locally (pH > 10, van der Weerd et al. 2002, cited in note 7) in order to explain the precipitation of minium and the re-precipitation of lead white. It is suggested that it is the dissolution of the lead white and the release of carbonate and hydroxide moieties that lead to the high pH environment. The alternative model proposed in this article avoids the need for extreme pH conditions in the paint film.

42 If basic soaps are formed, it is possible that the 'PbO' associated with the soap forms the lead carbonate, see note 12.

43 See note 38.

44 Carboxylic acids have been shown to undergo facile thermal or photochemical oxidative decarboxylation in the presence of oxidising metal ions such as Pb(IV). See R.A. Sheldon and J.K. Kochi, 'Oxidative Decarboxylation of Acids by Lead Tetraacetate', in *Organic Reactions*, Vol. 19, eds R. Bittman, W.G. Dauben, J. Fried, A.S. Kende, J.A. Marshall, B.C. McKusick, J. Meinwald and B.M. Trost, New York 1972, pp. 279–421.

45 In accelerated ageing studies it has not proved possible to form lead carbonate from lead soaps, but the reaction is likely to be very slow and may be highly dependent on the pH (i.e. in a slightly acidic aged oil medium) and whether the environment is hydrophobic or hydrophilic. In a related reaction, lead acetate is readily converted to lead carbonate or basic lead carbonate, Greenwood and Earnshaw 1984, cited in note 37.

46 In two of the paintings in this study, Veronese's *Adoration of the Kings* (NG 268), 1573, and *Cleopatra* (NG 5762) by an anonymous French painter of the sixteenth century, a small amount of chloride was detected by EDX analysis in the inclusions. Noble et al. 2000, cited in note 10, also found some chloride in inclusions in Rembrandt's *The Anatomy Lesson of Dr Nicolaes Tulp*, which they were able to establish was present as lead hydroxychloride. The most likely source of chloride is from the environment – it is often present in dirt.

47 J. Cartwright, J. Manuel Garcia-Ruiz and A.I Villacampa, 'Pattern formation in crystal growth: Liesegang rings', *Computer Physics Communications*, 121, 1999, pp. 411–13.

48 This seems to be the case in lead white films examined. See also note 29.

49 See note 39.

50 E. Ordonez and J. Twilley, 'Clarifying the Haze: Efflorescence on Works of Art', *Analytical Chemistry*, 69, 1997, pp. 416A–22A; S.R. Williams, 'Blooms, Blushes, Transferred Images and Moldy Surfaces: What are these Disfiguring Accretions on Art Works?', *Proceedings of the 14th annual IIC–CG conference*, Toronto 1989, pp. 65–84; B. Singer, J. Devenport and D. Wise, 'Examination of a blooming problem in a collection of unvarnished oil paintings', *The Conservator*, 19, 1995, pp. 3–9; van den Berg 2002, cited in note 32; Koller and Burmester 1990, cited in note 33; A. Burnstock, M. Caldwell and M. Odlyha, 'A Technical Examination of Surface Deterioration of Stanley Spencer's Paintings at Sandham Memorial Chapel', *ICOM–CC 10th Triennial Meeting*, Washington 1993, pp. 231–8. The ratio of palmitic to stearic acids in the inclusions (and blooms) is generally found to give a good match to that in the paint, indicating that the oil is the source of the palmitate and stearate (Ordonez and Twilley, Koller and Burmester, Singer et al., van den Berg cited above).

51 Williams 1989, cited in note 50, states that 'increases in cross-link density (causing film shrinkage and syneresis) and changes in polarity of oxidized components (causing changes in solubility parameter) can create incompatibilities between components that can lead to separation and blooming, especially of scission products produced by oxidative degradation'. See also Ordonez and Twilley 1997, cited in note 50; G. Thomson, 'Some Picture Varnishes', *Studies in Conservation*, 3, 1957, p. 70.

52 Van den Berg 2002, cited in note 32, comments that 'Fatty acids that are not chemically or physically trapped within the paint might be driven out because of difference(s) in polarity between

the polar networks and the apolar saturated FAs (fatty acids), in other words, a 'phase' separation occurs. The fact that, as far as (is) known, no diacids have been observed in the bloom supports this theory.' An alternative view is presented by Koller and Burmester 1990, cited in note 33. They argue that the volume of the paint medium around metal soap agglomerations is reduced by losses during drying and ageing. Therefore, as the paint medium contracts on ageing, the agglomerations start to project through the paint surface.

53 The fact that we have not observed inclusions in lead white films may reflect the lower reactivity of lead white (and hence lower soap concentrations) compared to red lead. Dunn 1973 and Dunn 1975, both cited in note 27.

54 Carlyle 1999 (p. 73), cited in note 31, suggests that some of the problems associated with the use of excess driers in nineteenth-century paint formulations might be linked to the formation of excessively high levels of lead soaps. Koller and Burmester 1990, cited in note 33, suggest that the use of stand oil (with its higher levels of free fatty acids than linseed oil) was important to the formation of bloom. Van der Weerd 2002, cited in note 33, suggests that fatty acids would not be immediately available in fresh paint, and that time would be needed for glyceride hydrolysis, a process that could take several decades (see also J.D.J. van den Berg, K.J. van den Berg and J.J. Boon, 'Determination of the degree of hydrolysis of oil paint samples using a two-step derivatisation method and on-column GC/MS', *Progress in Organic Coatings*, 41, 2001, pp. 143–55). But this hypothesis assumes that the presence of free fatty acids is required prior to carboxylate formation (see notes 29 and 39).

55 Ordonez and Twilley 1997, cited in note 50.

56 P.M. Whitmore, V.G. Colaluca and E. Farrell, 'A note on the origin of turbidity in films of an artist's acrylic paint medium', *Studies in Conservation*, 41, 1996, pp. 250–5.

57 Under such conditions, fatty acids migrate until they encounter a nucleation site where they orient in their preferred position to 'grow'. The polymerised oil matrix is mobile enough to accommodate the growth. See Ordonez and Twilley 1997, cited in note 50, p. 421A.

58 The low symmetry and difficulties in the isolation of pure single crystals of metal soaps makes complete structure analysis difficult, Akanni et al. 1992, cited in note 12. However, these materials have been shown to adopt ordered lamellar structures. See J.-M. Rueff, N. Masiochi, P. Rabu, A. Sironi and A. Skoulios, 'Structure and Magnetism of a Polycrystalline Transition Metal Soap – $Co^{II}[OOC(CH_2)_{10}COO](H_2O)_2$', *European Journal of Inorganic Chemistry*, 2001, pp. 2843–8; J.-M. Rueff, N. Masiochi, P. Rabu, A. Sironi and A. Skoulios, 'Synthesis, Structure and Magnetism of Homologous Series of Polycrystalline Cobalt Alkane Mono- and Dicarboxylate Soaps', *Chemistry – A European Journal*, 8, 2002, pp. 1813–20. Lead palmitate and stearate contain both polar and non-polar groups within the same molecule and are therefore able to show orientation phenomena, surfactant-like behaviour and form sols, gels and pastes. See R.C. Mehrotra and R. Bohra, *Metal Carboxylates*, London 1983, pp. 151–6. See also note 12 in the Appendix. Mesubi 1982, cited in note 12, in his study of the effect of temperature on the infrared spectra of zinc, cadmium and lead fatty acid soaps, notes that the doublet around 720 cm⁻¹ (CH_2 rocking mode), seen at room temperature, indicates that the hydrocarbon chains of the soaps are in a crystalline state under ambient conditions. As the temperature is raised towards the melting point, the doublet becomes broad and the fine structure in the 1350–1180 cm⁻¹ regions disappears, indicating that the hydrocarbon chains of soaps can approach a 'liquid-like' state while the 'Pb–O' part of the structure remains unaltered (asymmetric and symmetric COO stretches unaltered).

59 Noble et al. 2000 and Heeren et al. 1999, both cited in note 10; O'Neill and Brett 1969, cited in note 27; van den Berg 2002, cited in note 32; van der Weerd 2002, cited in note 33.

60 Lead azelate has been prepared during the course of this study. W. Brzyska and H. Warda, 'Preparatyka I Właściwości Alkanodikarboksylanów Ołowiu (II)', *Rudy I Metale Niezelazne*, 28, 1983, pp. 204–8; A.J. Appleby and J.E.O. Mayne, 'Corrosion inhibition by the salts of the long chain fatty acids', *Journal of the Oil and Colour Chemists' Association*, 50, 1967, pp. 897–910. Metal oleates and linoleates prepared by M.-C. Corbeil and L. Robinet, 'X-ray powder diffraction data for selected metal soaps', *Powder Diffraction*, 17, 2002, pp. 52–60.

61 Koller and Burmester 1990, cited in note 33, report the presence of metal soaps of azelaic, palmitic, oleic, stearic and isomerised linoleic (from the use of stand oil) acids in paint films.

62 Mayne 1973, cited in note 25, reports the results of a study of the

degradation of the lead soaps of individual fatty acids. The saturated acid soaps did not degrade or render water non-corrosive. Oleic, linoleic and linolenic soaps degraded to give inhibitive materials – extracts of the soaps of unsaturated acids contained water-soluble peroxides. However, the major degradation product was lead azelate. It should be noted that lead azelate was not detected in inclusions in the present study.

63 Ordonez and Twilley 1997, cited in note 50, p. 417A.

64 See note 58.

65 The lead palmitate prepared for this study had a melting point of ~112°C, in good agreement with the literature (112.3°C, *CRC Handbook of Chemistry and Physics*, 68th edn, ed. R.C. Weast, Boca Raton 1987, p. B100). The sample of lead azelate started to turn grey at around 239°C, and had become very dark by 250°C when heating was stopped. The sample had not melted by this stage.

66 This phenomenon is not fully understood and other explanations may be possible: (i) decomposition of lead azelate may occur in the inclusions (possibly by decarboxylation, see note 44); (ii) azelaic acid may not be effectively released from lead soaps by TMTFTH in GC analy-sis; (iii) lead pigments may be less reactive towards azelaic acid than palmitic and stearic acids; (iv) the drying process and oxidative degra-dation to form azelaic acid may be affected by the presence of red lead, lead-tin yellow or lead soaps.

67 At room temperature, the lead carboxylates prepared in this study were extremely insoluble in water and in all common organic solvents. Contrary to the findings of B.K. Chatterjee and S.R. Palit, 'Solubilising effect of some basic organic compounds on lead and zinc soaps', *Journal of the Indian Chemical Society*, 31, 1954, pp. 421–5, there was no evidence for solubility in glycols or amines (glycol and triethanolamine were tested). It is suggested by van den Berg 2002, cited in note 32 (p. 48), that metal carboxylates will be vulnerable to citrates and other chelating cleaning agents and he cites studies where surface damage has occurred due, most probably, to loss of metal ions. However, triammonium citrate did not appear to have any effect on the soaps when tested in the laboratory, but further study should be under-taken.

TABLE 1 Summary of results of analysis

Artist, painting title and date	Description of the paint layers containing inclusions	Content of inclusion	GC–MS results; oil type, azelate/palmitate ratio (A/P)
Nathaniel Bacon, *Cookmaid with Still Life of Vegetable and Fruit*, 1620–5, Tate Britain.	Pale yellow highlight on the gourd; lead-tin yellow.[a]	Lead soaps and basic lead carbonate,[b] more carbonate than soaps.[c]	Partially heat-bodied linseed oil, A/P 1.4.
Bartholomeus van Bassen, *An Imaginary Church*, 1627, Brighton Museum and Art Gallery.	Red ground layer; red earth and red lead. Second brownish-grey ground layer; lead white, black, brown, red lead.	Lead soaps and basic lead carbonate,[b] in approximately equal amounts.[c]	Linseed oil, A/P 0.24.
Giovanni Bellini, attributed to, *Adoration of the Kings* (NG 3098), c.1490.	Pale yellow robe of the figure between the two horses on the right; lead-tin yellow.[a]	Lead soaps and lead carbonate,[b] more soaps than carbonate.[c]	Partially heat-bodied drying oil, A/P > 1.
Sandro Botticelli, workshop of, *Virgin and Child with Saint John the Baptist* (NG 2497), probably c.1482–98.	Brown architecture; red lead, lead white, black, vermilion and a little red lake.	Lead soaps and possibly some lead carbonate.[b]	
Hendrick ter Brugghen, *Jacob reproaching Laban* (NG 4164), 1627.	Pale yellow of lemon peel; lead-tin yellow 'type I'.[d]	Lead soaps and basic lead carbonate,[b,d] slightly more carbonate than soaps.[c]	
Lorenzo Costa, *A Concert* (NG 2486), c.1485–95.	Highlight on woman's sleeve; lead-tin yellow.[a]	Lead soaps and lead carbonate.[b]	
Gerard David, *Canon Bernardinus de Salviatis* (NG 1045), after 1501.	Yellow highlight from Saint Donation's cloth-of-gold cloak; lead-tin yellow 'type I'.[d]	Lead soaps and lead carbonate,[b] in approximately equal amounts.[c]	
Battista Dossi, ascribed, *Venus and Cupid*, 16th century, Gemäldegalerie, Berlin.	Yellow highlight on cloud; lead-tin yellow.[a]	Lead soaps and basic lead carbonate,[b] in approximately equal amounts.[c]	Drying oil, A/P 0.5.
Karel Dujardin, *Portrait of a Young Man (Self Portrait?)* (NG 1680), c.1655.	Grey underpaint; lead white, coarse black and red lead. Yellow highlight of the braiding on the sitter's jacket; lead-tin yellow.	Lead soaps only in both samples.[b]	Heat-bodied linseed oil in the yellow highlight, A/P 0.4.
Anthony van Dyck, *Lady Elizabeth Thimbelby and Dorothy, Viscountess Andover* (NG 6437), c.1637.	Yellow highlight on Lady Dorothy's gown; lead-tin yellow 'type I'.[d]	Lead soaps and basic lead carbonate.[b,d]	Partially heat-bodied linseed oil, A/P > 1.
Anthony van Dyck, *William Feilding, 1st Earl of Denbigh* (NG 5633), c.1633–4.	Yellow highlight on the shot pouch; lead-tin yellow.	Lead soaps.[b]	Heat-bodied walnut oil.
English School, *Wall painting from St Stephen's Chapel*, 1350–63, Palace of Westminster (now British Museum).	Priming layer; red lead.	Lead soaps and basic lead carbonate,[b] more carbonate than soaps.[c]	Drying oil, low azelate.
English School, *The Thornham Parva Retable*, c.1335.	Oil mordant beneath gilding on the canopy foliage; earth pigments and red lead.[a]	Lead soaps and basic lead carbonate,[b] more carbonate than soaps.[c]	Drying oil, A/P 0.1.
English School, *The Westminster Retable*, c.1260–80.	Orange lining of Saint John's robe, Scene IIIa; red lead.[a]	Lead soaps and basic lead carbonate,[b] in approximately equal amounts.[c]	Whole sample: linseed oil, A/P 1.0. Inclusion only: linseed oil, A/P 0.2.
English School, *Apocalypse Cycle*, 1375–1404, Westminster Abbey Chapter House.	South bay, Arch 3: red lead and a little vermilion.	Lead soaps and basic lead carbonate,[b] more carbonate than soaps.[c]	Partially heat-bodied linseed oil, A/P 0.93.
Fontainebleau School, *Cleopatra* (NG 5762), 16th century.	Yellow highlight on window shutter; lead-tin yellow.[a] The inclusions contain a little Cl in addition to Pb.[a]	Lead soaps and basic lead carbonate,[b] in approximately equal amounts.[c]	Linseed oil, A/P 0.35.
French School, *Portrait of a Man* (NG 947), probably 16th century.	White translucent highlight on gold chain; originally orange, traces of red lead remain.	Lead soaps and basic lead carbonate,[b] in approximately equal amounts.[c]	
French School, *Portrait of a Lady (Madame de Gléon?)* (NG 5584), c.1760.	Red ground layer; red earth and red lead.	Lead soaps and basic lead carbonate,[b] in approximately equal amounts.[c]	
Garofalo, *A Pagan Sacrifice* (NG 3928), 1526.	Pale yellow of drapery of naked woman; lead-tin yellow.	Lead soaps and lead carbonate,[b] in approximately equal amounts.[c]	
Francisco de Goya, *Portrait of Don Andrés del Peral* (NG 1951), before 1798.	Pinkish-orange ground layer; red lead, lead white and silica.	Lead soaps and basic lead carbonate,[b] more carbonate than soaps.[c]	Heat-bodied linseed oil, A/P 1.3.
Meindert Hobbema, *The Avenue at Middelharnis* (NG 830), 1689.	Yellow highlight on a small tree in the background; lead-tin yellow 'type I'.[d]	Lead soaps in translucent areas.[b] More opaque regions also contain basic lead carbonate[b] and possibly some cerrusite.[d]	Linseed oil, A/P 1.4.
Master of Cappenberg, *Christ before Pilate* (NG 2154), c.1520.	Yellow mordant of oil gilding; red lead, lead-tin yellow.[a]	Lead soaps and basic lead carbonate,[b] more carbonate than soaps.[c]	
Master of the Saint Bartholomew Altarpiece, *Saints Peter and Dorothy* (NG 707), 1510.	Yellow from the Virgin's crown, reverse of the panel; lead-tin yellow 'type I'.[d]	Lead soaps and basic lead carbonate,[b,d] more soaps than carbonate.[c]	Linseed oil, A/P 0.6.

92

Artist, painting title and date	Description of the paint layers containing inclusions	Content of inclusion	GC–MS results; oil type, azelate/palmitate ratio (A/P)
Michele da Verona, *Coriolanus persuaded by his Family to spare Rome* (NG 1214), *c.*1495–1510.	Orange underdress of woman second from left; red lead[d] and some massicot.[e]	Lead soaps and basic lead carbonate[b], possibly some cerrusite.[d] More carbonate than soaps.[c]	Walnut oil, A/P 0.2.
Moretto da Brescia, *Madonna and Child with Saint Bernardino and other Saints* (NG 625), *c.*1540–54.	Yellow highlight from lining of Virgin's cloak; lead-tin yellow 'type I'.[d]	Lead soaps and lead carbonate,[b,d] in approximately equal amounts.[c]	Walnut oil, A/P 0.1.
Moretto da Brescia, *Madonna and Child with Saints Hippolytus and Catherine of Alexandria* (NG 1165), *c.*1538–40.	Red hose of Saint Hippolytus; red lead and vermilion.[a]	Lead soaps and lead carbonate,[b] more soaps than carbonate.[c]	
Daniel Mytens, *Portrait of Charles I*, 1628, Royal Collection.	Red ground layer; red lead and red earth.[a]	Lead soaps and basic lead carbonate,[b] more carbonate than soaps.[c]	
Parmigianino, *The Madonna and Child with Saints John the Baptist and Jerome* (NG 33), 1526–7.	Red of Saint Jerome's cloak; vermilion and red lead.[a]	Lead soaps and basic lead carbonate,[b] more carbonate than soaps.[c]	
Raphael, *Saint Catherine of Alexandria* (NG 168), *c.*1507–8.	Yellow sunlit sky; lead-tin yellow.[a]	Lead soaps and (basic?) lead carbonate,[b] more carbonate than soaps.[c]	Walnut oil, A/P 1.98.
Rembrandt, *Belshazzar's Feast* (NG 6350), *c.*1636–8.	Yellow impasto highlight on Belshazzar's cloak; lead-tin yellow.[a,d]	Lead soaps (little or no lead carbonate).[b]	Linseed oil.
Jacopo Tintoretto, *Portrait of Vincenzo Morosini* (NG 4004), probably 1580–5.	Bright orange paint on sitter's sash; red lead and lead-tin yellow 'type I'.[d]	Lead soaps and basic lead carbonate,[b,d] more carbonate than soaps.[c]	
Paolo Veronese, *The Rape of Europa* (NG 97), 1570s?	Yellow highlight on Europa's pink brocade; lead-tin yellow 'type I'.[d]	Lead soaps and basic lead carbonate,[b,d] more soaps than carbonate.[c]	Walnut oil, A/P 0.6.
Paolo Veronese, *Allegory of Love, I* ('*Unfaithfulness*') (NG 1318), probably 1570s.	Primrose yellow of the drapery of man on the right; lead-tin yellow 'type I'.[d]	Lead soaps and basic lead carbonate,[b] in approximately equal amounts.[c]	
Paolo Veronese, *Allegory of Love, II* ('*Scorn*') (NG 1324), probably 1570s.	Highlight on man's drapery; red lead and lead-tin yellow 'type I'.[d]	Lead soaps and basic lead carbonate,[b] more carbonate than soaps.[c]	
Francisco de Zurbarán, *A Cup of Water and a Rose on a Silver Plate* (NG 6566), *c.*1630.	Grey paint of cup; lead white, black and lead-tin yellow.[a]	Lead soaps and lead carbonate,[b] more soaps than carbonate.[c]	

Notes to Table 1
a. Identified by EDX in the SEM
b. Identified by FTIR microscopy
c. The ratio of the peaks at *c.*1400 and *c.*1500 cm^{-1} in the FTIR spectrum was used to estimate the proportion of lead carbonate to lead soaps
d. Identified by XRD
e. Identified by Raman microscopy

Appendix: Preparation of Lead Fatty Acid Soaps

Azelaic, stearic and palmitic acids (or derivatives) are the principal fatty acids detected by GC–MS analyses on paintings and it was therefore decided to concentrate on the lead soaps of these acids. A variety of methods were used to prepare lead carboxylates in the laboratory but the basic strategy was to take a soluble lead(II) salt (lead acetate or nitrate) and to add a solution of the appropriate fatty acid directly.[1] As expected, the resulting lead fatty acid soaps were all extremely insoluble in a variety of solvents,[2] so purification was effected by washing to remove unreacted material and the acid by-product (acetic or nitric acid).

Lead palmitate and stearate were characterised by comparison with FTIR spectra of lead(II) and other metal palmitate and stearate soaps (salts) reported in the literature.[3] EDX analysis confirmed the presence of lead in the soaps and GC–MS demonstrated that the soaps contained palmitate and stearate respectively. The FTIR spectra for the two monocarboxylate soaps are shown in FIG. 5 (middle and lower traces) and the characteristic frequencies listed in Table 2.[4] XRD was not attempted as the d-spacings of the crystalline metal soaps are known to be too high to be detected on the available instrument.[5] In addition, most of the samples prepared appeared to be amorphous.

Lead azelate, prepared in the same manner, was more difficult to characterise, as there is little information available in the literature, and because of the extreme insolubility of the soap.[6] The FTIR spectrum is shown in FIG. 9, with the characteristic frequencies listed in Table 2. EDX analysis again confirmed the presence of lead, and GC–MS the presence of azelate. An elemental analysis was also obtained: Calculated for $PbC_9H_{14}O_4$: C, 27.48; H, 3.59; Pb, 52.67%. Found: C, 26.53; H, 3.26; Pb, 52.67%. While the results for the lead azelate were in good agreement with a 1983 study of lead(II) dicarboxylates,[7] further confirmation of the formation of lead azelate was sought. As with the palmitate and stearate soaps, the high d-spacings precluded powder XRD.[8] Using hydrothermal synthesis,[9] the Chemistry Department at the University of Aberdeen prepared crystals of lead azelate suitable for single crystal XRD.[10] The FTIR spectrum of the material prepared by this method matched that of the lead azelate derived from lead nitrate and azelaic acid produced at the National Gallery. The crystal structure, solved by the EPSRC National Crystallography Service,[11] confirmed that the sample was indeed lead azelate and showed that it has a 3D polymeric network structure, similar to the polymeric or polynuclear structures that have been found for the majority of lead carboxylates studied (including those of the monocarboxylic acids).[12]

Appendix notes and references

1 R.C. Mehrotra and R. Bohra, *Metal Carboxylates*, London 1983, Chapter 2; M.S. Akanni, E.K. Okoh, H.D. Burrows and H.A. Ellis, 'The thermal behaviour of divalent and higher valent metal soaps: a review', *Thermochimica Acta*, 208, 1992, pp. 1–41.

2 E. Rocca and J. Steinmetz, 'Inhibition of lead corrosion with saturated linear aliphatic chain monocarboxylates of sodium', *Corrosion Science*, 43, 2001, pp. 891–902; *CRC Handbook of Chemistry and Physics*, 68th edn, ed. R.C. Weast, Boca Raton 1987, pp. B100–1; W. Brzyska and H. Warda, 'Preparatyka I Wlasciwosci Alkanodikarboksylanów Olowiu (II)', *Rudy I Metale Niezelazne*, 28, 1983, pp. 204–8; Mehrotra and Bohra 1983, cited in note 1.

3 M.A. Mesubi, 'An Infrared Study of Zinc, Cadmium and Lead Salts of some Fatty Acids', *Journal of Molecular Structure*, 81, 1982, pp. 61–71; L.J. Bellamy, *The Infrared Spectra of Complex Molecules*, Vol. 1, 2nd edn, Cambridge 1975; N.P.G. Roeges, *A Guide to the Complete Interpretation of Infrared Spectra of Organic Structures*, Chichester 1994; R. Matura, 'Divalent metal salts of long chain fatty acids', *Journal of the Chemical Society of Japan*, 86, 1965, pp. 560–72.

4 Mesubi 1982, Bellamy 1975, Roeges 1994 and Matura 1965, all cited in note 3; Brzyska and Warda 1983, cited in note 2.

5 Rocca and Steinmetz 2001, cited in note 2; F. Lacouture, M. Francois, C. Didierjean, J.P. Rivera, E. Rocca and J. Steinmetz, 'Anhydrous lead(II) heptanoate', *Acta Crystallographica Section C – Crystal Structure Communications*, 57, 2001, pp. 530–1; M.-C. Corbeil and L. Robinet, 'X-ray powder diffraction data for selected metal soaps', *Powder Diffraction*, 17, 2002, pp. 52–60; Akanni et al. 1992, cited in note 1.

6 Brzyska and Warda 1983, cited in note 2; A.J. Appleby and J.E.O. Mayne, 'Corrosion inhibition by the salts of the long chain fatty acids', *Journal of the Oil and Colour Chemists' Association*, 50, 1967, pp. 897–910.

7 Brzyska and Warda 1983, cited in note 2.

8 Brzyska and Warda 1983, cited in note 2.

9 M.R.St J. Foreman, M.J. Plater and J.M.S. Skakle, 'Synthesis and Characterisation of Polymeric and Oligomeric Lead(II) Carboxylates', *Journal of the Chemical Society, Dalton Transaction*, 2001, pp. 1897–1903; M.R.St J. Foreman, T. Gelbrich, M.B. Hursthouse and M.J. Plater, 'Hydrothermal Synthesis and Characterisation of Lead(II) Benzene-1,3,5-tricarboxylate [Pb₃BTC₂]·H₂O: A Lead(II) Carboxylate Polymer', *Inorganic Chemistry Communications*, 13, 2000, pp. 234–8.

10 M. John Plater, University of Aberdeen, and Mark R. St J. Foreman, University of Reading.

11 Thomas Gelbrich, EPSRC National Crystallography Service, University of Southampton.

12 Foreman et al. 2001 and Foreman et al. 2000, both cited in note 9; Rocca and Steinmetz 2001, cited in note 2; Lacouture et al. 2001, cited in note 5; Akanni et al. 1992, cited in note 1; J.-M. Rueff, N. Masiocchi, P. Rabu, A. Sironi and A. Skoulios, 'Structure and Magnetism of a Polycrystalline Transition Metal Soap – Coᴵᴵ[OOC(CH₂)₁₀COO](H₂O)₂', *European Journal of Inorganic Chemistry*, 2001, pp. 2843–8; J.-M. Rueff, N. Masiocchi, P. Rabu, A. Sironi and A. Skoulios, 'Synthesis, Structure and Magnetism of Homologous Series of Polycrystalline Cobalt Alkane Mono- and Dicarboxylate Soaps', *Chemistry – A European Journal*, 8, 2002, pp. 1813–20.

FIG. 9 FTIR spectrum (3200–600 cm⁻¹) of a standard sample of lead azelate prepared during this study.

TABLE 2 Characteristic infrared frequencies (cm⁻¹) for lead soaps of palmitic, stearic and azelaic acids in the 4000–700 cm⁻¹ region (vs: very strong; s: strong; m: medium; w: weak; d: doublet)

Assignment	Lead palmitate	Lead stearate	Lead azelate
asymmetric C–H stretch of CH_3^-; CH_2^-	2955 (w); 2918 (vs)	2955 (w); 2918 (vs)	2959 (w); 2931 (s)
symmetric C–H stretch of CH_3^-; CH_2^-	2871 (w, shoulder); 2849 (vs)	2871 (w); 2849 (vs)	2914 (s); 2854 (s)
asymmetric COO– stretch (doublet)	1541 (s), 1513 (s)	1540 (s), 1513 (s)	1517 (vs)
C–H bend	1473 (m), 1462 (m)	1473 (m), 1462 (m)	
symmetric COO– stretch	1419 (m)	1419 (m)	
C–H bend (?)	1407 (m, shoulder)	1402 (m, shoulder)	1444 (vs)
symmetric COO– stretch			1403 (vs)
evenly spaced progression of bands – long chain n-alkyl chain rocking and twisting of $-CH_2-$	1349 (w), 1333 (w), 1315 (w), 1295 (w), 1274 (w), 1253 (w), 1232 (w), 1210 (w), 1189 (w)	1347 (w), 1333 (w), 1318 (w), 1299 (w), 1281 (w), 1263 (w), 1244 (w), 1225 (w), 1206 (w), 1187 (w)	
	930 (w)	930 (w)	1364 (w), 1341 (m), 1315 (w), 1283 (m; d), 1271 (m; d), 1245 (m), 1209 (w), 1118 (m), 1103 (m), 1094 (m), 988 (w), 941 (m), 827 (w), 769 (m), 722 (m)
$-CH_2-$ rock (torsion)	731 (w), 719 (w)	731 (w), 719 (w)	

'Black Earths': A Study of Unusual Black and Dark Grey Pigments used by Artists in the Sixteenth Century

MARIKA SPRING, RACHEL GROUT AND RAYMOND WHITE

In his *Lives of the Artists*, Vasari describes 'an astounding piece of painting' by Sebastiano del Piombo, a portrait of Pietro Aretino in which there may be seen 'five or six different kinds of black in the clothes that he is wearing – velvet, satin, ormuzine, damask, and cloth – and, over and above those blacks, a beard of the deepest black'.[1] Several different black pigments would have been available to painters in the sixteenth century to achieve this kind of effect. Those most commonly mentioned in treatises of the period on painting materials are charcoal black, bone or ivory black, lamp black, fruit-stone black and black earth.[2] The numerous references to black in Vasari's writing make it clear that artists were well aware of the differing hues and working properties of these blacks, and that they chose which pigment to use accordingly. Bone black gives a deep saturated warm black paint, charcoal black is bluer in tone, while lamp black has less body and can have a slightly greasy quality.[3] The nature of these carbon black pigments is well understood, because their preparation is discussed in detail in early treatises.[4]

Black earth, in contrast, is not a single pigment but a class of pigments, which could include a number of different black minerals. Comparatively little is known about which minerals were actually used as black pigments. In treatises on painting technique, the terms black earth, black chalk and black stone tend to be used interchangeably, whether discussing black pigments or drawing materials. Sometimes good sources are mentioned, or shreds of information about their properties are given, which could provide some clue as to their exact nature and composition. A soft black stone from Piedmont is described as being suitable for drawing by Cennino Cennini, and may also have been used as a pigment.[5] Vasari mentions black chalk from the hills of France,[6] and Antonio Filarete mentions a black earth from Germany which was suitable for use in fresco in his *Trattato dell'Architettura* (c.1461–4).[7] Much later, in the eighteenth century, the Spanish painter Palomino wrote that black earth 'is very

beautiful for all lights and all shadows, and especially if it is the one from Venice, which comes in little balls'.[8] A *terra nera di campana* (black earth of bells) is mentioned by Vasari, Armenini, Lomazzo, Borghini and Baldinucci. Vasari describes it as a pigment suitable for priming mixtures, and states that it has siccative properties in oil.[9] Borghini gives the most complete description, describing it as a crust that forms on the moulds in which bells and artillery have been cast, but he does not indicate what the composition of this crust might be.[10] Lomazzo also refers to *nero di scaglia*, which he says is a black earth.[11] Merrifield translates the word *scaglia* as 'scales' in her translation of the Marciana manuscript, where *scaglia di ferro*, used for colouring window glass, is described as 'those scales which fall from the iron when it is beaten'.[12] These last two are clearly not natural materials, and the fact that they are called black earths suggests that the term was being used in a broader sense to mean a pigment with soft, friable 'earth-like' properties.

In the current technical literature, black earth is generally assumed to be a black shale or chalk (the colour arising from incorporated carbon).[13] A coarse black silicate-containing pigment found in a painting in the National Gallery by Hendrik Terbrugghen may well be a black earth of this type.[14] During recent technical examination of sixteenth-century Italian paintings in the National Gallery, black pigments with the microscopic appearance of a crushed mineral were observed in many samples.[15] A number of these have been analysed in detail, using energy dispersive X-ray analysis (EDX) in the scanning electron microscope (SEM) and, in those cases where it was suspected the black might be predominantly organic in nature, pyrolysis–gas-chromatography–mass-spectrometry (Py–GC–MS). A few examples from seventeenth-century Italian paintings have also been included in the study.

From these analyses, several pigments were identified which were likely to have been termed black earth by artists, but which are not black shale. Some

96

selected results, listed in the Table, will be discussed in this paper. Two of the most interesting black minerals identified were black coal and pyrolusite (natural black manganese dioxide). Black coal has not, to our knowledge, previously been confirmed and characterised in paintings; the history of its use has so far been based solely on references to coal as a pigment in historical treatises.[16] A few scattered examples of the use of natural pyrolusite in paintings have been published but have received little attention.[17] As a result, the generally held belief that black manganese dioxide was only used as a pigment in oil paint in the nineteenth century, in a synthetic form, is often repeated in the literature.[18] The occurrences of pyrolusite added here seem to suggest that it was relatively common in sixteenth- and seventeenth-century paintings. The 'black' or dark grey minerals stibnite (antimony trisulphide) and bismuth were also found in a few paintings, as well as tin-rich (grey) bronze powder and black lead sulphide (see Table). Since the number of published occurrences is small,[19] the examples added here usefully contribute to our knowledge of where, when and how these pigments were used.

Sulphur-rich coal-type black

In a surprising number of the paintings in this study, a black pigment was found in which sulphur is the main element detectable by EDX analysis.[20] The particle characteristics suggest a crushed rock or mineral, as does the detection by EDX, in most cases, of variable (but small) amounts of calcium, silicon, aluminium and potassium as impurities associated with the pigment. The pigment appears

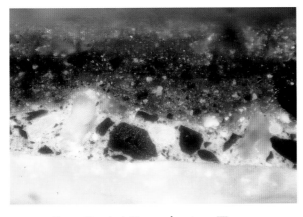

PLATE 1 Dosso Dossi, *A Man embracing a Woman* (NG 1234). Cross-section of a paint sample from the dark green of the woman's sleeve. The black pigment in the grey priming is coal. Original magnification 500×; actual magnification 440×.

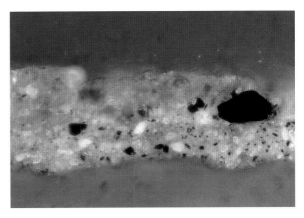

PLATE 2 Giulio Romano, *The Birth of Jupiter* (NG 624). Cross-section of a paint sample from the greenish blue of the distant hills on the left. The priming contains a large black coal particle together with some that are thinner and brownish in colour. Original magnification 500×; actual magnification 440×.

to be organic in nature, but harder and less soluble than the black organic pigments asphalt and bitumen; the particles in the paint layers have clean hard edges and there is no sign of solubility in the oil medium. Certain types of common coal can be sulphur-rich, and the initial analyses seemed to suggest that this is what was used in these paintings.[21] In some samples the rock has occasionally cleaved in such a way that the particle shape could be mistaken for charcoal, but there is none of the woody cell structure seen within particles of charcoal (PLATE 1). Larger particles of the pigment are a rich intense black, while smaller thinner particles have a slightly brownish hue. This can be seen very clearly in the biscuit-coloured priming on *The Birth of Jupiter* by Giulio Romano and his workshop (NG 624, PLATE 2; see also pp. 38–49).

Coal is a carbonaceous organic sedimentary rock, formed from the partial decomposition and metamorphosis of tree-like ferns, woody land-based plants and trees, formed millions of years ago. The plant material (composed predominantly of cellulose and lignin) would initially have degraded by oxidation and biological activity in aerobic conditions. The aerobic stage of the transformation of the biomass would cause a substantial elimination of the cellulosic components and transformation of the phenolic-based lignin polymer. Coal is formed in swamp-like wetland environments where immersion of the plant material and accumulation of the plant debris result in a decrease in the oxygen supply so that anaerobic organisms continue the degradation. Some of the anaerobic bacteria use sulphate salts in the environment as a source of

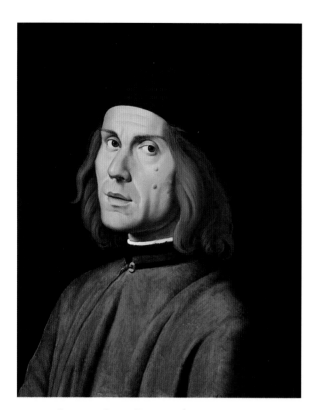

PLATE 3 Lorenzo Costa, *Portrait of Battista Fiera* (NG 2083), *c*.1507–8. Panel, 51.4 × 38.7 cm.

oxygen, employing it for redox reactions that produce sulphides and organic thio-compounds. This accounts for the pronounced sulphur levels in many lower rank coals. Anaerobic degradation is far less efficiently destructive of the organic biomass than degradation by aerobic organisms, so that the biomass is not completely destroyed but is altered, with loss of functional groups, fragmentation, loss of side chains and a relative increase in carbon content. As the deposits become buried more deeply, the effects of increasing temperature and pressure cause further alteration. The many different plant species from which coal can originate and the varying geological conditions endured during its formation are factors that influence the degradation process, leading to variation in the chemical composition of the resulting coal. One way in which different types of coal are classified is by their degree of 'coalification', which broadly corresponds to their geological age. The initial step in the coalification process is the formation of lignite (via peat), which is then transformed to brown coal (a low-grade coal), followed by bituminous coal and finally anthracite, which has a relatively high carbon content.[22]

Analysis of coals is a challenge, because their chemistry is complex and varies considerably. In addition, in most of the small paint samples examined here where coal appeared to be present, it was only a minor component of the pigment mixture. In three paintings, however, a black pigment of this description formed the main constituent of the paint, and was present in sufficient quantity to allow further investigation by Py–GC–MS to analyse the organic components of the pigment.

The results of Py–GC–MS carried out on the black pigment in a sample from the black background of *The Portrait of Battista Fiera* by Lorenzo Costa (NG 2083, PLATE 3) showed strong evidence for the presence of organic compounds that would point to the use of a coal-type material (rather than an asphaltic or bituminous rock). The liberated simple phenolics, alkylbenzenes and polynuclear aromatics seen in the chromatogram derive from fragmentation of partially functionalised aromatic macromolecular structures. These structures are generated from the original lignin by a combination of the early biological activity and the subsequent geological environment.[23] The high proportion of aromatic hydrocarbon species detected, and the presence of phenolic fragments, support a coal source and distinguish the pigment from other similar, but softer, materials such as bitumen and asphalt.[24] In addition, triterpanes and modified (partially aromatised) triterpane components are present. These include constituents such as fernane, indicating that the coal was formed from primitive fern-like plants, bacteriohopanoids from the accumulated remnants of bacteria, and other components indicative of a higher plant input, as would be expected for a geologically modified coal-type material.[25]

Py–GC–MS analysis of a sample from the black preparatory layer on Tintoretto's *Christ washing his Disciples' Feet* (NG 1130) suggested that the black pigment in this painting was similar in composition to that in the painting by Costa. The other painting in which a sulphur-rich black pigment was analysed in this way, Giampietrino's *Salome* (NG 3930), gave different results. Components that suggest a retinite-type material, derived from geologically modified diterpenoid resins, were detected. Modified diterpenoid resins are also found in softwood pitch, but pitch typically contains residual resin acids and other components (retene, hydroretene and norabietatrienes). These are not present in the Giampietrino sample and it is therefore not a pitch. Some retinite-like components were also found in the Costa and Tintoretto samples, but in the case of the Giampietrino sample no lignin-derived phenolics were detected, and thus a resinous

source is probable. A more detailed description of the Py–GC–MS analyses can be found in the Appendix.

Retinite can be similar in appearance to true coal, particularly if it has undergone geological modification at relatively high temperatures (greater than 150°C), and can be found in low-grade coal deposits.[26] In common with coal, it is a relatively translucent brownish black, harder than asphalt and bitumen, and can also be burnt as a fuel. Artists would not have been able to distinguish between them. The Py–GC–MS results on these three paintings suggest that, while the black pigment is not identical in composition in each case, it does derive from geologically modified organic material. Even in the painting by Giampietrino where the pigment is chemically somewhat different, it could originate from a coal deposit. The chemical differences are not surprising, given the variation in the conditions under which coal forms, and in the plant material from which it originates. It seems reasonable therefore to designate the sulphur-rich organic black pigment with similar optical and physical properties in the other paintings listed in the Table as a coal-type black.

References to the use of coal as a black pigment in Northern seventeenth-century painting treatises are well known. Theodore de Mayerne, for example, mentions *charbon de pierre* and *charbon de terre d'Escosse*, both common coal, and it also appears under the names of *sea coal* and *smythe coal* (forge coal) in several English treatises of the period.[27] The earliest reference seems to be in *The Arte of Limning* by Nicolas Hilliard dating from the beginning of the seventeenth century.[28] Edward Norgate stated that 'sea cole makes a Red Blacke', which is consistent with the warm black appearance of the coal that has been identified in paintings; in a second version of his treatise he even lists it among the brown pigments.[29] Several writers recommend its use for shadows, particularly in flesh paint.[30] The sea coal that was collected from shallow deposits on the coast was probably a low-grade coal, which would be likely to have a high sulphur content; it was therefore probably similar to the coal pigment identified in paintings in this study.[31] As noted earlier, none of the names of black pigments referred to in sixteenth-century Italian painting treatises can be specifically identified with common coal. Biringuccio confirms that it was available in Italy during this period, however, describing its use as a fuel in his *Pirotechnia*, first published in 1540 in Venice.[32] It is perhaps not surprising then to find a

PLATE 4 Lorenzo Costa, *A Concert* (NG 2486). Cross-section from the black background. The paint layer contains mostly coal with a little verdigris and silicaceous material. Original magnification 250×; actual magnification 220×.

large number of occurrences of a sulphur-rich organic black pigment (assumed to be coal) among the paintings analysed here, suggesting that it was already a common black pigment in Italy during the sixteenth century. Coal black was also found in two paintings by Guercino in this study (see Table), indicating that it was also used as a pigment in the seventeenth century in Italy. While there do not appear to be any specific references to its use as an artist's pigment in Italian painting treatises at this time, the French painter Pierre Lebrun does mention that the Italians were using coal as a black pigment for external painting.[33]

Although one might expect coal to be a poor drying pigment in oil, because other organic black pigments, such as asphalt, bitumen and pitch, are known to be problematic in this respect, this is an assumption not borne out in the examples found in this study. Verdigris was often mixed with the other black pigments available in the sixteenth century to aid drying, and has been found here mixed with coal in the black backgrounds of Lorenzo Costa's *Concert* (NG 2486, PLATE 4), Alvise Vivarini's *Portrait of a Man* (NG 2672) and Giampietrino's *Salome* (NG 3930). However, in the black background of Costa's *Portrait of Battista Fiera* (NG 2083) coal has been used without the addition of driers, yet does not appear to have caused any serious paint defects. The black paint does contain a significant amount of chalk, probably naturally associated with the black coal, but this would not act as a siccative for oil. Examination of the black background of this painting at close hand shows evidence of a fine drying craquelure, although this is not severe enough to be visible in gallery conditions.

PLATE 5 Jacopo Bassano, *The Purification of the Temple* (NG 228). Cross-section from the orange-pink highlight on the tunic of the man in the left corner. The thick black priming is composed almost entirely of coal. Original magnification 250×; actual magnification 220×.

Further evidence that the drying properties of coal were satisfactory is provided by two paintings where it is used as the major ingredient in black priming layers, *Christ washing his Disciples' Feet* (NG 1130) by Tintoretto and *The Purification of the Temple* by Jacopo Bassano (NG 228, PLATE 5). The priming layer would be the very worst place to employ a pigment if it were poorly drying, as it would almost certainly lead to serious defects in the paint layers above. However, in neither of these works does the state of the surface paint suggest that these black primings were problematic, even though the coal is not mixed with additional driers and is applied fairly thickly in Bassano's *Purification of the Temple*.

In most of the examples listed in the Table black coal has been found in pigment mixtures. Where it is mixed only with lead white, as in the priming of Romanino's polyptych of *The Nativity with Saints* (NG 297), the coal has imparted a distinctive warm brownish-grey colour to the layer. This is visible where the priming has been left exposed at the edge of one of the panels. The same is true of the priming of *The Birth of Jupiter* (NG 624) by Giulio Romano and his workshop, where the coal, again mixed only with lead white, is largely responsible for the warm biscuit colour (PLATE 2). In several paintings examined here, coal constitutes a minor component of the paint layers, added simply to deepen the local colour (see Table). Raphael appears to have exploited the warm, semi-transparent qualities of coal by employing it as an ingredient in some of the dark, saturated shadows in *The Ansidei Madonna* (NG 1171), notably the deep purplish shadow beneath the Virgin's canopy and the darkest

shadows of Saint John's red drapery. Other applications include Perugino's use of coal black for the warm greenish grey of Saint Francis's habit in *The Virgin and Child with Saints Jerome and Francis* (NG 1075), where it is mixed with lead white and a little ochre. The character of coal is perhaps most clearly displayed where it is used almost pure in the black backgrounds of the four paintings mentioned above. Employed in this way, the pigment is ideal for depicting the warm, penetrating darkness that lies behind the figures.

Pyrolusite (manganese black, natural manganese dioxide)

Pyrolusite is a soft black earthy manganese dioxide mineral. Its occurrence as a pigment in three sixteenth-century paintings, Correggio's *Allegory of Virtue* (Paris, Louvre) and two paintings by Perugino in the National Gallery of Umbria (Perugia) has been reported by Seccaroni.[34] Seven further occurrences on sixteenth-century paintings in the National Gallery are added here (see Table). In a number of paintings by Moretto and Moroni (who trained in Moretto's studio), pyrolusite was identified in the reddish-brown ground layers, mixed with red and yellow earth pigments. Only manganese could be detected in the pigment particles by EDX analysis, and it is therefore distinct from dark brown umber, where manganese is always associated with iron. In cross-sections the pigment is slightly more opaque and cooler in tone than the coal pigment described above, and is quite unlike the more transparent brown umber (PLATE 6). Larger particles appear soft, earthy and crumbly.

PLATE 6 Giovanni Battista Moroni, *Portrait of a Man* (NG 3129). Cross-section showing coarse particles of manganese black pigment in the brown priming. Original magnification 460×, actual magnification 400×.

The greenish-grey background of Moroni's *Portrait of a Man* (NG 3129) was also found to contain pyrolusite, mixed with lead white and a small amount of green earth. In Titian's *Virgin and Child with Saint John the Baptist and a Female Saint* (NG 635) it has been mixed with lead white for the grey underpaint beneath the orange shawl of the female saint (probably Saint Catherine).

In these paintings pyrolusite has been found only in pigment mixtures, and it has been suggested that if used alone its fast drying properties might cause problems.[35] However, this was not evident when painting out pyrolusite alone, bound in linseed oil, on a test panel, which in fact produced a rich glossy black paint with good working properties.[36] Many of Moroni's portraits depict the sitters in a range of black fabrics, and it may be that for some of these pyrolusite was used unmixed, but it was not possible to sample the draperies in these paintings. Hence, our understanding of Moroni's use of black pigments is at present incomplete.

The use of pyrolusite as a pigment is not confined to sixteenth-century paintings from Northern Italy; it has also been identified on the seventeenth-century *Portrait of a Man* in the National Gallery catalogued as 'After Guercino' (NG 5537), on *Saint John in the Wilderness* (NG 69) attributed to Pier Francesco Mola, and on *A Boy with a Bird* (NG 933) which is currently catalogued as 'After Titian' (see Table).[37] The *Boy with a Bird*, probably painted in the seventeenth century, contains pyrolusite associated with a small amount of barium, and is therefore slightly different from that in the *Virgin and Child* discussed above that is securely attributed to Titian.[38] Pyrolusite has also been reported on Dutch seventeenth-century paintings by Cuyp and Verspronck, although in the context of a general study of the painters' technique and hence with little discussion.[39] It is well known that manganese accelerates the drying of oil, so the 'black chalk that dries easily' mentioned by Theodore de Mayerne in the seventeenth century may well have been pyrolusite.[40]

There are deposits of black pyrolusite mineral in several parts of Italy; these were known already in Renaissance times, as they are listed by Biringuccio. He states that it is found 'on the shore at Salo', which is on Lake Garda only 25 km from Brescia where Moroni and Moretto were working. He also mentions that pyrolusite was being imported from Germany, and it must have been easily available because it was widely used in other branches of the arts such as glassmaking and ceramics.[41] As Seccaroni has discussed, pyrolusite was also used as a pigment in early civilisations. It has been found in the prehistoric cave paintings at Lascaux, France,[42] on wall paintings in Cyprus of the Roman period, and on Greek paintings of the bronze age.[43] A synthetic form of manganese dioxide, known as manganese black, was patented as a pigment by Rowan in England in 1871, and it has been stated in the past that the natural form has not been much used in oil painting.[44] However, the occurrences on sixteenth- and seventeenth-century paintings from both Italy and Holland discussed here tend to suggest that pyrolusite was much more widely used as a pigment in oil paintings than is generally recognised.

Stibnite (antimonite, antimony trisulphide)

Stibnite, or antimonite as it is sometimes called, is a naturally occurring mineral, the most abundant ore of antimony. Biringuccio's account of the ore notes: 'The ore of antimony is found in mountains just like other metallic ores and it is mined by various operations. The ore that I know is found in Italy in various places. From Germany they bring to Venice some of the smelted kind in cakes for the use of those masters who make bells.'[45] The smelted ore is likely to have been the partially oxidised sulphide.[46] He goes on to say that 'it serves to make yellow colours for painting earthenware vases and for tinting enamels, glasses and other similar works...'.[47] It was also used for making an alloy for casting type, for parting silver from gold, for making mirrors and for medicinal purposes.[48]

The numerous uses of stibnite in the field of the arts listed by Biringuccio, and the fact that mineral stibnite from a deposit in Germany was traded through Venice, suggests that it would not have been difficult for artists to obtain. Stibnite has been found as a pigment in the polychromy of German gothic sculpture, and also in much later polychromy dating from the seventeenth century on the exterior of the town hall in Duderstadt.[49] It was not commonly used as a pigment on easel paintings, however, and very few instances have been published. It was first reported as a grey pigment in easel paintings in 1991 by Ferretti et al., on three works by Correggio.[50] Several other occurrences have since been published, on other paintings by Correggio, two paintings by Fra Bartolommeo and a *Deposition* begun by Filippino Lippi and finished by Perugino.[51] Three paintings in the National Gallery have been found to contain stibnite (see Table).

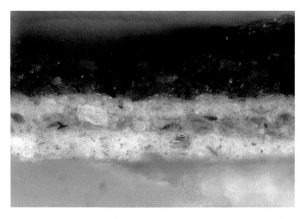

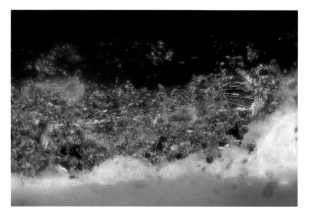

PLATE 7 Correggio, *The Madonna of the Basket* (NG 23). Cross-section of a paint sample from blue drapery at the left edge of the painting, showing stibnite particles in both the priming and undermodelling. Original magnification 500×; actual magnification 440×.

PLATE 9 Francesco Bonsignori, *The Virgin and Child with Four Saints* (NG 3091). Cross-section of a paint sample from the grey stibnite-containing shadow of the right-hand saint's white tunic. Original magnification 900×; actual magnification 790×.

They fit well into the pattern of occurrences discovered so far, since they were painted in Northern Italy in the first few decades of the sixteenth century. Correggio's *Madonna of the Basket* (NG 23), where stibnite has been used in the pinkish-grey priming layer, dates from around 1526 and was probably painted in Parma. The light purplish-grey mixture used for a sketchy undermodelling also contains some stibnite, mixed with lead white and a little azurite and red earth (PLATE 7).[52] In Francesco Bonsignori's *Virgin and Child with Four Saints* (NG 3091, PLATE 8), probably painted in Mantua in the first decade of the sixteenth century, stibnite is used as a dark grey pigment in the shadows of the white drapery of the unidentified saint holding a palm (PLATE 9), and in the grey beard of the elderly saint. Lorenzo Costa's *Adoration of the Shepherds* (NG

3105) is thought to date from around 1499, at which time the artist was working in Bologna.[53] Here Costa used stibnite for the mid-grey draperies of the lowest tier of angels (PLATE 10). In the detail of the infrared photograph of this painting illustrated in FIG. 1, the shadows and the dark grey borders of the draperies (also painted with stibnite) have almost completely disappeared. Unusually for a black pigment, it is remarkably transparent to infrared light. This property was also clearly demonstrated by infrared reflectography of a test panel painted with stibnite in linseed oil.

Mineral specimens of stibnite often consist of needle-shaped crystals with a metallic lustre. This metallic lustre was exploited in German polychrome sculpture such as the Franziskaner-Altar in Rothenburg by Tilman Riemenschneider, where

PLATE 8 Francesco Bonsignori, *The Virgin and Child with Four Saints* (NG 3091), *c*.1490–1510. Canvas, 48.3 × 106.7 cm.

PLATE 10 Lorenzo Costa, *The Adoration of the Shepherds* (NG 3105). Detail of the group of angels in the lower right corner. Their cool grey draperies contain stibnite mixed with lead white.

FIG. 1 Lorenzo Costa, *The Adoration of the Shepherds* (NG 3105). Detail of the infrared photograph.

coarsely ground stibnite was used to give texture and sparkle to areas depicting the ground in the landscape.[54] In polished cross-sections of samples from the paintings in this study, the pigment also has a characteristic silvery metallic appearance. It was not chosen to create a metallic effect, however, as it has been ground to a fine grey powder; the lustre is visible only under the microscope. Its appeal over a conventional carbon black (which was presumably cheaper) may have been the subtle clean cool grey colour obtained when it is mixed with lead white, and that when unmixed it is a dark grey rather than a true black.

Bismuth

The use of a bismuth-containing grey pigment was first reported in several paintings by Fra Bartolommeo.[55] It has similar properties to stibnite – in cross-sections under the microscope it has the appearance of shiny metallic particles – but with a distinctive pinkish or reddish tinge. The reddish tinge of the pigment is evident in the pale purplish-grey colour of the architecture on Raphael's large altarpiece of *The Madonna and Child with Saints John the Baptist and Nicholas of Bari (The Ansidei Madonna)* (NG 1171), where it is mixed with lead white (PLATES 11 and 12). It was established by spot EDX analysis on a paint cross-section in the scanning electron microscope that the pigment in this painting contains the element bismuth. Both bismuth metal and bismuth trisulphide (bismuthi-nite mineral) have a metallic lustre when viewed under the microscope, and distinguishing between them by EDX analysis is not straightforward, as the Bi M_α peak in the spectrum is close to the S K_α peak

and they are not well resolved. However, X-ray diffraction, and matching of the EDX spectrum to constructed spectra of bismuth metal and bismuth trisulphide, show that in the painting by Raphael, at least, the pigment is bismuth metal.[56] Bismuth metal

PLATE 11 Raphael, *The Madonna and Child with Saints John the Baptist and Nicholas of Bari (The Ansidei Madonna)* (NG 1171), 1505. Panel, 209.6 × 148.6 cm.

PLATE 12 Raphael, *The Madonna and Child with Saints John the Baptist and Nicholas of Bari (The Ansidei Madonna)* (NG 1171). Cross-section from the grey stone arch where it extends over the landscape paint. The grey paint layer contains lead white, bismuth and some colourless silaceous particles. Original magnification 500×; actual magnification 440×.

PLATE 14 Raphael, *The Procession to Calvary* (NG 2919). Macro photograph of the grey horse's under-belly, showing the sparkly grey paint surface. Original magnification 20×; actual magnification 17×.

is, in any case, the most abundant ore of bismuth.[57] The mines at Schneeberg in Saxony were probably the main source in the sixteenth century. Mining of bismuth began in Schneeberg around the middle of the fifteenth century, which can probably be taken as

a boundary for the earliest possible use of the pigment.[58]

When the surface of Raphael's *Procession to Calvary* (NG 2919) was examined under the stereomicroscope, a silvery grey pigment with a metallic

PLATE 13 Raphael, *The Procession to Calvary* (NG 2919). Detail of the grey horse.

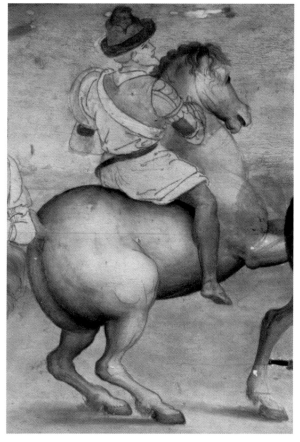

FIG. 2 Raphael *The Procession to Calvary* (NG 2919). Detail of the infrared reflectogram mosaic showing the grey horse.

PLATE 15 Attributed to Francesco Granacci, *Portrait of a Man in Armour* (NG 895), *c.* 1510. Panel, 70.5 × 51.5 cm.

PLATE 16 Attributed to Francesco Granacci, *Portrait of a Man in Armour* (NG 895). Surface of an unmounted paint sample from the man's silvery-grey armour. The coarse, reflective bismuth-containing particles are visible, but the overall colour of the sample is affected by the presence of a yellowed varnish. Original magnification 400×; actual magnification 350×.

lustre was seen in the paint of the grey horse (PLATES 13 and 14) and the grey hose of Simon of Cyrene. The horse has a clean grey colour, and the paint has rather poor covering power. Raphael has exploited this property by applying it thinly in areas of highlight, allowing the off-white priming to show

through. Since it was not possible to take samples from these areas of the painting, no further analysis has been carried out, but the pigment has a pinkish tint that suggests it is bismuth rather than stibnite. Even more compelling evidence is provided by the infrared reflectogram, in which the shadows of the horse and of Simon's legs appear a deep black, despite the fact that in normal light they are a relatively light grey (FIG. 2). This is very characteristic of bismuth, as was confirmed by infrared reflectography of a test panel on which bismuth ground in linseed oil had been painted. This contrasts conveniently with the properties of stibnite which, as mentioned above, is surprisingly transparent to infrared light. The same bismuth-containing pigment was used for the armour in the *Portrait of a Man in Armour* attributed to Granacci (NG 895, PLATES 15 and 16). As in the painting by Raphael, the properties of bismuth have resulted in an unusual effect where the dark grey half shadows of the armour (painted in bismuth) are darker in the infrared reflectogram than the deepest black shadows, which contain a carbon black. In this painting bismuth has also been mixed with red earth for the brown paint of the architecture behind the figure.

The main use of bismuth in the sixteenth century appears to have been in alloys for type metal.[59] In Germany, bismuth metal was used to imitate metal leaf on decorated wooden boxes, but perhaps the use most closely related to the field of painting was in manuscripts. Numerous German documentary sources of the fourteenth and fifteenth centuries have recipes for inks made from bismuth, to imitate silver, and an example of its use in a fifteenth-century German bible has been published.[60] Some bismuth was also found mixed with red earth and red lake in the mordant layer beneath God the Father's gilded halo on the *Coronation of the Virgin* (NG 263) by the Master of Cappenberg. The Master of Cappenberg was probably in fact Jan Bagaert, who was working in Westphalia at the beginning of the sixteenth century (see Table).[61] The use of bismuth does not, therefore, seem to be entirely confined to Italian paintings.

Tin-rich bronze powder in Perugino's *Archangel Michael*

A sample from the brownish-grey paint of the armour of Perugino's *Archangel Michael* (NG 288.2, PLATE 17) contains some particles that are microscopically very similar in appearance to the

PLATE 17 Pietro Perugino, *The Archangel Michael*
(NG 288.2), *c*.1496–1500. Panel, 114 × 56 cm.

PLATE 18 Pietro Perugino, *The Archangel Michael*
(NG 288.2). Cross-section of a blue-grey paint sample
from Saint Michael's armour, showing the presence of a
grey metallic pigment which contains copper and tin.
Original magnification 500×; actual magnification 440×.

stibnite and bismuth pigments, and were initially mistaken for one of these (PLATE 18). However, copper in combination with tin was detected in the particles by spot EDX analysis. Their metallic lustre suggests that they are finely ground particles of a copper-tin alloy, which is, of course, bronze. The proportion of tin to copper is high – quantitative EDX analysis on several particles in the cross-section gives an average ratio of roughly one part tin to two parts copper by weight – which is consistent with the fact that the particles have the appearance of a white metal. Bronze is more usually a yellow metal and typically contains around 10–15% tin. A

high-tin bronze with about 25% tin content by weight, which may well have been white or grey in colour, was used for bells and for mirrors in the sixteenth century, according to Biringuccio.[62]

Interestingly, Seccaroni has also reported finding copper in combination with tin in some areas of paint on two paintings in the Accademia Gallery in Florence; the *Pala di Vallombrosa* painted by Perugino in 1500 (in very dark blue paint), and the *Deposition from the Cross* begun by Filippino Lippi but finished by Perugino (in bluish-grey paint).[63] The *Archangel Michael* in the National Gallery, which is part of a polyptych painted for the Certosa di Pavia, was probably painted in the last year of the fifteenth century.[64] Seccaroni's analyses on the Accademia Gallery paintings were carried out by X-ray fluorescence (XRF), a non-destructive technique which allows the elements in the paint to be detected, but does not give information on the characteristics of the pigment particles, the pigment mixtures or the layer structure. However, the constant ratio of copper to tin Seccaroni detected in the blue areas on the *Deposition* by Perugino and Lippi suggests that the copper and tin are combined in the same particles, and that the pigment in this painting is similar to that observed in the samples from Perugino's *Archangel Michael*.[65]

Seccaroni puts forward several possibilities for the identity of this pigment, with reference to pigment recipes of the period for tin white and for artificial blue pigments which contain tin oxide, as well as copper or its compounds, as an ingredient. His hypotheses can be re-examined in the light of the additional information obtained from the samples from the National Gallery painting. The

PLATE 19 Lorenzo Costa with Gianfrancesco Maineri, *The Virgin and Child Enthroned between a Soldier Saint and Saint John the Baptist* (NG 1119). Detail of the soldier saint.

possibility that tin white has been used can be excluded, since the copper and tin are located in the same particles. He also suggests that copper stannate ($CuSnO_3.nH_2O$) might be a possible product of the recipes for artificial blues, but this is clearly not present in the National Gallery painting since the copper-tin particles are metallic in appearance. Moreover, the treatises indicate that the blue pigment made with these recipes is as good as ultramarine and better than azurite, but in the National Gallery painting, the paint of the Archangel Michael's armour is bluish grey and is certainly not comparable in colour to ultramarine.[66]

In the National Gallery painting, the metallic grey copper-tin particles in the bluish-grey paint are mixed with a small amount of blue copper carbonate, which could suggest that an artificial blue has been made from powdered bronze rather than pure copper, with the metallic particles being residual unreacted bronze. However, the grey underpaint in Saint Michael's armour contains far more bronze powder than blue copper carbonate, and ordinary natural mineral azurite has been used for the bluer areas, while the copper-tin metallic particles are in areas that are more grey than blue. In another panel of Perugino's Certosa di Pavia altarpiece, *The Archangel Raphael with Tobias* (NG 288.3), the same grey metallic pigment was found in the pale grey underpaint of Raphael's blue robe, where it was mixed only with lead white. The powdered tin-rich bronze, which is grey in colour, has therefore been used as pigment in its own right, in the same way as the grey metal bismuth.[67]

Galena (black lead sulphide)

The large altarpiece *The Virgin and Child Enthroned between a Soldier Saint and Saint John the Baptist* (NG 1119) is thought to have been painted mainly by Gianfrancesco Maineri in Ferrara, but finished and altered by Lorenzo Costa.[68] The armour of the soldier saint in this altarpiece has a blue cast, which is rather similar to Saint Michael's armour in the painting by Perugino (PLATE 19). Comparison of paint samples from the armour in these two paintings shows that they are

PLATE 20 Lorenzo Costa with Gianfrancesco Maineri, *The Virgin and Child Enthroned between a Soldier Saint and Saint John the Baptist* (NG 1119). Cross-section from a grey-blue shadow on the soldier's armour. The grey under-layer contains galena mixed with lead white, and the grey-blue glazed shadow contains azurite and galena. Original magnification 500×; actual magnification 440×.

PLATE 21 Lorenzo Costa with Gianfrancesco Maineri, *The Virgin and Child Enthroned between a Soldier Saint and Saint John the Baptist* (NG 1119). Detail of the soldier's cool grey sword.

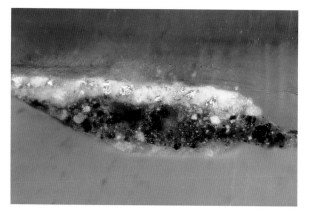

PLATE 22 Lorenzo Costa with Gianfrancesco Maineri, *The Virgin and Child Enthroned between a Soldier Saint and Saint John the Baptist* (NG 1119). Cross-section from the soldier's sword. The grey upper layer contains lead white and coarsely ground galena. The mixed brown paint layer underneath, corresponding to the wooden part of the Virgin's pedestal, contains particles of coal black. Original magnification 500×; actual magnification 440×.

painted in a very similar technique. The upper blue-grey layer visible in the cross-sections is based on azurite, mixed with a pigment that has a metallic lustre under the microscope. The grey underpaint also contains this lustrous pigment, mixed only with lead white (PLATE 20). Although it is similar in microscopic appearance to the copper-tin particles in the samples from the painting by Perugino, analysis identified the pigment as lead sulphide.[69] The occurrence of a different pigment with similar properties in this blue armour lends weight to the argument that in the paintings by Perugino discussed above a grey tin-rich bronze powder deliberately mixed with azurite was used, rather than a copper-tin blue.

As with stibnite and bismuth, the metallic appearance of the pigment in cross-sections does not correspond with the dark grey colour observed when viewing the surface with the naked eye. The true colour is best seen in the paint of the soldier saint's sword, where it is mixed only with lead white

(PLATES 21 and 22). It may be either the natural mineral (galena) or the synthetic lead sulphide described in the sixteenth century by Agricola in *De Re Metallica*, his treatise on metallurgy.[70] Both were used as a flux, for ceramics and glassmaking, and for parting gold from copper.[71] The properties of galena place it in the same category as stibnite, bismuth and tin-rich bronze, since it is a grey pigment rather than a true black. The Latin names used by Agricola also illustrate the close relationship between galena and bismuth; he calls galena *plumbum nigrum* and bismuth *plumbum cinereum*.[72] Two later instances of the use of galena as a pigment in exterior polychromy have been published. It was used in the paint on a tower which is part of the castle at Jever, Friesland (dating from 1730), and for the polychromy on figures on the outside of the town hall at Duderstadt, which dates from the seventeenth century.[73]

Discussion and conclusions

This survey of black pigments has covered a relatively limited number of sixteenth-century Italian paintings and is therefore far from comprehensive. It seems very likely that with further work, some other black minerals will be found to have been used as pigments. For example, preliminary EDX analysis of a black pigment in *The Sons of Boreas pursuing the Harpies* (NG 5467) by Paolo Fiammingo, suggests that it is an iron phosphate.[74] It would be interesting to investigate whether this has been used

more extensively in oil paintings. Black iron oxide has been reported in a sixteenth-century Italian wall painting and black iron sulphide in a fifteenth-century German manuscript.[75] Small amounts of black iron sulphide have been detected in three oil paintings in the National Gallery: *Saint John the Evangelist on Patmos* (NG 6264) by Velázquez, Parmigianino's *Mystic Marriage of Saint Catherine* (NG 6427) and *A Bearded Man holding a Lamp* (NG 5537) after Guercino. In each case the iron sulphide was found in the ground layers mixed with red and yellow iron oxides and silica, where it is very likely that it is simply a natural mineral impurity associated with the iron oxide pigments.[76] It seems possible, however, that black iron oxide, and iron sulphide as a pigment in its own right, may be found in future examinations of oil paintings.

Some conclusions can be drawn from the occurrences of black mineral pigments identified in this study. The pattern that has emerged so far is that a coal-type black was perhaps as common as the other carbon blacks, given the number of occurrences found from analysis of a relatively small group of paintings. The earliest occurrence in the Table dates from the last years of the fifteenth century, and a preliminary look at some blacks in seventeenth-century paintings has shown that it was still being used in Italy at this time. It seems likely that if black pigments were analysed more frequently black coal would also be identified in Dutch and English seventeenth-century paintings, since there are references to coal in Northern European documentary sources.

Pyrolusite, while apparently used less frequently than coal, cannot be considered rare as a pigment. All four of the paintings by Moretto in the National Gallery that have been sampled have been found to contain pyrolusite. These were painted in Brescia between 1526 and about 1555, and the painting by Titian in which pyrolusite has been used dates from around 1530–5. Although these were all painted in Northern Italy, the occurrence in paintings by Perugino and Correggio reported by Seccaroni, and in seventeenth-century Dutch and Italian paintings, show that its use was not restricted to a limited geographical area or time.

Stibnite and bismuth seem to have been much less frequently used than coal and pyrolusite. They might more accurately be described as dark greys rather than blacks, and are natural minerals. It is unlikely that the tin-rich bronze powder observed in the painting by Perugino is a natural pigment, but it has been included in this study of black earth

pigments because microscopically it could easily be mistaken for stibnite or bismuth and because it was almost certainly also used as a dark grey pigment. In any case, as discussed above, some of the 'black earths' described in treatises, were probably not natural minerals. The occurrences of stibnite and bismuth reported here add to the list of artists known to have used them, and also reinforce the impression that they were only used in easel paintings during the first few decades of the sixteenth century. Lead sulphide (galena), reported here for the first time in an easel painting, has similar properties to stibnite and bismuth, and was found on a painting that also dates from the beginning of the sixteenth century. The artists who have been found to use these pigments are not an entirely random group. There are perhaps some geographical connections. Among the artists who used bismuth, Granacci and Fra Bartolommeo were both working in Florence. The two paintings by Raphael containing bismuth were painted in Perugia around 1505, but it is possible that Raphael had already visited Florence. The city of Mantua could be a link between the artists using stibnite. Lorenzo Costa was established as court painter to the Gonzaga at Mantua by 1507. Correggio's early training is thought to have taken place at Mantua, and Bonsignori was also active at the Gonzaga court from about 1490.[77] The mobility of artists at this time should not be underestimated however. A more convincing pattern may become apparent once more occurrences have been found.

The question of why artists chose to use these unusual pigments is intriguing, and is probably related to their differing working properties and hue, as was made clear in our experiments painting them out (bound in linseed oil) on a test panel.[78] Both stibnite and bismuth were indeed dark grey rather than black when used alone. They have a tendency to sink, and require a high proportion of oil to make a workable paint, in the same way as the other natural minerals that were painted out. What is not obvious is why artists started to use these pigments at the beginning of the sixteenth century. These materials were all more commonly used in other branches of the arts, and were perhaps also sold by the *speziali* from whom artists usually obtained their pigments.[79] Some of these artists may have obtained their pigments from the same source – Perugino and Granacci, for example, are both known to have bought pigments from the Gesuati in Florence.[80] Biringuccio used the general term 'marcasite' for all sulphide minerals with a metallic

lustre and also for bismuth metal, as no distinction was made between it and bismuth sulphide at this time. Although Biringuccio and Agricola had some understanding of the different types of marcasite, it seems likely that artists did not know which type they were using, but simply bought it as a dark grey pigment.[81] These pigments with a metallic appearance were used for painting armour in three of the paintings, even though their lustre is only visible under the microscope. However, a dark grey rather than a black pigment would be ideal for depicting a metallic reflective surface where even the deepest shadows are not true black.

The paintings in this study illustrate that artists were indeed using a wide range of black pigments in the sixteenth century. Raphael used both bismuth and coal in different areas of the same painting; bismuth where a cool grey was required, and coal black for deeper shadows and in mixtures, while in paintings by Perugino coal, pyrolusite, stibnite, and tin-rich bronze powder have been discovered, sometimes in the same painting.[82] Lorenzo Costa also used both stibnite and coal, and coal and galena were used in the painting by Gianfrancesco Maineri that Costa is believed to have finished (PLATE 22). Raffaello Borghini, in his Il Riposo of 1584, lists nine black pigments and states that 'some of the listed pigments are more black and some are less black'.[83] The way individual black pigments have been used in the paintings examined in this study suggests too that artists were aware of the distinctive yet subtle differences between them.

Acknowledgements

We are grateful to Ashok Roy and Jilleen Nadolny for allowing us to use the results of their EDX analysis on samples from three of the paintings in this study. Thanks are also due to Rachel Billinge, for infrared reflectography, and to Ad Stijnman (ICN, Amsterdam, The Netherlands) for useful discussions on the use of bronze powder for works on paper.

Notes and references

1 G. Vasari, Le Vite de'più eccellenti pittori, scultori ed architettori, Florence 1966–87, ed. R. Bettarini, Vol.V, 'Vita di Sebastiano Viniziano, frate del Piombo e Pittore', pp. 94–5. 'Ritrasse ancora in questo medesimo tempo messer Pietro Aretino, e lo fece sì fatto, che, oltre al somigliarlo, è pittura stupendissima per vedervisi la differenza di cinque o sei sorti di neri che egli ha addosso, velluto, raso, ermisino, damasco e panno, et una barba nerissima sopra quei neri, sfilata tanto bene, che più non può essere il vivo e naturale.' The portrait described still survives in the Palazzo Comunale in Arezzo (reproduced in Michael Hirst, Sebastiano del Piombo, Oxford 1981, plate 119) but is in poor condition.

2 G.B. Armenini, De' Veri Precetti della Pittura, 1586, ed. M. Gorreri, Turin 1988, p. 192. Black earth (negro di terra), willow charcoal, peach-stone black and lamp black are recommended as pigments for painting. G.P. Lomazzo, Trattato dell'arte de la pittura, Milan 1584, p. 191, lists ivory black, almond-shell black, lamp black, and black earth. R. Borghini, Il Riposo, Florence 1584, pp. 206–7, lists ivory black, peach-stone and almond-shell black, lamp black and black earth.

3 J.A. van de Graaf, Het De Mayerne manuscript als bron voor de schildertechniek van de barok, Utrecht 1958, p. 142. De Mayerne mentions the blue-black colour of charcoal. Armenini (cited in note 2) refers to lamp black lacking body, Book II, chapter IX, p. 142. R.D. Harley, Artists' Pigments c.1600–1835, second edn, London 1982, p. 160, discusses the greasy qualities of lamp black.

4 Cennino d'Andrea Cennini, The Craftsman's Handbook, 'Il Libro dell'Arte', trans. D.V. Thompson, New York 1960, pp. 19–23. Cennini describes the preparation of charcoal black and lamp black. N. Hilliard, The Arte of Limning, c.1600, eds R.K.R. Thornton and T.G.S. Cain, Northumberland 1981, pp. 90–1. Hilliard gives detailed instructions on how to make ivory black.

5 Cennini, cited in note 4, pp. 20 and 22.

6 Vasari, cited in note 1, p. 118.

7 Antonio Averlino Filarete's Trattato dell'Architettura, c.1461–4, German edn, Tractat Über die Baukunst nebst seinen buchern von der Zeichenkunst und den bauten der Medici, trans. W. von Oettingen, Vienna 1890, pp. 638–9. Under the heading 'Farben fur Malerei al fresco' Filarete states 'auch ein Schwarz wird gefunden, das aus Deutschland kommt und eine Erde is'.

8 Z. Veliz, Artists' Techniques in Golden Age Spain, Six Treatises in Translation, New York 1986, p. 179.

9 Vasari, cited in note 1, Vol. I, p. 134: 'Ma conviene far prima una mestica di colori seccativi, come biacca, giallolino, terre da campane...' Armenini, cited in note 2, p. 129. Lomazzo, cited in note 2, p. 191.

10 Borghini, cited in note 2, pp. 206–7: '...nero di terra di campana, cioè quella scorza della forma con cui si gittano le campane, e l'Artiglieria, e questo s'adopra à olio.' Baldinucci almost repeats this in his Vocabulario del Disegno, Milan 1800, Vol.I, p. 364: 'Nero di terra di campana. Una sorta di color nero fatto d'una certa scorza della forma, con cui si gittano le campane e artiglierie.'

11 Lomazzo, cited in note 2, p. 191: 'il nero di scaglia detto terra nera'.

12 Merrifield, Original Treatises, dating from the XIIth to XVIIIth Centuries on the Arts of Painting, London 1849, p. 614. The Marciana manuscript is thought to be Venetian and to date from the sixteenth century. Other types of scales such as copper scales are mentioned by Agricola: G. Agricola, De Re Metallica, 1556, trans. H.C. Hoover and L.H. Hoover, New York 1950, p. 221. In this edition it is suggested that copper scales are cupric oxide and iron scales are partly iron oxide.

13 J. Winter, 'The Characterization of Pigments Based on Carbon', Studies in Conservation, 28, 1983, pp. 49–66. A black earth from Verona which is a carbonaceous clay is mentioned in P. Scarzella and P. Natale, Terre Coloranti Naturali e Tinte a Base di Terre, Turin 1989, Seconda Parte, Catalogo, 1.2. Terre Veronesi (no pagination).

14 The first red-brown ground layer on Terbrugghen's Jacob reproaching Laban (NG 4164) contains a relatively translucent coarse black pigment in which the principal component detected by EDX analysis was silicon. The EDX analysis was carried out by Ashok Roy. A black chalk from France supplied by Kremer Pigmente was found to be very similar in composition, as was a black chalk from a nineteenth-century paint box in the Victoria and Albert Museum formerly belonging to the English nineteenth-century painter William Etty.

15 The results of pigment analysis presented here are drawn from technical examination of Italian sixteenth-century paintings in the National Gallery carried out for a programme of revision of the scholarly schools catalogues, as well as from samples taken for a study of the preparatory layers in paintings of this period. The latter was published in J. Dunkerton and M. Spring, 'The development of painting on coloured surfaces in sixteenth-century Italy', Painting Techniques. History, Materials and Studio Practice, Contributions to the IIC Dublin Congress, 7–11 September 1998, eds A. Roy and P. Smith, London 1998, pp. 120–30. Some of the analyses of blacks were published here first. The paintings by Raphael discussed in this paper were examined for a forthcoming exhibition.

16 Harley, cited in note 3, pp. 156–7. Harley states that common coal is mentioned in a number of early seventeenth-century sources, indicating its use in oil and watercolour at this time, but that it was hardly used before or after this period.

17 A number of occurrences of pyrolusite in seventeenth-century Dutch

paintings have been published, but little discussed. See M. Spring, 'Pigments and Color Change in the Paintings of Aelbert Cuyp', *Aelbert Cuyp*, ed. A. K. Wheelock Jr., Washington 2001, pp. 64–73; E. Hendriks, 'Johannes Cornelisz. Verspronck. The technique of a seventeenth century Haarlem Portraitist', *Looking through Paintings*, Leids Kunsthistorisch Jaarboek XI, eds E. Hermens, A. Ouwerkerk and N. Costaras, London and Baarn 1998, pp. 227–68. A more extensive discussion appears in C. Seccaroni, 'Some rarely documented pigments. Hypotesis [sic] and working observations on analyses made on Three Temperas by Correggio', *Kermes*, 34, January–April 1999, pp. 41–59. In this article, three occurrences on sixteenth-century paintings are published.

18 K. Wehlte, *Werkstoffe und Techniken der Malerei*, Ravensburg 1967, p. 170. H. Kühn, H. Roosen-Runge, R.E. Straub and M. Koller, *Reclams Handbuch der künstlerischen Techniken, Band 1, Farbmittel, Buchmalerei, Tafel- und Leiwandmalerei*, Stuttgart 1984, p. 42.

19 Seccaroni, cited in note 17.

20 The EDX detector used for the analyses in this paper does not detect elements lower in atomic number than 12, that is sodium. Also, the S K_α peak in the EDX spectrum overlaps the Pb M_α peak, so that it can be difficult to identify a sulphur-containing black when mixed with lead white.

21 The sulphur content of different types of coal is discussed in P. Brimblecombe, *The Big Smoke, A History of Air Pollution in London since Medieval Times*, Cambridge 1987, p. 66. The sulphur content of some coals can be as much as 12%.

22 J.G. Speight, *The Chemistry and Technology of Coal*, New York 1994, pp. 3–39 and 94–112.

23 S. Watts, A.M. Pollard and G.A. Wolff, 'Kimmeridge Jet – A Potential New Source for British Jet', *Archaeometry*, 39, 1, 1997, pp. 125–43.

24 R. White, 'Brown and Black Organic Glazes, Pigments and Paints, *National Gallery Technical Bulletin*, 10, 1986, pp. 58–71.

25 J.M. Hunt, *Petroleum Geochemistry and Geology*, 2nd edn, New York 1996, p. 89. G. Ourisson, P. Albrecht and M. Rohmer, 'The Microbial Origin of Fossil Fuels', *Scientific American*, 251, no.2, 1984, pp. 34–41.

26 J.C. Crelling, 'The Petrology of Resinite in American Coals', *Amber, Resinite, and Fossil Resins*, eds K.B. Anderson and J.C. Crelling, Washington 1995, pp. 218–33.

27 Van de Graaf, cited in note 3, pp. 148 and 151. Harley, cited in note 3, refers to five English seventeenth-century treatises that mention coal as a pigment, see p. 157. See also C. L. Eastlake, *Methods and Materials of Painting of the Great Schools and Masters*, New York 1960, Vol. 1, p. 467, for references to coal in van Mander and MS Harley 6376. A Spanish seventeenth-century treatise on painting by Hidalgo mentions *carbon de piedra molida*, which is probably coal. See Veliz, cited in note 8, p. 136 and n. 9.

28 Hilliard, cited in note 4, p. 99.

29 Eastlake, cited in note 27, p. 467. The quote is from MS 6376, which is a variant of the first version of Norgate's treatise (for the history of this manuscript see J. Kirby, 'The Painter's Trade in the Seventeenth Century: Theory and Practice', *National Gallery Technical Bulletin*, 20, 1999, p. 42, n. 38). *Seacole* is listed with the brown pigments in the second version of Edward Norgate's *Miniatura or the Art of Limning*, eds J. M. Muller and J. Murrell, New Haven and London 1997, p. 59. However, in a variant list from a copy of Norgate's first treatise (National Library of Wales 21753 B, 91) it is listed with the black pigments, see eds Muller and Murrell, cited above, p. 254.

30 Hilliard, cited in note 4, p. 99, when discussing how to depict pearls, recommends applying 'a small shadow of seacoal undermost of all'. De Mayerne in van de Graaf, cited in note 3, p. 148, suggests coal for rendering the shadows of flesh, as does Henrie Peacham: H. Peacham, *Graphice or The Most Ancient and Excellent Art of Drawing and Limning*, London 1612, p. 95.

31 Hilliard, cited in note 4, indicates that sea coal had a high sulphur content, 'the culers them sellues may not endure some ayers, especially in the sulfirous ayre of seacole', p. 74. Brimblecombe, cited in note 21, discusses the foul, sulphurous fumes produced by burning medieval sea coal, pp. 7–9.

32 Vannoccio Biringuccio, *Pirotechnia*, originally printed in Venice in 1540, trans. C. Stanley Smith and M. Teach Gnudi, Cambridge, Mass, 1959, p. 174. Deposits of coal in Italy, in Liguria, Lipari and Sicily, are mentioned by Theophrastus. His discussion is discussed and quoted in a note in Hoover and Hoover's translation of Agricola, cited in note 12, pp. 34–5. Liguria and Lipari are rich in lignite, a low-grade coal. See Scarzella and Natale, cited in note 13, Seconda Parte, *Catalogo*, 2, 'Terre Piemontesi, Terre coloranti delle principali località di cave

piemontesi, descritte nel 1835 da V. BARELLI, 2.1.1, Terre di Vicoforte, Barelli', confirms the existence of a black earth pigment: 'lignite so widely dispersed in this soil decomposes so as to turn into earthy lignite and this is used like its predecessor for painting.'

33 Merrifield, cited in note 12. See the *Brussels manuscript*, 'Recueuil des essaies des merveilles de la peinture' by Pierre Lebrun, painter, 1635, p. 813: 'Les Italiens se servent de noir de charbon de terre pour travailler hors d'oeuvres, comme estant un noir qui reste plus longtemps à l'injure du temps que pas ung autre.'

34 Seccaroni, cited in note 17.

35 Seccaroni, cited in note 17.

36 Natural mineral pyrolusite from India was used for the test samples.

37 For the history of NG 5537 see M. Levey, *National Gallery Catalogues: The 17th and 18th century Italian Schools*, London 1971, pp. 144–5; for the history of NG 69 see pp. 161–2. For the history of NG 933 see C. Gould, *National Gallery Catalogues: The Sixteenth-century Italian Schools*, revised edn London 1975, pp. 298–9.

38 J. Vouvé, J. Brunet and F. Vouvé, 'De l'usage des mineraux de manganese par les artistes de la grotte prehistorique de Lascaux, Sud-ouest de la France', *Studies in Conservation*, 37, 1992, pp. 185–92. Minerals containing barium in combination with manganese, such as psilomelane, are often found with pyrolusite.

39 Spring 2001 and Hendriks 1998, both cited in note 17.

40 Van de Graaf, cited in note 3, p. 142, 'black (c)halke qui facilement se seiche'. It is well known that manganese accelerates the drying of oil. See J.S. Mills and R. White, *The Organic Chemistry of Museum Objects*, second edn, Oxford 1994, p. 38.

41 Biringuccio, cited in note 32, p. 113.

42 Vouvé et al., cited in note 38.

43 I. Kakoulli, 'Roman Wall Painting in Cyprus: A Scientific Investigation of their Technology', *Roman Wall Painting. Materials, Techniques, Analysis and Conservation, Proceedings of the International Workshop on Roman Wall Painting, Fribourg March 1996*, Fribourg 1997, eds H. Béarat, M. Fuchs, M. Maggetti, D. Paunier, pp. 131–41. S. Profi, B. Perdikatsis, S.E. Filippakis, 'X-ray analysis of Greek Bronze Age pigments from Thera (Santorino)', *Studies in Conservation*, 22, 1977, pp. 107–15.

44 R. Mayer, *The Artist's Handbook of Materials and Techniques*, revised and updated edn, New York 1982, pp. 40 and 55.

45 Biringuccio, cited in note 32, p. 92. Biringuccio is quite specific about where the ore can be found – he mentions several mines in central Italy near Siena (which in fact is where he came from) and also the Maremma, near the west coast. There are also small deposits in the mountains north of Milan.

46 Agricola, cited in note 12, p. 110.

47 Biringuccio, cited in note 32, p. 92.

48 E.L. Richter, 'Seltene Pigmente im Mittelalter', *Zeitschrift für Kunsttechnologie und Konservierung*, 2/1988, Heft 1, pp. 171–6.

49 For German gothic sculpture see Richter, cited in note 48, and C. Böke, 'Ein neuer Beleg zu Antimonglanz', *Restauro*, 100, 6, 1994, pp. 402–3. For seventeenth-century polychromy see W. Fünders, 'Aktuelle Befunde zur Verwendung "vergessener" Pigmente in niedersächsischen Raumfassungen', *Restaurierung von Kulturdenkmalen: Beispiele aus der niedersächsischen Denkmalpflege*, 1989, pp. 44–8.

50 M. Ferretti, G. Guidi, P. Moioli, R. Scafè and C. Seccaroni, 'The presence of antimony in some grey colours of three paintings by Correggio', *Studies in Conservation*, 36, 1991, pp. 235–9.

51 Seccaroni, cited in note 17. The paintings by Correggio in which stibnite was found, discussed in this article, date between c.1517 and 1531. The two paintings by Fra Bartolommeo are from the first decade of the sixteenth century, and *The Deposition* begun by Filippino Lippi was finished by Perugino around 1507.

52 An undermodelling with this pigment composition was seen in all four of the cross-sections from this painting.

53 Gould, cited in note 37, p. 75.

54 Richter, cited in note 48.

55 P. Moioli, R. Scafè and C. Seccaroni, 'Appendice I, Analisi di fluorescenza X su sei dipinti di Fra' Bartolomeo', and G. Lanterna and M. Matteini, 'Appendice II, Analisi SEM/EDS di un campione di film pittorico (sez. n. 5312 – s. 744.3 – Fra' Bartolomeo, pala Pitti)', *L'Età di Savonarola, Fra' Bartolomeo e la Scuola di San Marco*, ed. Serena Padovani with Magnolia Scuderi and Giovanna Damiani, Venice 1996, pp. 314–18. See also E. Buzzegoli, D. Kunzelman, C. Giovannini, G. Lanterna, F. Petrone, A. Ramat, O. Sartiani, P. Moioli, and C. Seccaroni, 'The use of dark pigments in Fra' Bartolomeo's paintings', *Art et Chimie, la couleur. Actes du Congrés*, Paris 2000, pp. 203–8.

56 An Oxford Instruments INCA system was used for the EDX analysis, with a GEM detector which has a resolution of 125eV. Thanks are due to Simon Burgess for assisting us with the analysis. The conventional Si(Li) detector in use at the National Gallery has a resolution of about 155eV. The X-ray diffraction pattern was in agreement with JCPDS file no. 5–519.

57 C.S. Hurlbut Jr, *Dana's Manual of Mineralogy*, 18th edn, New York and London 1971, pp. 233–4.

58 Katharina Mayr, 'Wismutmalerei', *Restauratorenblätte*, 7, 1984, pp. 153–71, states that mining of bismuth in Schneeberg began in 1460.

59 J.R. Partington, *A History of Chemistry*, Vol. 2, p. 59. Mathesius (1571) states that the metal was used in Milan work called counterfey and for metal type.

60 R. Gold, 'Reconstruction and Analysis of Bismuth Painting', *Painted Wood: History and Conservation*, Proceedings of a symposium in Williamsburg, Virginia, November 1994, eds V. Dorge and F.C. Howlett, Los Angeles 1998, pp. 166–78.

61 M. Levey, *National Gallery Catalogues: The German School*, London 1959, pp. 66–70.

62 Biringuccio, cited in note 32, p. 210, 'Those who want it to make bells put twenty-three, twenty-four, twenty-five, and twenty-six, (pounds of tin with every hundred pounds of copper) depending on the tone.' Biringuccio states that bell metal was traditionally also used for casting metal mirrors, but that 'nowadays most of the masters who make them take three parts of tin and one of copper', p. 388.

63 Seccaroni, cited in note 17.

64 M. Davies, *National Gallery Catalogues: The Earlier Italian Schools*, London 1951, rev. edn 1961, pp. 403–7.

65 Seccaroni, cited in note 17.

66 Seccaroni, cited in note 17.

67 The history of the use of bronze powder (which was not always true bronze) for writing inks and printing is discussed in C.W. Gerhardt, 'Das Drucken mit metallpigmenten in Geschichte und Gegenwart', *Polygraph*, 1982, pp. 1121–41. Milling of gold, silver, brass and copper to make a powder to use for illuminating manuscripts is described in Theophilus, *On Divers Arts*, trans. J.G. Hawthorne and C. Stanley-Smith, New York 1979, pp. 34–5. This work is thought to have been written in the twelfth century. It seems likely that bronze powder was also used.

68 Gould, cited in note 37, pp. 47–50. It has been proposed that Maineri started the painting, and that it was probably he who painted the armour of the soldier saint. Costa is thought to have altered the soldier's head and right hand.

69 Identified by X-ray diffraction, in agreement with JCPDS file no. 5–592.

70 Agricola, cited in note 12, mentions artificial lead sulphide prepared from metallic lead and sulphur to be used as a flux, p. 237.

71 Agricola, cited in note 12, pp. 462–4.

72 Agricola, cited in note 12, p. 110.

73 Fünders, cited in note 49. On the town hall in Duderstadt, galena was used for the cuirass of the figures of Commerce and Justice. Interestingly, stibnite was used for the cuirass of the figure of War on the same building.

74 *The Sons of Boreas pursuing the Harpies* is thought to date from between 1581 and 1596. Fe and P were detected in a black pigment in the priming layer by spot EDX analysis in the SEM on a paint cross-section.

75 The use of pyrite as a black pigment (iron sulphide) has been reported in the Bylant-Stundenbuch, dated 1475. See D. Oltrogge and O. Hahn, 'Über die Verwendung mineralischer Pigmente in der mittelalterlichen Buchmalerei', *Aufschluss*, 50 (6), 1999, pp. 383–90. A black iron oxide has been reported in wall paintings dating from *c*.1500 attributed to the circle of Pintoricchio. See *Materiali e Tecniche nella pittura Murale del Quattrocento*, Vol. 2, Parte II, Inchiesta sui dipinti murali del XV secolo in Italia sotto il profilo delle indagini conoscitive in occasione di restauri (1975–2000), Schede analitiche, coordinated by C. Seccaroni, Rome 2001, p. 330.

76 The pyrite in these paintings was identified by spot EDX analysis on cross-sections in the SEM.

77 Gould, cited in note 37, and Davies, cited in note 64.

78 Stibnite, bismuth, pyrite, pyrolusite, graphite and black shale as well as several types of carbon black were ground with linseed oil. Three patches were painted out on a panel for each pigment: a pale grey, a mid grey (both mixed with lead white) and the black or dark grey pigment alone. The pyrolusite was from a mineral sample from India, the others were supplied by Kremer Pigmente.

79 For a discussion of where artists obtained their pigments see L.C. Matthew, 'Vendecolori a Venezia: The Reconstruction of a Profession', *The Burlington Magazine*, CXLIV, November 2002, pp. 680–6.

80 P. Bensi, 'Gli Arnesi dell'arte. I Gesuati di San Giusto alle Mura e la Pittura del Rinascimento a Firenze', *Studi di Storia delle arti*, 1980, pp. 33–47.

81 Biringuccio, cited in note 32, pp. 92–3. Potters would almost certainly have known about the different types of sulphide as they were used to produce different colours in glazes.

82 Seccaroni, cited in note 17.

83 Borghini, cited in note 2.

TABLE 1 Summary of EDX analysis

Sulphur-rich organic black: coal

Lorenzo COSTA, *A Concert* (NG 2486), *c*.1485–95, panel, Bologna.
Black background; S-rich black mixed with a little verdigris and siliceous extender. Some Ca and a little red iron oxide in the matrix around the sulphurous black particles. Also a minor ingredient in other areas of the painting.

Alvise VIVARINI, *Portrait of a Man* (NG 2672), 1497, panel, Venice.
Black background; S-rich black mixed with a little verdigris (with a large amount of chalk and tiny amounts of red iron oxide, K and Si).

Lorenzo COSTA with Gianfrancesco MAINERI, *The Virgin and Child Enthroned between a Soldier Saint and Saint John the Baptist (La Pala Strozzi)* (NG 1119), probably 1499, panel, Ferrara.
S-rich black in the dark, transparent brown paint of the wooden parts of the pedestal.

RAPHAEL, *The Madonna and Child with Saint John the Baptist and Saint Nicholas of Bari (The Ansidei Madonna)* (NG 1171), 1505, panel, Perugia.
S-rich black in some of the darker paint mixtures, including the deep purplish shadow beneath the canopy of the Virgin's throne and the deepest shadows of Saint John's red drapery.

Lorenzo COSTA, *Portrait of Battista Fiera* (NG 2083), *c*.1507–8, panel, Mantua.
Black background; S-rich black with chalk.

Pietro PERUGINO, *The Virgin and Child with Saints Jerome and Francis* (NG 1075), *c*.1507–15, panel, Perugia.
Saint Francis's warm greenish-grey habit; S-rich black, lead white and a little ochre.

GIAMPIETRINO, *Salome* (NG 3930), probably *c*.1510–30, panel, Milan.
Black background; S-rich black with small amounts of Ca, Si, K and Fe and a little verdigris.

DOSSO Dossi, *A Man embracing a Woman* NG 1234, probably *c*.1524, panel, Ferrara.
Dark grey priming layer; S-rich black (with a little K, Ca and Si), lead white.

Gerolamo ROMANINO, *The Nativity with Saints* (polyptych) (NG 297.1–5), probably 1525, panel, Brescia.
S-rich black in the donkey-brown priming and a minor ingredient of Joseph's orange cloak.

PARMIGIANINO, *The Mystic Marriage of Saint Catherine* (NG 6427), *c*.1527–31, panel, Bologna.
Brownish-grey priming; S-rich black, lead white, silicaceous particles.

Workshop of GIULIO Romano, *The Birth of Jupiter* (NG 624), probably 1530–9, panel, Mantua.
Warm biscuit coloured priming layer; S-rich black and lead white.

Workshop of GIULIO Romano, *The Nurture of Jupiter* (Royal Collection), 1530s, panel, Mantua.
Warm biscuit-coloured priming layer; S-rich black and lead white.

DOSSO Dossi, *The Adoration of the Kings* (NG 3924), probably 1530–42, panel, Ferrara.
Large particles of S-rich black pigment in the priming and as an ingredient of some paint layers.

Jacopo TINTORETTO, *Christ washing his Disciples' Feet* (NG 1130), *c*.1556, canvas, Venice.
Black priming; S-rich black, with some silicaceous particles.

Jacopo BASSANO, *The Purification of the Temple* (NG 228), *c*.1580, canvas, Bassano.
Black priming; S-rich black, a little yellow earth, some K and Si, all possibly associated with the black pigment.

GUERCINO, *The Incredulity of Saint Thomas* (NG 3216), 1621, canvas, Cento.
A S-rich black pigment was identified in a thin brown underpaint from Christ's blue shawl.

GUERCINO, *La Vestizione di S. Guglielmo d'Aquitania* (Pinacoteca, Bologna).
A few particles of a S-rich black pigment were identified in a blue paint layer.

Manganese black

TITIAN, *The Virgin and Child with Saint John the Baptist and a Female Saint* (NG 635), probably 1530–5, canvas, Venice.
Grey underlayer beneath the female saint's orange shawl.

MORETTO da Brescia, *The Madonna and Child with Saints Hippolytus and Catherine of Alexandria* (NG 1165), *c*.1538–40, canvas, Brescia.
A coarse black containing Mn only in the brown priming.

MORETTO da Brescia, *The Madonna and Child with Saint Bernardino and other Saints* (NG 625), *c*.1540–54, canvas, Brescia.
A coarse black containing Mn only in the brown priming

MORETTO da Brescia, *Portrait of a Man at Prayer* (NG 3095), *c*.1545, canvas, Brescia.
A coarse black containing Mn only in the reddish-brown priming

Giovanni Battista MORONI, *Portrait of a Gentleman (Il Cavaliere dal Piede Ferito)* (NG 1022), probably *c*.1555–60, canvas, Brescia.
A coarse black containing Mn only in the brown priming

Giovanni Battista MORONI, *Portrait of a Lady (La Dama in Rosso)* (NG 1023), probably *c*.1555–60, canvas, Brescia.
A coarse black containing Mn only in the brown priming.

Giovanni Battista MORONI, *Portrait of a Gentleman* (NG 1316), *c*.1555–60, canvas, Bergamo(?).
A coarse black containing Mn only in the brown priming.

Giovanni Battista MORONI, *Portrait of a Man* (NG 3129), probably *c*.1560–5, canvas, Bergamo.
A coarse black containing Mn only in the brown priming. Also found in the greenish-grey background paint.

After TITIAN, *Boy with a Bird* (NG 933), probably 17th century, canvas.
Manganese black was identified in a paint layer beneath the dark sky, which may belong to an earlier composition. A very small amount of Ba was detected in the Mn-rich black particles.

After GUERCINO, *A Bearded Man holding a Lamp* (NG 5537), 1617–64.
A coarse black containing Mn in the brown ground.

Pier Francesco MOLA, *Saint John the Baptist preaching in the Wilderness* (NG 69), *c*.1640, canvas.
A coarse black containing Mn only in the red-brown ground layer.

Stibnite

Lorenzo COSTA, *The Adoration of the Shepherds* (NG 3105), *c*.1499, panel, Bologna.
Stibnite is mixed with lead white in the cool grey drapery of the lowest tier of angels along the edge of the painting and used almost pure for the dark grey edging of the drapery.

Francesco BONSIGNORI, *The Virgin and Child with Four Saints* (NG 3091), *c*.1500, canva, Mantua.
Stibnite was found in the grey beard of the elderly saint and in the grey shadows of the white robe of the saint holding a palm.

CORREGGIO, *The Madonna of the Basket* (NG 23), *c*.1524, panel, Parma.
Stibnite was identified in the pinkish-grey priming and the greyish-pink undermodelling, mixed with lead white and a little bright red earth.

Bismuth

RAPHAEL, *The Procession to Calvary* (NG 2919), *c*.1502–5, panel, Perugia.
A silvery-grey pigment, most likely bismuth, is visible under the stereomicroscope in the grey horse and the grey hose of Simon of Cyrene.

RAPHAEL, *The Madonna and Child with Saints John the Baptist and Nicholas of Bari (The Ansidei Madonna)* (NG 1171), 1505, panel, Perugia.
Bismuth was used for the grey stone arch that frames the figure group, mixed with lead white and a little silicaceous material.

Attributed to Francesco GRANACCI, *Portrait of a Man in Armour* (NG 895), *c*.1510, panel, Florence.
Stibnite is the main pigment used for the grey armour, mixed with a little azurite, lead white and another black pigment. It is also used as a minor ingredient in the dark, chocolate-brown wall colour, behind the man's right elbow.

MASTER of CAPPENBERG (Jan Bagaert?), *The Coronation of the Virgin* (NG 263), *c*.1520, panel.
Stibnite is mixed with red earth and red lake for the mordant beneath God the Father's gilded halo.

Tin-rich bronze powder

Pietro PERUGINO, *The Archangel Michael* (NG 288.2), *c*.1496–1500, panel.
Silvery-grey pigment containing only Cu and Sn in the grey paint of Michael's armour and chainmail. The grey layer is thinly glazed with azurite.

Galena (black lead sulphide)

Lorenzo COSTA with Gianfrancesco MAINERI, *The Virgin and Child Enthroned between a Soldier Saint and Saint John the Baptist* (NG 1119), probably 1499, panel, Ferrara.
Coarse lead sulphide with lead white for the cool grey paint of the soldier's sword and for the grey underlayer of the soldier's armour. Also mixed with azurite in upper blue-grey modelling strokes on the soldier's armour.

Appendix: Py–GC–MS analysis of samples of the sulphur-rich organic black pigment

The samples used had previously been treated with TMTFTH to extract the paint binding medium. The remnants of the samples after this treatment were centrifuged and briefly washed with benzene/methanol (9:2). The solid residues were transferred to a quartz pyrolysis capillary for pyrolysis in a SGE Pyroprobe furnace-type on-column pyrolysis unit. Pyrolysis was carried out at 450°C in a helium carrier and the products were flushed onto a 30 metre long SGE BP5-0.5 quartz column (0.32mm internal diameter) in a Hewlett Packard 5890 Series II gas chromatograph, temperature programmed: 70°C (1 min.) × 10°C min^{-1} to 300°C (55 min.), linked to a Micromass Trio 2000 gas chromatograph–mass spectrometer. Mass spectra were collected at 70 eV, source temperature: 210°C, scanned at 1 cycle sec^{-1}, mass range 45–620 Da. The total ion chromatograms were recorded and the relevant sections are displayed in FIGS 3a, b and c.

In the sample of black background paint from Lorenzo Costa's *Portrait of Battista Fiera* (NG 2083) and Jacopo Tintoretto's *Christ washing his Disciples' Feet* (NG 1130), the overall range of liberated component types is similar, although there are quantitative differences (FIGS 3b and c). For the sample of black pigment from Giampietrino's *Salome* (NG 3930), the spectrum of liberated components is restricted essentially to smaller aromatic hydrocarbon ring systems, without any evidence of phenolic fragments (FIG. 3a). This sample appears to match more closely the character-istics of a defunctionalised and aromaticised retinite derived from purely resinous material. No furan-based fragments, resulting from cellulosics or heated cellulosics, were found in any of the samples and no still-extant diterpenoid or triterpenoid resin acids were detected at any stage of the analysis to suggest the possibility of wood or resin pitch. Indeed the intractability of the samples would speak against this – the organic components of the pigment could not be extracted by treatment with TMTFTH.

On the other hand, the Costa and Tintoretto samples exhibit a much broader range of liberated chemical types, which include simple phenolic fragments, alkyl-benzenes, and polynuclear aromatic hydrocarbons. These groups of compounds can be related to the sheets of aromatic ring structures that are typical of coal, with some hydroxyl functions attached that result from the geological transformation of originally lignin-based material from trees or their 'woody' predecessors, such as plants of the tree fern type. The absence of syringyl, sinapyl, coniferyl and cinnamyl entities precludes the likelihood of a lignin content of any significance remaining, as might be the case for peats and low-rank lignitic coals. The presence of triterpanes, some of which show the characteristics of extended hopane- and moretane-based homologues, underlines the activity of a seething, bacteria-rich, reducing environment that participates in the metamorphosis of the lignins.

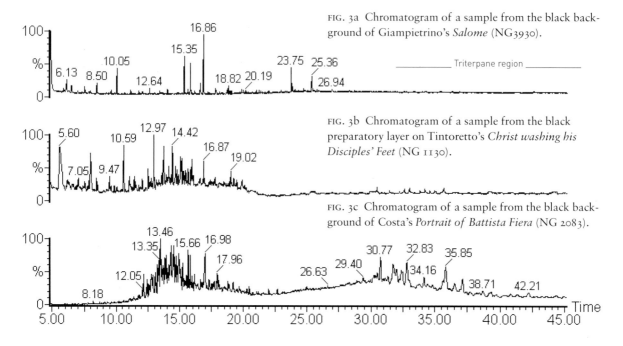

FIG. 3a Chromatogram of a sample from the black background of Giampietrino's *Salome* (NG 3930).

FIG. 3b Chromatogram of a sample from the black preparatory layer on Tintoretto's *Christ washing his Disciples' Feet* (NG 1130).

FIG. 3c Chromatogram of a sample from the black background of Costa's *Portrait of Battista Fiera* (NG 2083).